YŪREI
THE JAPANESE GHOST

Zack Davisson

 CHIN MUSIC PRESS

All rights reserved
ISBN 978-16340596-9-5
Second (2) edition

Published by:
Chin Music Press
1501 Pike Place #329
Seattle, WA 98101 USA
www.chinmusicpress.com

Chin Music Press hardback edition/2015
Chin Music Press paperback edition/2020

Book design by Carla Girard

Printed in the United States of America

Library of Congress Cataloguing-in-Publication data
LCCN 2020938488 (print)

CONTENTS

"A portrait of death, painted from life.
Maruyama Okyo's painting of his lost love
Oyuki is the one that started it all."

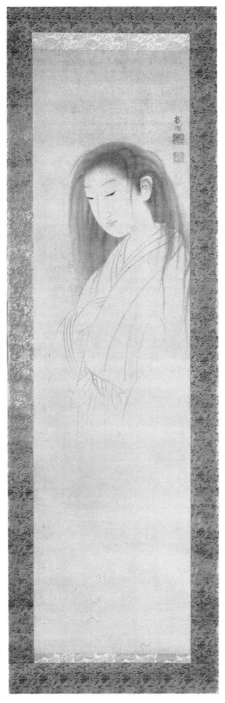

Ghost of Oyuki,
Maruyama Ōkyo

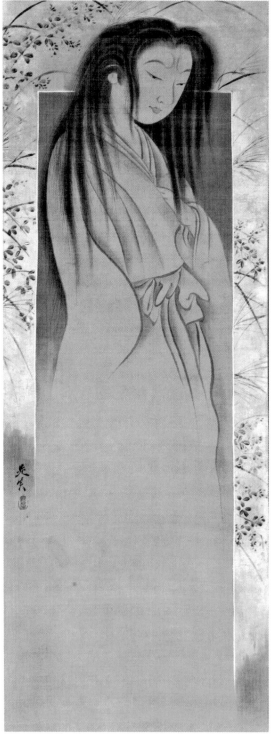

Ghost, Shibata Zeshin

Okyo's ghostly portrait of Oyuki had many imitators, such as this painting by Shibata Zeshin.

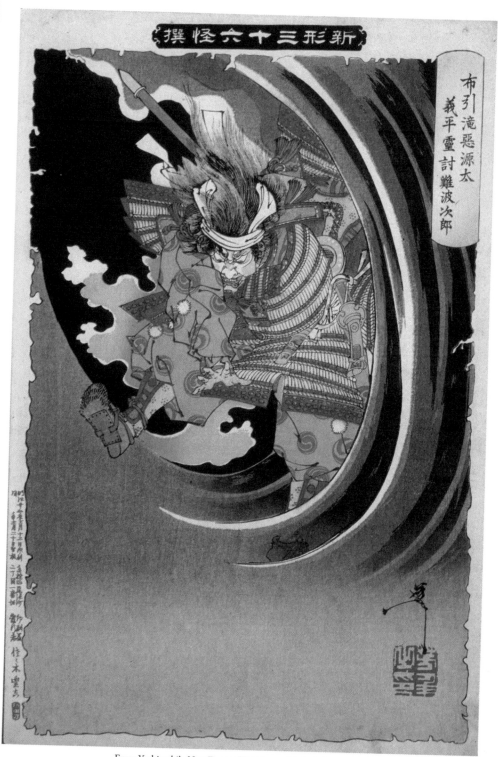

From Yoshitoshi's *New Forms of 36 Plays*, a shin kabuki play that dramatizes ghostly revenge.

Kimi Finds Peace, Evelyn Paul

An artist, Sawara, is haunted by the yūrei of his pupil Kimi who died with her love unfulfilled. An illustration from F. Hadland Davis' 1918 *The Myths & Legends of Japan*, this is one of the first images of a yūrei by a Western artist.

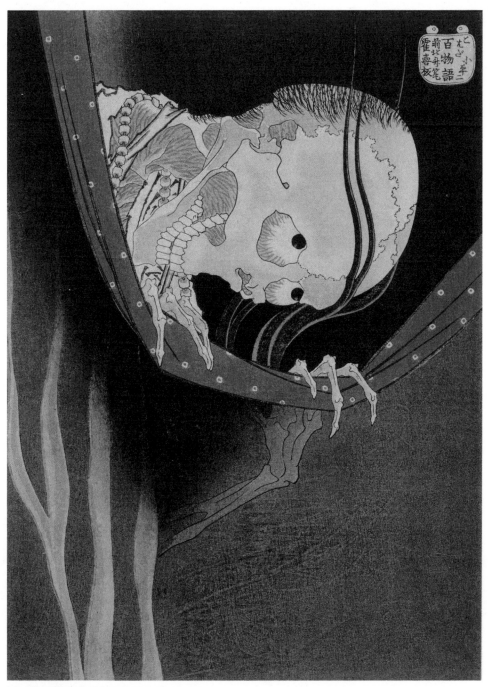

The Ghost of Kohada Koheiji, Tsukioka Yoshitoshi

Kohada Koheiji was a kabuki actor so adept at yūrei roles that he became a yūrei himself. This is a classic picture of that famous kabuki spirit.

Pages 14-15:

Maruyama Ōkyo, Tsukioka Yoshitoshi

Yoshitoshi imagines the manifestation of *The Ghost of Oyuki,* as Maruyama Ōkyo's ghostly lover emerges directly from the painting.

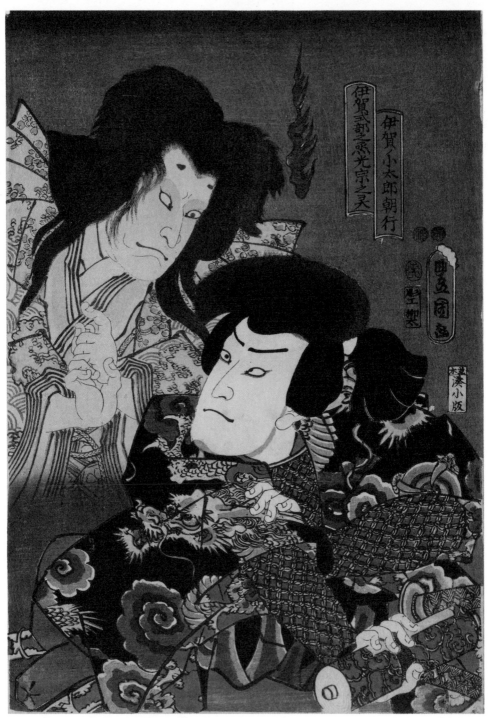

Ghost Appearing to a Warrior, Utagawa Kunisada

A ghostly scene from a kabuki play. These were sold as souvenirs, featuring popular actors in their roles.

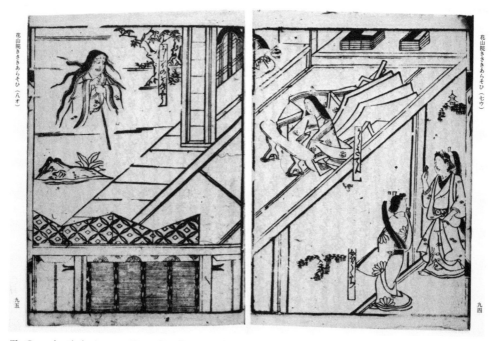

花山院ききあらそひ（八オ）

花山院ききあらそひ（七ウ）

九五

九四

The Quarrel with the Queen at Kasano Temple, artist unknown

From 1673, this picture book of the puppet play, *Kasannoin Kisakiarasou,* is the oldest known image of an ashinonai yūrei—a footless yūrei.

Introduction

GHOSTS AND YŪREI
ゴーストと幽霊

I lived in a haunted apartment.

Several years back, my wife and I lived in Ikeda, a small, suburban city eighteen minutes by train outside of the massive industrial metropolis of Osaka, Japan. Ikeda was a nice place: not too rural, not too urban, with a zoo, some good restaurants, and a museum dedicated to instant ramen. We had lived in the same apartment for about two years. Then, trying to save money during our last year in Japan, we moved into a cheaper place.

Kishigami Bunka, the name of our new apartment, was an old two-story wooden building built sometime in the 1920s. It was a dusty, ramshamble place called a "cultural apartment" due to its traditional Taisho-period style of living—woven tatami flooring and a tiny trough where the toilet should have been, with not a drop of hot running water in sight. The rent was absurdly cheap—only ¥20,000, around $180 a month. Our previous apartment in Ikeda, of equal size and quality, had been ¥60,000.

I thought we were getting a bargain.

But Kishigami Bunka had an...odd atmosphere, something almost every visitor sensed. It just felt weird. The unease wasn't helped by the strange red marks all over the ceiling, almost like a small child's hand- and footprints. The marks didn't want to wash off no matter how much we scrubbed. We even tried bleach. And then there were the unusual bumps and noises, often coming from the kitchen wall. Stranger still was the door in the living room that led to nowhere. My wife and I had been commanded by the landlord: *"Never open that door!"* He gave no reason for this, offered no explanation. And, unlike the foolish people in horror movies, we did as we were told.

For the seven months that we lived in Kishigami Bunka, we never opened the door.

There were few outright scares other than brief glimpses out of the corners of our eyes and the sometimes-overwhelming sensation that we were not alone in a particular room. We had hung a large, black, patterned tapestry over the mystery door—neither of us wanted to be reminded of it. And we took to turning our mirrors towards the wall at night due to a firm but inexplicable feeling that looking in the mirrors in the dark was a Very Bad Idea.

The worst event happened one night when my wife had a horrible dream. So vivid was the nightmare that she woke me up screaming. As I shook her awake, it took several minutes to convince her that what she had seen wasn't really happening. She had dreamed that the red handprints on the ceiling had stretched and extended down to grab her from our futon, and that she was being slowly dragged up into a black hole in the ceiling from which she would never emerge. She believes to this day that I must have plucked her out of midair and saved her life.

Maybe it was just our nerves and imagination, but there was an unmistakable *something* to the place. Our Japanese visitors had no problem putting a name to it. Soon upon entering Kishigami Bunka, they would sense the vibes of the place, look around a bit, and inevitably say *"Ahhh...yūrei ga deteru..."*—"There is a yūrei here."

I found out later that the haunting was the reason for the ridiculously low rent. Nobody wanted to live in Kishigami Bunka. The apartment had been vacant for years.

Kishigami Bunka was not my first yūrei. Long before sharing a home with one in my cultural apartment, I had met yūrei in a large, hardcover book about ghosts.

When I was in elementary school, I had been fascinated with folklore and the supernatural. My mother bought me a series of books from Time Life called *The Enchanted World*, which included a volume on ghosts. Inside was a Japanese ghost story called "The Wife's Revenge." Illustrated with old ukiyo-e prints, the story showed figures identified as "Japanese ghosts." But they didn't look anything like my idea of ghosts. The wild black hair, trailing white robes, and exaggerated facial features went against my ingrained cultural concepts of ghosts—and were thus more disturbing. One particular image stuck in my head: a woman whose face dripped like candle wax as she floated down from a burning lantern.

I know now, many years later, that this picture was *Oiwa Emerging from the Lantern* by the Edo-period artist Utagawa Kuniyoshi. Oiwa, from the ghost story *Tōkaidō Yotsuya kaidan*, was a popular subject for artists of that period. Kuniyoshi's image is only one of hundreds.

Oiwa is a sort of celebrity spirit, one whose presence still haunts modern-day Japan.

Several decades later—the book, picture, and Oiwa long forgotten—I watched, terrified, as Yamamura Sadako crawled out of a television set during the 1998 film *Ring*. Not only was the film horrifying, but the image of Sadako touched some long-buried memory of a ghostly woman with wild black hair, hanging white robe, and face dripping like candle wax. I knew there was an immediate and definite connection between the 1836 print by Kuniyoshi and the film made over a hundred years later. I was determined to trace that path, to find that connection.

I found in my research that yūrei are largely misunderstood in the West. The increasing popularity of Japanese horror films, or "J-horror" as they are commonly called, thrust an unfamiliar folkloric creature into the Western consciousness with little explanation or attempt at understanding. Creatures like Yamamura Sadako from *Ring* (1998) or Saeki Kayako from *Ju-on* (2003) were imitated, parodied, discussed, complained about, and admired—all without Western viewers really grasping exactly what they were. "Japanese ghost" is what they are usually called. But that is a mistake. They are not just ghosts.

Physicist and philosopher Richard Feynman once observed, "You can know the name of a bird in all the languages of the world, but when you're finished, you'll know absolutely nothing whatever about the bird." What is true of birds is also true of ghosts. Translating yūrei as "Japanese ghost" tells you nothing. A more direct translation of "dim spirit" tells you even less. Some words carry specialized meaning—wrapped up in history, in folklore, in religion—and one-for-one word translations cannot accurately convey that meaning. There is too much culture bound up in those single words.

Take for example, the word "leprechaun." From the Irish word *leipreachán*, leprechaun could easily be translated as "Irish fairy." But it isn't. A leprechaun is a specific creature, with a specific look and personality, which summons up an instant image that could not be expressed otherwise. Say "leprechaun" and a jolly little fellow dressed up in green and hoarding gold starts dancing in your head, maybe with some wishes and a rainbow thrown in. Say "Irish fairy" and you get…well, whatever you think of when you hear the words "Irish fairy."

Translating yūrei as "Japanese ghost" is equally imprecise. Yūrei are entirely different creatures than what the Western world knows as ghosts. The Japanese language can even separate the two, using the kanji 幽霊 for yūrei and the Westernized ゴースト for ghosts.

Of course, both Western ghosts and Japanese yūrei are spirits of the departed—both symbols of the past reaching a cold, dead, and often unwelcome hand into the comfortable present. But Western ghosts are more of a storytelling device. They are amorphous things that suits the needs of the moment and can be used to incite fear or humor. Or even romance and healing.

Take a look at Capt. Daniel Gregg from *The Ghost and Mrs. Muir* (1947) or Sam Wheat in *Ghost* (1990), then compare them to the terrifying entities of *Poltergeist* (1982), *The Shining* (1980), and *Insidious* (2011). Now, cross-reference those with the silly souls in *The Frighteners* (1996), with the flying green puffball called Slimer in *Ghostbusters* (1984), or with Casper the Friendly Ghost. You will soon see there is no template that must be obeyed. The holly jolly Ghost of Christmas Present from *A Christmas Carol* is every bit as much a specter as the haunted Dr. Malcom Crowe in *The Sixth Sense* (1999). The Western ghost conforms to the capricious whims of the storytellers.

Of course, some cultural clues exist in the West about ghosts. Anyone can immediately identify a Hallowe'en costume ghost with a draped white sheet and some clanking chains, or a movie version of a semi-transparent wraith colored white and floating down a staircase. These are stereotypes of ghosts, it's true. But a ghost can just as easily be a solid thing, capable of interacting with the physical world. They can look every bit like the human being they were when alive or equally like a risen, rotting corpse or often both in the same movie—just look at 1988's *Beetlejuice*.

A Western ghost can be anything.

Yūrei, on the other hand, follow certain rules, obey certain laws. They are bound by centuries of culture and tradition. Like the leprechaun, they have a specific appearance and purpose. These rules supply authenticity, making them culturally relevant and recognizable. Also, these rules make them more horrifying than the constantly changing Western ghost, which can be played for laughs, romance, or fear at any given moment. And to most Japanese people, yūrei are very, very real.

Yūrei are a part of the everyday, wielding influence over the living, determining the course of events. They cause disaster if ill-treated or bring good fortune if properly respected. They have their own holiday: the summer festival of Obon—the Feast of the Dead. The Japanese prepare welcome feasts and festivities for the departed spirits who make the long journey home once a year, when the walls between the world of the living and the dead stretch thin.

Yūrei have relocated the nation's capital. Until the establishment in 710 of a permanent capital in Heijō-kyō, modern-day Nara City, the capital and all associated courts and buildings were moved to a new location whenever an emperor died, and an heir ascended to the Chrysanthemum Throne. This prevented lingering bad will from the previous emperor's yūrei, who might be jealous of his heir's rise in power.

Foreign policy with other nations has gone sour due to yūrei. Much to the anger of the Chinese and Korean people, Japanese Prime Minister Koizumi Junichiro visited Yasukuni Shrine five times while in office, the first time on August 13, 2001. Yasukuni Shrine is one of Japan's most holy Shinto shrines, home to more than 2.4 million yūrei.[1] These are the souls of Japan's war dead, who gave their lives for their emperor and their country and have been transformed through a system of enshrinement and ritual into deity-like protector spirits called *kami*. That was one of the promises made to soldiers in World War II—that if they died, they would be enshrined as kami in Yasukuni. When soldiers were going on suicide missions or were sure to die, they would bid each other a final farewell by saying, "See you in Yasukuni."

The controversy is that not all these soldiers were virtuous. In the ranks of these kami spirits are 1,068 war criminals, including all of the kamikaze suicide pilots and fourteen Class A war criminals from World War II, such as Prime Minister General Tōjō Hideki. Even today, a politician cannot step foot into Yasukuni Shrine without making news and inciting protests across Asia. The reach of the dead is long.

Yūrei are also one of the primary elements of Japanese storytelling. Death and the dead are as essential to Japanese storytelling as love and marriage are to Western traditions; perhaps even more so.

Look at theater, literature, art, or film, and you will find that Japan's stories are inherently haunted. Japan's most ancient theatrical tradition, noh, includes a yūrei in almost every performed play. Kabuki, which is in many ways responsible for the familiar look of the yūrei, has an astounding repertoire of ghostly tales—tales of revenge, love, and loyalty, all confined in and defined by a system of rules and traditions that even the most powerful yūrei must obey. During the Edo period, ukiyo-e artists fed on these kabuki thrills, creating series of yūrei prints for fans to buy as mementos of the most chilling scenes and most memorable

1. While I use the term yūrei here, it should be noted that the spirits of Yasukuni Shrine are never called by that name. In their elevated state, they are either *kami*, or *eirei*, meaning "heroic spirits."

yūrei. Modern artists continue this tradition and incorporate yūrei into their work, like Murakami Takashi's installation *The 500 Arhats*. Probably Japan's most famous modern artist, Murakami's installation was a monumental painting hearkening back to great works of Buddhist art, including modern takes on ghostly ancestor guardians.

Literary Japan is no exception. Almost all of Japan's most talented writers have turned their considerable skills towards yūrei at some point in their careers. Just as everyone is said to have at least one novel in them, every Japanese author has at least one yūrei story to tell.

Kawabata Yasunari, who in 1968 became the first Japanese person to win the Nobel Prize for literature, wrote several yūrei stories. One of these is the *Palm-of-the-Hand* story "Fushi," in which a beautiful young yūrei and an old man, her former lover, take a walk together, recounting their past and the situations that separated them and led to the girl's suicide. Author Ueda Akinari wrote a collection of yūrei tales for his 1776 masterpiece *Ugetsu monogatari,* considered the greatest work of eighteenth-century Japanese literature. Popular modern novelist Yoshimoto Banana has spun her own yūrei tales in books like *Hardboiled & Hard Luck* and *Kitchen,* and Japan's most acclaimed modern author, Murakami Haruki, included yūrei in *Kafka on the Shore.*

Japanese film, of course, is particularly known in the West for modern yūrei stories, although most viewers wouldn't know to put that name to them. Ever since its inception, Japanese film has embraced the medium as a vehicle for yūrei tales.

In 1897, Asano Shiro of the Konishi Camera Shop imported the first motion-picture camera into Japan. The new technology was greeted with disdain by the kabuki actors who were the theatrical power of the day. Proud of their training and talent, the vain actors were only lured to perform before the cameras with the promise of preserving their abilities as a gift to the generations who would come after. The direct result of this was that several adaptations of popular plays were made in rapid succession, each featuring the talents of a different kabuki actor. The irony is that few of these performances reached posterity. Unstable film stocks and limited knowledge of film preservation led to the destruction of most of the adaptations.

The first yūrei appeared on screen in 1898, in the short scene *Shinin no sosei* (*Resurrection of a Corpse*). Twelve years later, the first full-fledged yūrei feature film was made with an adaptation of the kabuki play of *Kaidan botan dōrō.* A production of *Tōkaidō Yotsuya kaidan* soon followed in 1912, and since then, not a single decade has gone by without

a new adaptation of these popular stories.

Ueda's 1776 stories were adapted by director Mizoguchi Kenji for the feature film *Ugetsu monogatari* (1953), which is on almost anyone's short list of the greatest Japanese films ever made and is often called the most beautiful ghost story ever filmed. Kurosawa Akira, probably the best-known Japanese director in the world, filmed yūrei for his late-life anthology film *Dreams* (1990). There are many more. Odds are, anyone reading this book had their first yūrei encounter on screen and can rattle off several Japanese films of yūrei revenge.

It's strange that yūrei films have become so popular in the West, considering how few people realize the significance of what they are watching. The white-faced ghost girl is intriguing—yes—and scary—definitely—but what is she? Why is she wet? Why does she look the same in every film? What's with the hair?

Imagine watching a movie about leprechauns and wondering why Darby O'Gill keeps grabbing the little man in green clothes and demanding his wishes. Or watching a vampire movie and having no idea why people keep waving crosses at and sticking wood into the pale people with the pointed teeth. Yūrei films are similar. If you understand what you are seeing, then the story becomes deeper and more enjoyable. And that's the goal of this book—to provide this understanding and to allow a clearer insight, not only into the popular products of Japan but also the history and culture from which they sprang. I will take you on a guided tour of the yūrei, from where they live to why they look the way they do, the rules they must obey, as well as the culture and traditions behind them. I will delve into the distant past, when the only gods of Japan were the yūrei, and I will show you the Rule of the Dead. For even today, the hand of the dead lays heavy on the world of the living.

We might even hear a *kaidan* (weird tale) or two along the way.

Chapter 1

THE GHOST OF OYUKI
幽霊図: (お雪の幻)

Otsu, Ōmi, Japan. The second year of Kan'en, in the reign of the Emperor Momozono-tennō. A hot, damp summer's night…

Maruyama Ōkyo opened his eyes from a fitful sleep and beheld a dead woman. She was young. Beautiful. And pale. Unnaturally drained of color, her bloodless skin peeked from her loose, bone-white burial kimono. Her bleached appearance was contrasted only by the thin slits of her black eyes and by the long, black hair that hung disheveled across her shoulders. She had no feet.

But her face was calm. Soothing. There was nothing in her eyes to make the seventeen-year-old Ōkyo apprehensive. The dead woman watched him a moment—and disappeared.

An artist by training and nature, Ōkyo sprang from his futon, grabbed his brushes and a nearby roll of silk and mustered all of his skill to capture the apparition exactly as she had appeared before him. His lover, Oyuki.

The Ghost of Oyuki [2] was painted sometime in the year 1750, on the morning directly following Maruyama Ōkyo's strange visitation. According to a note on the scroll box put there by a former owner named Shimizu, the painting is an image of Ōkyo's mistress, Oyuki. She was a geisha at the Tominaga geisha house in Otsu City in the province of Ōmi, modern-day Shiga Prefecture. Oyuki had died young; how or when the note does not say. Ōkyo mourned her deeply. Perhaps too deeply.

This young lover, Maruyama Ōkyo, was no ordinary artist. Born Maruyama Masataka into the farming caste in Ano-o (modern-day Kameoka City, Kyoto Prefecture), while still a young teenager, Ōkyo moved to Kyoto City and began his artistic career at a toyshop, painting

2. 幽霊図: (お雪の幻); Yūreizu (Oyuki no Maboroshi) is most often translated into English as The Ghost of Oyuki, but a more direct translation would be Ghost Picture: The Vision of Oyuki.

the faces on wooden dolls. From there, he sharpened his skills and apprenticed to various master artists, both indigenous and foreign.

By the time Ōkyo came into his own, he was a man of incredible talent and reputation. He regularly produced commissioned paintings for both emperors and shōguns, all the while creating major works for religious sites. His monumental 148-foot scroll, *The Seven Misfortunes and Seven Fortunes* (1768), hangs in Enman-in Temple, in the same town of Otsu where Oyuki had died.

Founder of the Maruyama school of painting, Ōkyo was the ultimate naturalist painter and emphasized direct observation of subjects—if he painted something, you could trust that he had seen it. Perhaps he would make some flourishes of design and artistry, but he fabricated nothing from whole cloth. Ōkyo even insisted on using living models when depicting horrifying scenes such as a man being ripped in half by two bulls for *The Seven Misfortunes and Seven Fortunes*. In pursuit of the real, he did not shy away from forbidden subjects. Ōkyo was the first Japanese artist known to use nude models for life drawings, considered pornographic at the time.

In fact, legend spread that the owners of an Ōkyo original must be careful. The paintings were so realistic, so true to life, that the subjects took life from time to time and strolled off from their respective surfaces.[3]

Ōkyo's insistence on observation was more than just an artistic sentiment. A devout Buddhist, Ōkyo's introduction to *The Seven Misfortunes and Seven Fortunes* stated that man must find Buddha in the here and now, in the real world—not in fantastic visions of other realities. Reality was his religion. But what he was seeing that hot, damp summer night tested his devotion.

Perhaps his emotions for his lost love were strong enough that Oyuki's spirit was bound to the Earth. Or perhaps it was nothing more than the desperate longing of a lonely young man seeing what he so very much wanted to see. Whatever the reason, one night Oyuki appeared to Ōkyo, hovering over his futon and watching him contentedly. Not a terrifying vision, not something to wake him shuddering in his bed; Oyuki was merely there, watching peacefully.

When he woke that morning, the image in his mind was painfully

3. Meiji-period artist Yoshitoshi Tsukioka referenced this legend in his 1882 print of Maruyama Ōkyo. In the print, Maruyama is startled as the yūrei he is painting springs from the silk surface.

clear. He knew immediately what he must do. Grabbing his brushes and a nearby roll of silk, using all his considerable skill, Ōkyo carefully painted the portrait of his lover. He captured her exactly as she had appeared to him in the night. Perhaps, he may have thought, it was what she wanted: To be painted. To be remembered. To be immortalized.

When he was finished, he had created more than a simple picture. Unknowingly, he had painted the first *yūrei-e*, meaning a portrait of a ghost, a yūrei. He had given Japan a true image of what their departed looked like. And this painting of Oyuki would become more famous and outlast anything else Ōkyo ever painted—lasting longer than his commissioned works for emperors and shōguns, becoming more famous than that 148-foot scroll hanging in the town where Oyuki had died.

In the age of cameras and digital imagery, of stunning makeup and special effects so life-like it can be difficult to tell fantasy from reality, *The Ghost of Oyuki* is not such a startling image. Light colors on a creamy silk; it is a mere wisp of a picture. Oyuki's figure takes up only about two-thirds of the roll of silk. Soft lines curve gently, creating the outline of a woman. Ōkyo gave his muse a Mona Lisa-like inscrutable half-smile under hard eyes, an expression that either reprimands or romances depending on the angle. The dense black of her hair fades to nothing more than flicks of a brush by the time your eye makes it to the bottom of her kimono. Her right hand, tucked into the folds of her clothes, covers her breast. The diaphanous kimono fades to nothing below her waist. She has no feet.

It is hard to see that this is the literary great-grandmother of both famous Edo-period ghosts such as Oiwa, Otsuyu, and Okiku, known collectively as the *San O-Yūrei* (三大幽霊), or *Three Great Yūrei of Japan*, and of modern horror movie specters like Sadako and Kayako. It is hard to see that Oyuki's legacy would send millions dashing for the light switch after getting a good scare in the company of friends.

Maruyama Ōkyo would paint other yūrei-e during his lifetime. These were usually commissioned paintings, sometimes portraits of family members that had passed on or simply collectors who wanted their own ghost painting by the famous artist. He still used models for these portraits, usually a living family member who resembled the dead person. Sometimes the dead themselves.

Ōkyo did not give up attempting to capture another authentic yūrei. In his 1894 book *Glimpses of Unfamiliar Japan*, Japanologist Lafcadio Hearn tells a story of Ōkyo being commanded by the shōgun to produce an image of a yūrei. In response, Ōkyo went to the house of a sick

aunt and waited by her bedside for her to die so he could paint her yūrei as it escaped her body. He was not able to capture the evacuating spirit; instead he contented himself with sketching her emaciated body. She had the look of one long dead. Yet none of these paintings had the same impact.

So, what makes *The Ghost of Oyuki* unique? How could this single, simple painting so dramatically influence a culture?

Part of its fame is the story. A dead lover returned from the grave. A passionate young artist who immortalized her. Sex and death, with a tangible souvenir of the encounter. All the necessary elements to create a legend. But there are many paintings with interesting stories, and the impact of *The Ghost of Oyuki* is due just as much to the fame of the painter as to the painting. After all, this was Maruyama Ōkyo. If Ōkyo claimed this was an actual and honest portrait of a yūrei—not a fantastic image spawned from an overactive imagination—then Japan would believe him. This is what they looked like.

And credit where credit is due—as we will see, Ōkyo's timing was perfect. The Edo period had been waiting for him.

Chapter 2

WEIRD TALES
怪談-

"...Shogakan Gahakudo was a legendary gathering place for hya-kumonogatari kaidankai. At the entrance hung a permanently burning lantern, of the sort normally only used for the Obon festival of the dead. You didn't even need to plan the event—such was the passion for the game that on any given night you could be assured a spontaneous round of storytelling would begin, with members alternating turns, exchanging their favorite kaidan."
–translated and excerpted from *Nihon no yūrei*,
1959, Ikeda Yasaburo

When Maruyama Ōkyo roused from sleep that morning in 1750, he awoke in the unprecedented era of peace and refinement of Edo-period Japan (1603–1868). The country was busy transforming itself into the nation we all know today, and many of the *things Japanese*—the aristo-cratic samurai and the artisanal geisha; the elegant theater of *bunraku* and the wild spectacle of kabuki; the floating world of ukiyo-e artists—sprouted and flowered during the Edo period. Threaded throughout each of these were ghost stories—kaidan. And yūrei.

The Edo period was a renaissance of the weird. Noriko Reider says in her book *Japanese Demon Lore* that the Edo period was "an interesting time and space in Japanese culture in which individuals from all walks of life, on some level or other, seem to unite in their belief in the super-natural." The touch of the supernatural was in everything in the Edo period. And the touch of the Edo period is in all of Japan's supernatural folklore. They are intimately intertwined.

What was so special about the Edo period that made it ripe for the otherworldly? A number of different elements came together to create a perfect storm—to begin with, the closure of Japan's long history of civil wars.

Japan must have heaved a collective sigh of relief when almost 150

years of fighting finally came to an end. Preceding the Edo period was the Sengoku, or Warring States, period. From the start of the Ōnin War (1467–1477) to the final defeat of the Toyotomi clans by Tokugawa Ieyasu at the Siege of Osaka (1614–1615), Japan had endured almost constant warfare.

Periods of war do not easily breed kaidan. People do not want to read or be entertained by gruesome tales of blood and vengeance when there is the very real chance that they might have their head chopped off, be skewered on a spear just for the crime of being in the wrong place at the wrong time, or find themselves in the sights of a hungry and desperate soldier on the run.

With the peace of the Edo period, people finally felt safe enough again to seek amusement in the supernatural, to play with the grave now that they no longer felt themselves a hair's breadth from occupying one. The ghosts of Japan were only waiting in the dark for their chance to rise again. After all, their roots were deep and the foundations had been laid long ago.[4] To know the full story, we must delve into Japan's literary past.

Japan's gods and monsters were born in the *Kojiki* (*Records of Ancient Matters*). The oldest known work of Japanese literature, the *Kojiki* dates to the eighth century, most likely 712. Claiming to be a historical record of Japan, in truth it concerns itself with creation myths and the hijinks of gods—like Izanagi and his sister-wife Izanami, the proto-yūrei about whom we will learn more later.

The *Kojiki* was a commissioned work by the ruling family meant to authenticate the divine lineage of the emperor and cement the Yamato clan's right to rule. Rumors persist of older books, such as the *Kujiki* (Record of former matters), which claims a publication date of 626, or the *Tennōki* (Record of the emperor) and *Kokki* (National record), both of which claim publication dates of 620. However, no authentic copies are known to have survived. These books are largely considered either forgeries or apocryphal.

Not that the common people cared. While the emperor and the ruling family fretted over their bloodlines and magical ancestors, the rest of Japan did what people do everywhere—gathered round the fire to swap myths, legends, yūrei tales, and occasionally a few true stories

4. This chapter owes a great debt to Noriko Reider's groundbreaking study "The Emergence of Kaidan-shū: The Collection of Tales of the Strange and Mysterious in the Edo Period."

thrown in for good measure. Scholars started writing down this oral folklore around the Heian period (794–1185), when Buddhist monks created the genre called *setsuwa*.[5]

The monk Kyōkai wrote the first setsuwa, called the *Nihon ryōiki* (Japanese chronicle of miracles), sometime between 787 and 824. Kyōkai was a self-ordained monk—a wanderer with no order or temple. By his own admission, he was not particularly learned in the esoterics of his faith. But he was passionate and devoted to sharing the lessons of Japan's latest religion, Buddhism.

To give you some idea of its contents, the *Nihon ryōiki* is occasionally known by its full title of *Nihonkoku genpō zen'aku ryōiki* (Miraculous stories of the reward of good and evil from the country of Japan). Kyōkai intended the *Nihon ryōiki* to be a teaching tool about the laws of karmic causality. He gathered local legends and supernatural stories and coupled them with didactic Buddhist teachings.

The stories had titles like "Of an Evil Daughter Who Lacked Filial Respect for Her Mother and Got the Immediate Penalty of a Violent Death" or "Of a Monk Who Observed the Precepts, Was Pure in his Activities and Won an Immediate Miraculous Reward." Simple and direct, the tales in the *Nihon ryōiki* had uncomplicated plots that showed how good deeds are rewarded and evil acts punished in this lifetime. No one ever accused Kyōkai of subtlety.

Like the *Nihon ryōiki*, the majority of setsuwa were written with an educational motive in mind. Arduously hand-copied, most setsuwa were intended to be used by traveling Buddhist monks to give sermons and frighten the population into behaving. The idea of the supernatural as entertainment was still waiting to be discovered.

Sometime after the year 1120, stolid, high-minded Buddhist morals momentarily yielded to low-minded fun as the massive, multi-volume *Konjaku monogatarishū* (Collected tales of times now past) was published. Although it did borrow stories from the didactic *Nihon ryōiki* and makes a good show of being a Buddhist lesson book, the *Konjaku monogatarishū* was also pure pleasure reading.

Collecting over one thousand stories in thirty-three volumes, the *Konjaku monogatarishū* burst with fairy tales and legends and gods and monsters. The stories dealt with all levels of people, both noble and naughty—including the supernatural tengu and oni and a variety of transformed animals collectively called henge. Also, in contrast

5. The kanji for setsuwa (説話) translates directly as "speaking tales."

to previous setsuwa collections, the *Konjaku monogatarishū* collected together the folktales and legends of the three countries that were considered to be literarily and religiously important at the time: India, China, and Japan.

The *Konjaku monogatarishū* is a mystery unto itself. No one knows precisely why it was written, or for whom. Like many works of such age, the author and publication are disputed. Some say it was written by the scholar Minamoto no Takakuni, author of *Uji dainagon monogatari* (Tales of great councilor of Uji; 1052–1077), while others say the true author is Takakuni's son, the Buddhist monk Toba Sōjō and supposed artist of the *Chōjū-jinbutsu-giga* scroll (Animal-person caricatures; twelfth and thirteenth centuries). Still others point to an anonymous monk living somewhere near Kyoto or Nara. Some say it has several authors, each contributing a chapter or a story here and there over the years. This is to say, nobody knows for sure. It is an anomaly.

Only twenty-eight volumes of the *Konjaku monogatarishū* still exist. Many well-known Japanese kaidan, like "How a Man's Wife Became a Vengeful Spirit and How Her Malignity was Diverted by a Master of Divination," originally hail from the *Konjaku monogatarishū*—although few are aware of that ancient tome as the origin. Stories from this collection have found their way into texts as dissimilar as Akutagawa Ryūnosuke's adaptation "In a Grove" ("Yabu no naka"), which was adapted into film as Kurosawa Akira's award-winning *Rashomon* (1950). A version of "How Tosuke Ki's Meeting with a Ghost-Woman in Mino Province Ended in His Death" even appeared in such far-flung venues as the American comic book *Hellboy* by writer/artist Mike Mignola.

The influence of the *Konjaku monogatarishū* cannot be overestimated. The book opened the door to stories of the strange and mysterious that had been excommunicated from religious teaching. Books such as the *Uji shūi monogatari* (A collection of tales from Uji; thirteenth century) directly copied many of its stories.

However, the entertaining and non-didactic nature has often taken it out of the realm of serious literature. *Konjaku monogatarishū* is rarely a candidate for English translation and study. This first kaidan collection has always lived under the shadow of that titan of Heian literature *Genji monogatari* (The Tale of Genji; eleventh century), which was published around the same time. As of this writing, *Genji monogatari* has eighty-eight separate editions in publication and has been translated into every major language including Braille. *Konjaku monogatarishū* has no complete translation.

Although the *Konjaku monogatarishū* is widely considered the first work of kaidan, the book itself did not carry that name. The word kaidan, in fact, had not yet been created. That would require a sick emperor and a crafty doctor.

During the third year of Kan'ei, which was the twenty-fourth year of the Edo period (1627), the third shōgun-regent of the Tokugawa dynasty, Tokugawa Iemitsu, lay bedridden from illness. His attending physician, Confucian scholar Hayashi Razan, sought to entertain Iemitsu and take his mind off his sickness and inactivity. Razan translated a collection of strange and mysterious Chinese tales and read them to Iemitsu. It is said that the story of the wondrous land of Tōgenkyō, where nobody ever ages or dies, was a particular favorite of the ill ruler. Tokugawa Iemitsu dreamed of a land where he could be healthy and vibrant.

As a further present, Razan compiled thirty-two of the more popular legends into five volumes and presented them to the shōgun. Razan titled his collection *Kaidan* (怪談), putting together the kanji for "strange" and "tales" to make a new word. In modern times, the work is more commonly known by the title *Kaidan zensho* (Complete works of kaidan). The compilation was written exclusively for the entertainment of the shōgun and was never intended for popular consumption. However, innovation rarely stays hidden, and by creating a new word, Razan inadvertently named a genre.

Scholarship and literary development ground along at a centurion pace due to the toilsome process of handwriting all books. When it came to mass-produced volumes and an expansion of a literate population, Japan was late to the party. Johannes Gutenberg developed his first printing press in Germany around 1440, but it was not until more than 150 years later that a printing press with movable type would find its way into Japan and, thus literature, into the hands of the masses.

Jesuit Alessandro Valignano arrived in Japan in 1579, holding the official title of Visitor of Missions, with the stated task of reforming missionary efforts in Asia. Valignano identified the problem as one of language. By 1590, he had established a stable of printing presses in the port of Nagasaki, all of them busily churning out Japanese-language copies of the Bible and the lives of saints. His instincts were wrong; Valigano's mission was a failure, and he was recalled by the Vatican in disgrace.

Valignano did not trust the Japanese. He had always been careful to keep the deepest secrets of Western technology from his Japanese converts, using his influence to ensure that no native Japanese disciple could ever rise above the rank of Brother in the Jesuit order. When Valignano

went, his printing presses went with him.

Although Japan was now aware of the wonders of the printing press due to Valignano, it was not until the capture of a Korean machine a few years later in 1593 that the country would see any significant impact from the new technology. Brought over as a spoil of war from Korea and presented as a gift to Emperor Go-Yōzei, the printing press was seized following Japan's defeat in the Siege of Pyongyang, a battle significant for another display of new technology: the then cutting-edge tools of firearms and cannons.

The emperor was pleased with this gift and commanded his staff to reverse-engineer its secrets. Made of metal, the Korean press was unsuitable for Japanese characters, which required a greater adaptability of characters due to its complex writing system. But four years later in 1597, a wooden press was created, and for the first time, Japan had mass media. After taking power in 1603, the first shōgun, Tokugawa Ieyasu, made the secrets of the printing press available to the public, encouraging the publication of classic texts and creating a literate, reading population. Finally, publishers were able to churn out piles of cheap books and have an audience available to read them.

Publishers soon saw the value in printing kaidan collections, called *kaidan-shū*, which the public rapidly snatched up in the newly established book trade. The first kaidan-shū to come literally hot from the presses imitated the earlier *Nihon ryōiki*. They used the supernatural as a tool for Buddhist and Confucian moral education.

The kaidan-shū *Inga monogatari* (Tales of cause and effect), published in 1660 and attributed to the monk Suzuki Shōsan, was one of the first to bridge the gap, although inadvertently. Two separate versions of *Inga monogatari* were published, each aimed at a specific audience. The hiragana version had pictures and was considered easier to read and used a simpler language. The katakana version, on the other hand, was printed to rectify the supposed mistakes made in the hiragana version. The katakana version was meant to lead people to religious awakening. The hiragana version was full of fabulous tales for children to enjoy.

Even in the katakana version, several of the tales of *Inga monogatari* seem devoid of Buddhist lessons. One tells the story of a young priest who wakes up ill one morning and finds that his penis has fallen off. The priest takes this in stride, becomes a woman, gives birth to two children and makes his/her living selling wine. There is no obvious moral here, no reason for the transformation other than sensationalistic entertainment. Another story featured a type of yūrei known as an *ubume*, meaning a

woman who dies in childbirth or while pregnant. Her dead spirit comes back to care for her living child.

Then, in 1666, the Buddhist priest Asai Ryōi wrote one of the most influential kaidan-shū of all time, *Otogi bōko* [6] (Hand puppets).

Containing sixty-eight tales, seventeen of which were taken directly from the 1378 Chinese collection *Jiandeng xinhua* (New tales under the lamplight), *Otogi bōko* liberally adapts Chinese folk tales. Asai rewrote them completely, removing the Buddhist overtones and changing them to Japanese settings more familiar to readers. Most importantly, *Otogi bōko* adapted the Chinese folktale *Mudandeng ji* as the story "Botan dōrō," one of the most famous yūrei tales ever written. "Botan dōrō" featured the lonely Otsuyu, who we will meet in later chapters.

As popular as these early kaidan-shū were, something was still missing. Yūrei appeared in these stories and even took on physical form. But they were much more fluid and undefined. Sometimes in the shape of animated bones or a rotting corpse, they were most often in no way different from a regular human. In fact, for most of Japanese history, yūrei had no stereotypical appearance.

Up until the ends of the Muromachi period, the Azuchi–Momoyama period, and even into the early Edo period, yūrei looked no different than when they were alive. They were indistinguishable from the living. Many of Japan's oldest yūrei tales are characterized by the protagonist not realizing they are speaking to a dead person until the grand reveal is made at the climax. This can be taken to extremes: in stories such as "The Yūrei Wife Who Came to Bear a Child," a dead woman is able to return as a yūrei and live with her husband. The husband is completely unaware that his wife is deceased. They live together for three years and she even gives birth to three children, all without the husband ever suspecting—until a letter from her parents reveals the truth, and the wife's yūrei vanishes.

In 1750, Ōkyo's *The Ghost of Oyuki* gave a focus to these tales, an image people could hold on to and understand. Artists copied Maruyama's yūrei and cranked out artwork as fast as they could manage. Several of the more popular yūrei, like Oiwa, Otsuyu, and Okiku, became something like celebrities. They appeared over and over again in different artists' interpretations but were always recognizable as yūrei and always followed Maruyama's basic image of a pale-faced, white-robed person with long, disheveled black hair and no feet.

6. Otogi is a word seen over and over again in kaidan-shū of the time. It means roughly "companion," although it came to mean something more like "nursery tales."

Another important element of kaidan and all kaidan-shū collections, from the Nihon ryōiki to the Konjaku monogatarishū on down to The Ghost of Oyuki, is that they all promised to be true stories. They professed to be written "from life" and provable by the people who wrote them.

There was no question amongst Edo-period Japanese regarding the existence of the supernatural. Yūrei stories were taken at face value, many explaining some local phenomenon, perhaps an oddly shaped rock or an ominous tree at the local shrine that refused to bend or sway in strong winds. Often the kaidan in kaidan-shū collections were very short, without a beginning or an end, merely recording some strange occurrence that the author had seen or heard of. This aspect of the collections was a powerful selling point, appealing to the public's taste for true kaidan and yūrei tales. The public was known to reject stories that had too much of the stink of literature about them.

One such famous story that had no stink of literature whatsoever occurred in 1749—a year before The Ghost of Oyuki was painted. For over a month, the Inō House in the Bingo area of Miyoshi City, Hiroshima, was a beehive of supernatural phenomena. Poltergeist-like, furniture moved on its own. Strange lights and sounds emanated from the building. Crowds gathered around the building every day, straining their eyes to catch a glimpse of mysterious forces at work in the famous haunted house.

The occurrence was heavily publicized and documented. Famed scholar Hirata Atsutane—ranked as one of the four great men of kokugaku (nativist) studies—sketched the building itself as well as the daily crowds of onlookers. The legend of the Inō House passed rapidly by word of mouth, and soon, everyone was trading stories and flocking to supposed hauntings, hoping to witness some bizarre phenomena or supernatural manifestation.

This interest in ghostly storytelling transformed from a fad to an actual obsession due to an emerging parlor game—hyakumonogatari kaidankai, which translates as "a gathering of one hundred weird tales."

The way to play was simple. Late at night, a group would gather together and light one hundred candles about the room, sometimes in a circle, sometimes wherever there was space to put them. The guests would tell kaidan, one after the other, and each time a story was told, they would reach over and extinguish a single candle. The room would slowly darken, and the tension would heighten.

The game was rumored to serve as an evocation, summoning evil spirits to the home where it was played. When the final candle was

killed, something was supposed to be waiting in the dark.

It was *de rigueur* for social gatherings in Edo-period Japan. Public houses such as the Shogakan Gahakudo in Ginza were home to on-going games, where fanatics gathered every night to share their stories and douse the candles. A stranger could not walk into the Shogakan Gahakudo without being instantly set upon to give a kaidan of his native region for the crowd, hopefully something new and interesting that had not been heard before.

No one knows exactly how hyakumonogatari kaidankai came to be played. Some say it has its origins in a Buddhist ritual called *hyakuza hodan* (one hundred Buddhist stories), in which one hundred Buddhist stories were told over one hundred days, after which it was believed a miracle would happen. Others believe that the game was originally created by the samurai as a test of courage. With the wars ended, the samurai class went through an identity crisis. Of what use was a stand-ing army of trained warriors with no one to fight? Still, they clung to their old codes of bravery. As proof of this, the grizzled veterans of old campaigns would gather the young pups together to play the game as a test of courage, to see who was brave enough to withstand the gruesome tales and who would shiver when the final light was doused.

A version of the game is described as early as 1660, in Ogita Ansei's kaidan-shū *Tonoigusa* (The tales of the straw bed), more popularly known as *Otogi monogatari* (Nursery tales).

In a dark cave high in the mountains, a group of samurai gathered to test each other's courage with tales of horror. The candles cast flickering shadows on the wall, and with each tale told in succession, the nerves of the young men began to fail along with the fading firelight. With only one candle remaining, the last storyteller reaches out to complete the ritual and plunge the cave into total darkness. Suddenly, a great black hand reaches down from the top of the cave, sending the samurai scattering. One warrior keeps his wits, however, and a quick swipe of his sword severs the body of a spider gently lowering itself near the final candle—a spider whose shadow was the origin of the enormous hand. Spreading in popularity, hyakumonogatari kaidankai slowly found its way down from the high castles of the aristocratic warrior class to the low markets of the working classes of peasants and townspeople.

Eventually, it was known and played everywhere in Japan.

The public developed an insatiable appetite for kaidan. People played the game so much that they were on the lookout for new kaidan that would impress and shock the other members of the gathering. It

wouldn't do to be the boring guest who tells the same stories over and over again. They demanded even bloodier and scarier tales, and artists, storytellers, and entertainers worked like mad to meet the demand. All different forms of entertainment played off the fad and reinforced each other to keep the profits coming and the fires burning.

Where there is demand, supply soon follows, and a cottage industry sprang up to take advantage of this. Special kaidan-shū were designed to provide stories for the game. Many of these kaidan-shū books even had the word *hyakumonogatari* (one hundred tales) in the title. They were of varying quality, produced quickly to meet a need rather than satisfy any sort of artistry.

China, India, and other foreign lands maintained a mystical quality during the Edo period. They served as appropriate backgrounds for tales of the supernatural, and accordingly, the first book to use the name *hyakumonogatari* was published in 1677 and was called the *Shokoku hyakumonogatari* (One hundred tales of many countries). As suggested by the title, it gathered mysterious tales from several countries. After the success of the *Shokoku hyakumonogatari,* there were numerous imitators, such as *Shokoku shin hyakumonogatari* (One hundred new tales of many countries), *Otogi hyakumonogatari* (One hundred companion tales), *Taihei hyakumonogatari* (A Hundred Tales from the Era of Great Tranquility), and *Bansei hyakumonogatari* (One hundred tales of eternity). All of them used the term *hyakumonogatari* in the title. All of them hoped to capitalize on the reading public's fascination and frenzy.

Writers scoured Japan for grisly legends and folktales, climbing up the tallest mountains, through the darkest forests, hunting out the most remote villages looking for horror, and trying to be the first to get them into printed format. Artists supplied the illustrations, dedicating long scrolls to depict the various creatures in the tale such as Toriyama Sekien's famous *Gazu hyakki yakō (The Illustrated Night Parade of a Hundred Demons*; 1776) or Tsukioka Yoshitoshi's *Shinkei sanjurokkaisen (New Forms of Thirty-six Ghosts*; 1889–1892). The vast majority of the yūrei and yōkai stories and images known today came from this period, and they still form the spine of Japanese horror storytelling. This was the Golden Age of the yūrei.

One final element fed into the perfect storm that was the Edo-period kaidan boom and the development of yūrei—perhaps the most influential and lasting player to join in the craze: kabuki theater.

Chapter 3

KABUKI AND YŪREI

歌舞伎と幽霊

The Kawarazaki-za Theater, Tokyo, Japan. The First year of Bunka, in the reign of the Emperor Kōkaku …

Though the theater was dark, the firepots near the stage provided ample illumination for the performance and just enough darkness for the performers to work their magic. They would need the darkness more than the light if they were to pull this off properly.

And then the moment was upon them. The switch was thrown, the trapdoor opened, and the double actor dropped to the ground while Onoe Matsusuke I emerged from his secret entrance onto the stage, horrifying with his bone-white kimono, lifeless white face, and massive, unkempt black wig, the hair of which seemed to flow with the darkness as if alive. For the first time, Matsusuke I strode the stage as a yūrei.

The audience screamed in fear.

The year 1603 had been a monumental year. The death of Queen Elizabeth I of England lead to the coronation of James VI of Scotland, officially uniting the crowns of the long-warring Scotland and England. London had more bitter news: The return of the Black Death in the same year caused the deaths of more than 38,000 Londoners. And in faraway Japan, Emperor Go-Yōzei officially granted the upstart Tokugawa Ieyasu the title of shōgun, the equivalent of generalissimo, the highest possible military rank. However, under Tokugawa, "shōgun" would come to mean absolute ruler of the country to whom even the emperor would be subservient. Tokugawa's ascension to the rank ended the brief Azuchi–Momoyama period (1568–1603) and began the era of peace that would become known as the Edo period, so called because Tokugawa moved the capital city from Kyoto to Edo, present-day Tokyo.

But while Kyoto would lose the capital, something new would be born in its streets, something that would outlast even the 265-year reign

of the Tokugawa shōgunate. In 1603, a woman named Okuni, possibly a shrine maiden from the great shrine at Izumo or possibly a prostitute (but most likely both), dressed outrageously and danced provocatively in a dry river bed of the Kamo River on Shijōgawara street near the Kitano Shrine in Kyoto City—and thus created kabuki theater.

From this simple beginning, kabuki skyrocketed into a crowd-pleasing extravaganza. By the late Edo period, it was the most popular form of mass entertainment. Unlike the austere and aristocratic noh theater, kabuki was strictly for the lower classes and pandered to the most primal of tastes. Sex, revenge, murder, and its consequences—all of these were served up as gorily and as shockingly as possible. Nothing was taboo.

Audiences had a taste for kaidan, and it was only a matter of time before the kabuki stage experimented with and explored the mysterious realms. In the eleventh year of the Genroku era (1698), a handsome young hero crouched on stage and nonchalantly burned the love notes and faithful promises he had elicited from his courtesan lover. But she was not so easily dismissed. The smoke from that fire parted, and the dead spirit of the courtesan emerged to smite the hero with words of both love and jealousy—in the process becoming what is most likely the first yūrei to tread the kabuki stage.

Actor Yoshizawa Ayame I claimed this honor in the role of the courtesan in *Keisei Asama-ga-Dake* (The courtesan Asama Dake). A complex drama of sacrifice and love in the world of courtesans, the story hangs loosely from the framework of a display of holy Buddhist relics from Mt. Asama. Over time, the connection to the holy mountain of Buddhist relics was entirely forgotten, but such was the power of this particular scene that hence forth all scenes involving a woman, yūrei or not, pouring out her feelings to someone became known as *asama mono*—Asama scenes.

Keisei Asama-ga-Dake was influential, especially in scenes involving emotive female characters, yet it would take a few more years for the supernatural to truly catch fire with kabuki. Ghostly lovers emerging to confront their still-living betrayers would eventually become a classic kabuki theater trope, but when *Keisei Asama-ga-Dake* was produced, the zeitgeist was not yet quite right.

Forty-six years later, in 1744, Japan saw the first performance of *Momo chidori musume Dōjōji* (The daughter of numerous birds at the Dōjō temple) based on the Dōjōji temple legend. The story told of a beautiful daughter of a feudal lord in Kishū Province. Once every year, a handsome young priest would stop by the mansion on his annual

pilgrimage to the nearby Kumano shrine. The lord of the castle told his daughter that she was betrothed to the priest, something which she believed and so attempted to seduce him. Fearing for his soul, the priest fled from the woman, hiding in the bell of the Dōjōji temple. The maiden, overcome with lust, followed him, transformed into a serpent and wrapped around the bell. So hot was her passion that she melted down the bell, complete with the priest inside.

Now, the audiences were ready. *Momo chidori musume Dōjōji* was a massive success. And they wanted more. With their palates whetted and their appetites enriched for the weird, audiences demanded new and stranger thrills from kabuki. Waiting in the wings to take advantage of this were two men, writer Tsuruya Nanboku IV and actor Onoe Matsusuke I.[7] They would work together to create spectacular visions of gore and ghostly vengeance. Nanboku IV and Matsusuke I introduced yūrei to a waiting audience, providing thrills the likes of which they had never before seen. Under Nanboku IV and Matsusuke I's guiding hands, a new genre was introduced to kabuki, called *kaidan mono*.

The first kaidan mono dealt with a popular historical figure, Tenjiku Tokubei. A merchant traveler in the Marco Polo vein, Tokubei traveled to the far areas of Asia, including the subcontinent of India, then returned to write a popular 1630 memoir *Tenjiku tokai monogatari* (Relations of sea travels to India). Nanboku IV and Matsusuke I were less concerned with Tokubei the historical personage and more concerned with presenting Tokubei as a supernatural character, able to summon monstrous toads to aid his cause and capable of lightning transformations. The play, called *Tenjiku Tokubei ikoku banashi* (Tokubei of India: tales of strange lands) told the story of Tokubei returning from India and passing himself off as the deceased son of Mokusokan, a Korean distraught over his failed assassination attempt on the shōgun. Nanboku IV specifically wrote the play for Matsusuke I, and the two worked together to create new special effects for the kabuki stage and to showcase Matsusuke I's tremendous quick-change abilities.

Nanboku IV's new kaidan mono genre was based on special effects as much as anything else. In fact, so amazing were the special effects and ghostly presence of *Tenjiku Tokubei ikoku banashi* that a local magistrate investigated the production on rumors of the use of Christian sorcery.

7. It is a tradition for kabuki actors and playwrights to adopt the name of their teacher. Succeeding a famous name is a great honor. Thus, Tsuruya Nanboku IV was the 4th playwright to carry that name.

The flashy effects were only outdone by the flashy attire.

Matsusuke I knew the importance of costumes. He was the disciple of Onoe Kikugoro I, one of the most famous actors of his day, who had begun his career as a *wakaonnagata*, a kabuki actor who specialized in playing female roles, before transferring to *tachiyaku* (leading male) roles. Kabuki theater was then, as now, performed exclusively by males, and actors would be called upon to transform themselves entirely into the role.

Maruyama Ōkyo's painting *The Ghost of Oyuki* had been a gift to kabuki theater. One of the thrills of the theater was watching the virtuosity of the lead actors, who would assume many parts in the same production. But with the same actor on stage, constantly changing into a variety of roles, the storyline could get confusing.

In order to let audiences know which character the actor was at any specific time, costumes and makeup were used only for certain character types so that the audience could relax and say, "Ah! Onoe is the Villain now. Oh, and now he is the Scrappy Boy. And now the Venerable Ancient. And now he is the Yūrei."

By now *The Ghost of Oyuki* had been accepted as *the* image of a yūrei. Kabuki actors playing a yūrei emulated the painting, dressing in simple white burial kimono. A welcome and drastic contrast was provided. Set off against the flashy and outrageous ensembles worn by other characters, the yūrei were draped in pure white.

In Japan, white is the color of death. This statement is as often repeated as it is incorrect. In Japan, white is the color of celebration. White ties are worn on important events like weddings, graduations, or at government functions. Much like in the West, white is the color of the bridal gown. In fact, white is directly opposed to death. A full white kimono signifies those who have been ritually purified, who are free from the stain of things of this world. So great is the symbolism of this purity that white kimono are worn regularly only by three classes of people: Shinto priests, brides, and corpses.

The dead rarely go into the ground naked. In ancient times, Western culture employed a simple winding sheet to bury their dead. White cloth was used for a simple reason—spun cottons and linens were white to begin with, and an extra expense was required to color them. Winding sheets were merely long strips of cloth without pretense, lacking buttons or fasteners or decoration of any kind. Japan had a slightly different reason for wrapping their dead in white kimono: purity.

In the religion of Shinto, purity is a remarkably big deal. Many

activities now common in Japan, such as the taking of long baths and the removing of shoes inside the house, can be traced back to Shinto roots and concepts of purity. Certain activities and statuses are considered tainted, and only ritualized purity can cleanse these taints. Blood is one of the tabooest of taints—traditionally menstruating women cannot enter a Shinto shrine due to the blood taint. However, of all the taboos of Shinto, nothing is more tainted than death.

Shinto kami love life and hate death. They love clean and despise dirty. Dead bodies are inherently tainted and cannot be brought into the presence of kami unless they are purified.

Water is one way to wash away this taint, and the color white is another. Even today in modern Japan, Shinto shrines are often decorated with white strips of paper symbolizing purification, and almost every shrine has a small basin of water out in front where visitors can wash themselves of the outside world and enter the holy place pure.

A total purification, symbolized by a complete washing of the body and the wearing of a stark white kimono, leaves one pure enough to directly enter the presence of the kami spirits of Japan. Shinto priests, who commune daily with these deities, regularly undergo this total purification. For average citizens, there are few occasions when such ritual cleansing is necessary. Marriage is one of these cases, and burial is another.

For journeys to the afterlife, Japanese bodies were washed thoroughly. Traditionally, this was done by close family members in a ceremony known as *yukan.* Once ritually cleansed, the body was clothed in what is called the *kyōkatabira,* a special white kimono reserved for this purpose. (Kimono worn by brides are of a different style and called *shiro-maku,* although this similarity of costumes has led some to speculate that the Japanese bride is symbolically "dying" as a child.)

In daily wear, the right side of the kimono is always against the body, with the left side folded over. Only on corpses does the right side cross over the left. The exact reason for this has been lost to time, although some speculate on practices such as a reversed world of the dead, where everything is done backwards. Others consider the elevated status of the dead person. It is thought that in ancient China, laborers wore their kimono left-over-right, while aristocrats were right-over-left. The dead, having assumed a higher form, are dressed in the aristocratic style.

More than just the kimono, the entire body is swaddled in white, with white cloth gauntlets being placed over the wrists and hands and white gaiters for the ankles and feet. Above the head, a small white sack

might be placed with paper money or things needed for the journey,

The head itself was sometimes decorated, depending on the era and the area, with a small strip of cloth cut or folded into a triangle that covered the forehead and wrapped around the back. This ornament goes by multiple names depending on the region, from the grandiose tenkan, meaning "heaven's crown," to the more commonplace zukin, meaning "hood" or "kerchief," to the simply descriptive hitaieboshi, meaning "forehead hat." There is also hitaikakushi or kamikakushi, meaning "forehead hider" or "hair hider," respectively. Perhaps the most basic of all is sankaku no shiroi boshi, meaning "white triangle hat."

The meaning of this peculiar hat is unknown, although there are two main theories. One is that the dead have ascended to a higher level, and thus, the heaven's crown is placed upon their heads to show their new status. Another says that the sharp point of the triangle is there to ward off evil spirits or demons from entering the now-empty body from the head and resurrecting the corpse or preventing the spirit's transition. In all likelihood, there is some truth in both of these explanations.

In Ōkyo's The Ghost of Oyuki, the artist's spectral lover does not wear the tenkan, though she can be seen wearing the kyōkatabira. Like the winding sheets of Western culture, these kimono are undecorated and would not be worn in day-to-day life. Kabuki actors playing a yūrei emulated this dressing in simple white burial kimono, sometimes with the triangle hat and sometimes without. But the simplicity of the white kimono was not enough for kabuki. Priest and bride characters also dress in a white kimono, and the visual shorthand required additional details. Something more was needed.

A silk cloth pressed to the face, preserving the makeup of an actor's performance, has long been a sought-after and valuable collector's item for kabuki fanatics. The thick face-painting of kabuki actors is one of the most instantly recognizable aspects of the theatrical style.

In the old theaters of the Edo period, there were no bright electric lights illuminating the stage, and audiences were hard-pressed to see the important facial expressions when sitting far away during a popular performance. Stage lighting was provided entirely by fire pots, with the obscuring smoke creating a dramatic atmosphere. Thus was developed the makeup, called kumadori, which is prescribed for each role. The sharp lines and bright colors of kumadori are clearly visible from the farthest seats in the auditorium, letting the audience know what kind of character is on stage.

For instance, sujikuma makeup has thick eyebrows sweeping upward

in broad black lines highlighted by graded reds and represents a courageous warrior with an expression of rage and indignation. *Mukimi,* featuring two spatula-shaped eyebrows and graded curves of red, is a brave and handsome hero. Nearly vertical red lines sweeping from the outer corner of the eyes identifies *ippon kuma* and is the mark of a plucky young hero. The variant of kumadori for yūrei is called *aiguma.*

Contrasting with the bright red of standard kumadori, which shows the blood of heroes pumping so fiercely that it cannot be contained by the skin of the face, the colors of aiguma create a dead pallor. Beginning with a base of white, the lips are either blue or black, and the shading is all done in indigo. There is heavy shadowing around the eyes. The eyebrows are high up on the head, and the eyes are often surrounded by black circles. The expanse of white shining between the black circles creates the appearance of huge, wild eyes.

The pale indigo coloring is reminiscent of a corpse. Like the white burial kimono and the flashy costumes, this kumadori was a sharp contrast to the bright colors of all other styles and created an atmosphere of instant dread, with the yūrei seemingly drained of all color, stepping from the dreary shadows of the afterlife into the dazzling world of vibrant life.

A small boy, face drained of color with an indigo pallor and eyes circled with deep pools of black—the yūrei of the boy Saeki Toshio in the films in the *Ju-on* series introduced many Western audiences to the aiguma makeup. Although lacking the most dramatic elements of aiguma, such as the deep lines, the influences are instantly recognizable. Director Shimizu Takashi borrowed heavily from traditional kabuki ghosts for his yūrei, especially with the indigo base coloring and dark blacks emphasizing the eyes. This is especially apparent in Toshio, a character colored head-to-toe, leading some viewers to say that it looks like he has been dipped in talcum powder. Toshio's mother, the yūrei of Saeki Kayako, has less of the indigo base but retains the deep black eyes of kabuki.

Another recognizable feature of *Ju-on's* Saeki Kayako is her long, black hair that hangs from her head like a from where her pale aiguma-face emerges. As with the white kimono and white face, the roots of this hairstyle lie deeper than a filmmaker's fancy.

Chaetophobia is the technical name for a fear of long, flowing hair. While Japan may not have suffered from that phobia as a nation, it can be said that the supernatural nature of women's hair was well-ingrained in the Japanese audience. Kabuki theater would not let an opportunity

to shock their audience go untapped. Actors took advantage of this innate fear and weird nature of ghostly hair, creating heavily stylized wigs and effects to accentuate the horror.

From the tips of the toes to the top of the head, every inch of a kabuki costume is prescribed. Nothing is left to chance or left to appear natural. Like the kumadori makeup, every role in kabuki has its own wig, called a *katsura*.

It is impossible to overestimate the role of hair in Edo-period society. By law of the Tokugawa shōgunate, the feudal class into which someone was born determined everything about them. Hair was one of the most demonstrative aspects of this, and according to their rank—samurai, farmer, artisan, or merchant—Japanese people were legally bound to wear their hair in a specific style. This had the effect of being able to instantly identify a person's social status. Changing the way one wore his or her hair was a heavy crime.

A woman entering the stage with her hair pulled back from her face and back, bound up in a double bun behind her head, confronts a man with his hair pulled back into a topknot, with a shaved swath down the center of his head. From the hair alone—the woman in a *takashimada* wig and the man in a *namajime* wig—the audience is aware that they are viewing a scene between a samurai and a female maidservant, most likely in some house of nobility.

Kabuki katsura such as these were replicas of normal daily hairstyles regulated by the shōgunate. However, a man on stage wearing the top-knot without bothering to shave his cleft—the *mushiri* wig—could be seen as an outsider, a rogue, or romantic scoundrel. An even more outrageous character might pound his feet loudly on the floorboards announcing his presence, demanding the audience's attention with his voice and actions just as much as with his *kuruma bin* wig; looking something like a wagon wheel stuck on the actor's head, the kuruma bin demonstrated the physical power of a mighty hero.

Yūrei had no specific wig to show their dead status. Even the dead were not able to escape the strict laws of the Tokugawa military government; they were still bound to the social class of whatever they had been while alive. Instead, the wig appropriate to that character was mussed, with shocks of hair sticking out from all sides and hanging straight and loose down the shoulders and back.

In Japan, hair, particularly women's hair, had always been considered to have a supernatural quality about it. Early Japanologist Lafcadio Hearn, a man who lived in Japan and had taken Japanese citizenship,

outlined this in his essay "Of Women's Hair," which was published in his 1894 book *Glimpses of Unfamiliar Japan*. The Japanese, like those in the West, believed that corpses continued to grow hair after death, an illusion created when the skin of the scalp retreated, and the subcutaneous hair was revealed.

Kabuki theater took advantage of this innate fear and weird nature, creating heavily stylized wigs and effects to accentuate the horror. If a woman with loose, hanging hair was frightening, it only stood to reason that a woman with an enormous amount of loose hanging hair would be more frightening still. As kaidan took over on the kabuki stage, yūrei characters' hair began to grow far beyond what was necessary or realistic. One of the special effects developed for kabuki was to have stagehands underneath the stage pushing more and more hair up through special holes when a yūrei appeared, giving it an unearthly and terrifying appearance.

This fear of women's hair has not been lost to time, but continues to be used for effect in modern Japanese horror movies. And while kabuki directors were limited by physical constraints, film directors using computer graphics can stretch the fear of hair to lengths that the old kabuki practitioners could only dream of. Oikawa Ataru's yūrei in his film *Apartment 1303* (2007) is able to fill up an entire apartment with hair, stretching out like dark tentacles from the dead girl's head. Perhaps the most extreme example was Sono Sion's film *Ekusute* (2007), known in English as *Exte: Hair Extensions*, in which the supernatural nature of women's hair becomes almost a parody.

The white kimono, white face, and long black hair of Ōkyo's *The Ghost of Oyuki* were easy enough to reproduce, but there was one more critical element that had become accepted as an established fact for yūrei in the Edo period. They had no feet.

The grand extravaganza of kabuki always demanded ever more spectacular achievements, in much the same way that Hollywood always strives to top the latest summer blockbuster action film. These effects, called *karen*, were especially dynamic in kaidan mono. And whether it was to preserve the authenticity of their yūrei or merely to dazzle their audience with visual thrills, the yūrei of kabuki floated above the stage.

Two methods were created to transform an actor into the footless yūrei expected by the audience. The first, and most complicated, was to strap the actor into a pulley-device known as a *chunori*, which allowed stagehands to heave the actor into the air and fly them about the stage, creating the illusion of a proper footless yūrei. This was not the only

use of the chunori, which aided all manner of flying characters with its system of ropes and pulleys above the stage.

The other method was much more low-tech and involved a manipulation of the fires that lit the stage, always keeping the lower half of the yūrei character in darkness, contrasting with the stark white kimono and eliminating the feet. This much simpler method made use of the low visibility already inherent in kabuki performances due to the fire-lit stages.

Another kabuki technique of fire manipulation was brought into play with yūrei characters to unnerve the audience and give the yūrei character an unearthly feel. Small firepots dangling down on something resembling fishing poles accompanied the yūrei, the unearthly glow of the fires being reminiscent of the phenomena of *hitodama*, known in English as corpse candles or will-o-the-wisp.

In modern times, hitodama are most often seen in Japanese animation, appearing when one character tells a scary story, or acts in a yūrei-like manner. The legacy of those firepot hitodama are also imitated today by Japanese children who play with a similar type of firework called a hitodama that has a green or blue burning spark on a dangling pole.

Popular kaidan stories were adapted for kabuki and, in turn, popular kabuki plays were adapted and published in kaidan-shū collections. The level of violence and cruelty increased as each sought to one-up the previous offering. Audiences' tolerance for gore grew. They demanded more spectacular and graphic scenes.

All the different mediums began to riff on each other. Yūrei developed ghastly faces that were a stark contrast to the serene face of Ōkyo's lost love. The deep lines of indigo aiguma makeup and the upswept eyes so unique to kabuki kumadori began to appear in other art forms. Kabuki, which had once only imitated the popular imagery, now took the place as the establisher.

The Edo-period kaidan boom was in full swing.

But this is only the middle of the story of the yūrei—a middle that begins with Maruyama Ōkyo and his portrait of his dead love and ends with the spectacle of kabuki and the closing of the nineteenth century. Ōkyo gave shape and form to something that had long haunted the folktales and storytelling of a people. But he did not invent them. The story of yūrei is much older, stretching back as far into Japanese history as modern researchers are able to stretch. It is, according to some researchers, the very foundation of the culture, the constant theme that Japanese artists have pursued ever since they had the words to do so.

Like Ōkyo's painting, there is the surface—simple and easy to com- prehend. But then there is the deeper story, of loves lost and boundaries broken, of folklore and religion, of art and human experience. To truly understand what a yūrei is, one must look past the white face and black hair and into the past. Deep into the past.

Chapter 4

THE RULE OF THE DEAD
死霊の支配

"…the welfare of the living depended on the welfare of the dead. Neglect of the household rituals would provoke, it was believed, the malevolence of the spirit; and their malevolence might bring about some public misfortune. The ghosts of the ancestors controlled nature; —fire, flood, pestilence and famine were at their disposal as means of vengeance."
–excerpted from *Japan: An Attempt at Interpretation,* 1903
by Lafcadio Hearn

The Rule of the Dead. That was the phrase coined by author Patrick Lafcadio Hearn in his landmark 1903 book *Japan: An Attempt at Interpretation.* A stranger in a strange land, Hearn had struggled to make sense of his new surroundings, of why his pretty new wife performed strange rituals every morning and evening before a family altar, of why he had to shut the top windows of his house on certain days of the year, of why the dead were so deeply revered and feared.

Japan was a mystery to Hearn. Like the puzzle boxes created by local craftsmen that presented a beautiful painted scene on the outside but with no discernable way to open them, the heart of the country was always hidden. A journalist by trade and nature, he probed and investigated, gleaned and gathered, until after several years he was finally able to discern something of the country's inner secrets. A symbiotic relationship—in which the living need to pacify the dead, and the dead in return watch over the living—was the foundational piece of the puzzle. Without understanding the relationship of the people of Japan with yūrei, with their dead, one could never understand Japan.

When talking about yūrei, all roads eventually lead to Lafcadio Hearn. In Japan, the two words are almost synonymous. Say "yūrei" to a Japanese person, and the response is almost always "Lafcadio Hearn." Go to a bookstore in Japan and ask the clerk for a book about yūrei,

and the first thing put into your hand will almost always be a copy of *Kwaidan: Stories and Studies of Strange Things* (1903).[8] Any discussion of the history and cultural impact would be incomplete without understanding the man who so diligently collected and published the legends with which he found himself surrounded.

Born in Greece, raised in Wales and Ireland, he spent his first years of adulthood in the United States when he took a boat across the ocean at the age of nineteen and began working as a low-level newspaper reporter. Hearn was a man of many nations and nationalities. All of these countries like to claim the enigmatic figure, and he is often credited as "Greek writer Lafcadio Hearn" or "Irish writer Lafcadio Hearn" or "American writer Lafcadio Hearn." What one almost never sees is "Japanese writer Lafcadio Hearn." But that is how he died, a citizen of the nation of Japan, living under the self-chosen name of Koizumi Yakumo—the name by which he is still best known in his adopted country.

Perhaps it was his lack of national identity that drove him to restlessness. Hearn had wandered from place to place for years, ever in search of the mysterious, yet never finding exactly what he was looking for. A decade in New Orleans produced two books: *Little Dictionary of Creole Proverbs in Six Dialects* (1885) and *La Cuisine Créole* (1885). The West Indies island of Martinique followed, which he chronicled in *Two Years in the French West Indies* (1890) and *Youma: The Story of a West-Indian Slave* (1890).

A taste for "exotic" women may have also been an impetus for his wanderings. He didn't arrive in New Orleans so much as flee there after his Cincinnati wedding to Alethea "Mattie" Foley on June 14, 1874. A black woman and a white man, their marriage was illegal according to the laws of the time—a felony offense that could have sent Hearn to prison. Eventually divorced, fired from his job, and an outcast from society, Hearn made his escape. Still, Hearn was not put off by this experience. There were rumors (probably unfounded, as she was in her eighties at the time) of an affair with the New Orleans voodoo queen Marie Laveau, whose obituary Hearn would write. His own writings imply he slept with the women of the West Indies as well. But as much as Hearn attempted to embrace these cultures, he was seldom embraced back in

8. Something I experienced myself on several occasions. After I explained I already owned all of Hearn's books, the clerks were often at a loss as to what to recommend. Because he is published in Japan under his naturalized name of Koizumi Yakumo, many are unaware that Hearn was not a native-born Japanese person. That's how strong the relationship is in Japan between Hearn and yūrei.

return. His own odd nature excluded him. Hearn remained a perpetual outsider. An 1890 assignment as a correspondent for *Harper's Weekly* sent him even further across the wide ocean to an island nation only then emerging into prominence. After almost 250 years of self-imposed isolation, Japan had only been opened for foreign commerce and tourism in 1853. Commodore Matthew Perry had come with the military might of his Black Ships, as the coal-fired armada of the USS Mississippi, USS Plymouth, USS Saratoga, and USS Susquehanna are known in Japan. He forced the country to open its ports at cannon-point.

Western interest in Japan was at an all-time high, due largely to the 1862 International Exhibition at London. Along with such wonders as massive industrial cotton mills and the analytical engine of Charles Babbage, the exhibition displayed 623 artifacts from Japan and hosted the first Japanese embassy in Europe. The outlandish group, with their court costumes and strange manners, caused a sensation wherever they went. The entire nation had an air of mystery and fantasy, of an undiscovered country. "The whole of Japan is a pure invention. There is no such country, there are no such people," playwright and poet Oscar Wilde had written in 1889, expressing a common sentiment that such a seemingly fantastic place could not be real.

But mystery and fantasy were just what Hearn was looking for, as well as something even more intangible, something even he didn't understand. The wandering ghost, as Hearn would come to be called, took the assignment with relish. The *Harper's* job would be short lived—a dispute over wages and Hearn's own stubborn pride soon severed ties with the magazine. But that did not trouble him for long. Taking up employment as a teacher in Matsue, Hearn threw himself into learning and writing about the country.

Japan was good to Hearn. He arrived during the Meiji period, which followed the Edo period and its mania for yūrei and kaidan. The country was ripe to bursting with the folklore and mythology that he loved so much. Japan satiated his curiosity and, at the same time, his vanity. It was a country where—for the first time in his life—he was considered physically attractive.

Lafcadio Hearn was a creature, as weird as anything he wrote about in his folklore sketches. Already large-nosed and with an odd face, a childhood accident had blinded Hearn in his left eye, leaving nothing in that socket but a white sheath. The vision in his remaining right eye was incredibly near-sighted. He saw only details. Friends often commented on Hearn's strange habit upon entering an unfamiliar room: He would

walk up close to a wall and position his head until he was inches away. Then, he would slowly scan his right eye up and down the surfaces until he was able to build a complete picture.

Only five feet, three inches tall and 130 pounds, Hearn was delighted to find a country where everyone was small. For the first time, he lived in houses built for his size, sat in furniture he was comfortable in and was not looked down upon by those around him. Because most Japanese people had never seen a foreigner before, they had no idea that he was odd-looking or that his habits were strange. People merely assumed that foreigners were supposed to look and act like that.

Marrying a sweet girl of samurai stock, Koizumi Setsu, Hearn would have four children—three boys, named Kazuo, Iwao, and Kiyoshi; and one girl, Suzuko. Hearn found both happiness and a life's purpose. Never getting a solid grasp of the Japanese language, Hearn was helped by Setsu with the translating and recording of Japan's tales of yūrei and other kaidan, which would be his legacy.

Hearn's first book from his new country, published in 1894, was *Glimpses of Unfamiliar Japan*. The two-volume set collected articles on daily life in Japan, comments on odd customs, and assortments of supernatural beliefs such as his essay "Of Women's Hair." The supernatural and death legends would come to dominate his work more and more in books such as *In Ghostly Japan* (1899) and his most famous work, *Kwaidan: Stories and Studies of Strange Things* (1903), which was later adapted for film by Masaki Kobayashi in the 1964 Kwaidan.

Published after his death, *Japan: An Attempt at Interpretation* was Hearn's final book and his magnum opus. In much the same way as he drew the image of a room with the limited vision in his right eye by passing over its component parts, so did he assemble a larger picture of Japanese society and customs by gathering all the small parts he had learned and arranging them to make sense of the strange traditions, customs, and stories that he had only recorded faithfully until then.

Two hundred pages or more in *Japan: An Attempt at Interpretation* are devoted to the history and evolution of Japanese religion and death practices. Influenced by sociologist and philosopher Herbert Spencer, Hearn wrote of the first spark of religion with ancestor worship and animism, the belief in the spirits not only of humans and animals but also of rocks and trees and of thunder and lightning. He described the progression of death rites such as burial mounds and corpse houses that evolved into Shinto shrines and the fourteen-day waiting period when *shinobigoto*, poems in praise of the dead, were recited.

Japan: An Attempt at Interpretation is a dense and thorough look into the ancient past. But the most important point that Hearn makes is this: The dead of Japan were mighty.

Where other cultures saw great mystical beings in the sky pounding out lightning bolts with silver hammers or crashing through the night sky on winged horses, Japan saw only the dead. From as far back as the distant history of the Jomon period (14,000–300 BC), the Japanese built their spiritual beliefs on ghosts and the grave. Ancient Japan may have had animistic and nature-worshipping elements, but there was a clear hierarchy: The spirits of nature bowed down to the power of the *onryō, goryō*, and the yūrei.

It was believed that each human carried a god inside them, bound and weakened by flesh only for the duration of his or her lifetime. Upon death, the spirit became infused with supernatural power. Called *mitama, reikon*, or *tamashi* in Japanese, the soul shed the meat-cocoon of its body and underwent a metamorphosis more glorious than any butterfly. Wielders of "fire, flood, pestilence, and famine," these dead gods ruled absolutely.

Geographically speaking, Japan is not the easiest place to live. A collection of islands ranging from a California-sized main island to a multitude of little bumps roughly comparable to the size of surfacing turtle shells, the nation and its people are constantly tested. Hammered by typhoons, swamped by tsunami, and rattled around by earthquakes like dice in a Vegas cup, it is a country beset by natural disasters—almost as if someone was seriously vexed that any human being would dare to settle there. If there was a fire, drought, plague, earthquake, crop failure, or any other carnival of carnage, then it was attributed to the whims of the dead. Natural disasters did not occur, only supernatural wrath.

For all the supernatural powers of the newly dead, they still needed living beings. The onryō could summon mighty waves to crash on and destroy villages, split the Earth and cause plagues, but they could not sow a rice field, raise and harvest the fruit of the crop, then refine and brew that crop into delicious sake. The spirits had no power over spirits (if you will excuse the pun).

These spirit-gods had physical requirements, such as a home, food and drink, and entertainment (usually poetry and dance). Having no body, the dead needed the help of the living to provide for them the necessities for a satisfying afterlife. In return, they watched over those still alive, protecting them from the mischievous and uncontrollable forces constantly battering them.

People were diligent in their service to the dead and were never allowed to forget that in every nook and cranny of their lives they were being watched over by their ancestors. The dead never really died in a true sense. They were always there. In Hearn's time, and to his astonishment, some people lived in abject poverty, devoting all their resources and even selling themselves into slavery just to ensure that their ancestor's spirits were properly tended to. The dead demanded constant observance and ritual.

Hearn himself was subjected to strange customs such as his wife's daily offering of food to the dead and being required to close his top-floor windows on festival days when the dead gods were paraded through town—no one was allowed to look down on the dead.

Care for an ancestor was a prescribed and lengthy process. How you were treated in death mattered far more than how you were treated in life. Everyone knew that their obligation to an aged parent was not finished simply because they had died and passed on to the world over there.

From this world to that one, from past to present, there is a chain linking all human beings. Each link in the chain is a person, with one half of the link being that person's life and the other half their death. Each living person is connected with a dead soul in a symbiotic fashion. The living person must care for the dead, and the dead in return watch over the living. Each living person must have a child to complete his or her link and be cared for in return when they die. This is more than social pressure—it is an obligation.

The Japanese language has two words for obligation. The first word, *giri,* is an obligation in the usual sense: someone does you a favor, and you pay them back. If you surprise me at work with a birthday cake on my birthday, then I have giri to you and feel the need to do the same for you when your birthday rolls around. The second word, *gimu,* is a much more serious obligation, one that can never be fully repaid.

I give life to you, and you have gimu to me. This means when I die, you are required to see to my needs, to provide me with food, drink, and entertainment. And you must do this for as long as you are alive. There is no time limit on gimu. You also need to give birth to a new child, so that they will have gimu to you and will tend to you in the afterlife.

Failure to repay gimu meant a restless and angry yūrei—a long chain lacking completion in its linkage that would swing wildly, causing great damage. The gentle protector of an ancestor spirit, called a *sorei,* would transform into a terrifying entity and vent its wrath on the ungrateful child who didn't satisfy obligation.

Unpaid gimu was not the only threat. One of Japan's most famous rituals—the highly ritualized belly-cutting of the samurai class, known in English as *hari-kiri* or in Japanese as *seppuku*—is thought to have begun as a way to execute enemy prisoners without engaging their yūrei. Because the enemy soldiers had been loyal to their lord and brave fighters in battle, even though they were on the losing side, it was thought that they could not justifiably be executed as if they had been criminals. The compromise was to allow captured soldiers to commit honorable suicide, ensuring not only the death of potential future enemies but also protecting the winning side from enduring supernatural grudges.

During times of national instability, when political strife and battle dominated the country, the threat of supernatural wrath loomed particularly large. Any who died amidst the chaos were capable of sustaining a powerful hatred—manifesting as a vengeful yūrei called an onryō. And this vengeance was unfocused. Onryō did not limit their hatred to those who had wronged them in life. The method of an onryō's revenge—fire, flood, pestilence, and famine—did not allow for such precise targeting.

The Heian period is full of examples of these wrathful onryō, mostly high-born and privileged in life. Fujiwara Hirotsugu, Prince Sawara, and Prince Osabe were all considered to have transformed into onryō after their deaths. To calm their raging spirits, they were posthumously raised in court rank and title and then enshrined as kami in Shinto shrines.[9] These rituals, it was said, transformed them from destroyers into protectors. This formed the basis of a new religion, Goryō Shinko—the Religion of Ghosts.

Goryō Shinko was based on a single goal—of transforming onryō to goryō. The belief was so pervasive that a ceremony was established and observed in the Imperial Court to welcome new spirits into the ranks of protective spirits. According to the 901 officially commissioned Japanese history text *Nihon sandai jitsuroku* (The true history of three reigns of Japan), the first such ceremony confirming goryō was held in Shinsenen on May 20, in the fifth year of the Jyogan era (863).

One of the most basic descriptions of onryō was made by the monk Jien. The son of Fujiwara no Tadamichi and a powerful aristocrat, Jien joined a Buddhist monastery of the Tendai sect when he was young. From an early age, he showed a passion for Japanese history, and Jien completed a seven-volume masterpiece around 1220, titled *Gukanshō*

9. A practice still observed in Japan today, although in an altered form. See the section in the Introduction about Yasukuni Shrine.

(Jottings of a fool). In *Gukanshō*, Jien wrote that an onryō was only as powerful as its reason for appearing. Once the spirit's claims had been settled, it would be appeased and cease to trouble the world. Jien's account remains relevant, and this basic description has carried through from ancient times through Japan's middle ages and beyond.

Goryō Shinko declined with the advent of Buddhism in Japan. Buddhism's rituals and beliefs gradually supplanted the Shinto beliefs of the Heian period, although they never vanished entirely.[10] In shrines such as Yanbekimiyori and Sakura-sotzuro, goryō were regularly enshrined and worshipped. And even with the dominant influence of Buddhism, the violence of the War of the Northern and Southern Courts was said to be influenced by onryō, and still more onryō-derived conflicts are recorded in the 1320 *Hogen monogatari* (Tale of the Hogen) and the 1371 *Heike monogatari* (The Tale of the Heike).

Although the earliest records of Goryō Shinko date to the Heian period, the religion was based on older traditions. This death transformation of the yūrei—the ascension to supernatural status—is a foundational myth of Japanese folklore.

Presented in 712 by chronicler Ō no Yasumaro to Empress Genmei, the forty-third Emperor of Japan, the *Kojiki*, or *Record of Ancient Matters*, is the oldest known book in Japan. The three-volume work had been commissioned by Emperor Tenmu, although he did not live to see it finished.

Yasumaro claimed that the *Kojiki* was a re-telling of an older book called *Kujiki* compiled in 620, although this claim is disputed. The *Kojiki* was an intricate propaganda tool—supposedly compiled from authentic folk legends but most likely specifically created to erase the memory of the rival Soga clan and establish the divine right of rule for the Yamato clan and, by proxy, the emperor who claimed direct descent from the sun goddess Amaterasu-ōmikami.

Amaterasu-ōmikami, known more commonly as Amaterasu, was the ancestor of Jimmu, the mythical first emperor of Japan from which all of Japan's emperors draw their lineage. But Amaterasu had famous parents of her own. She was the daughter of the two parent gods who had created the world, Izanagi and his sister-wife Izanami.

Izanami's story is the first example of what would become a template for many yūrei stories to follow: the spurned or wrathful person who gains power after death.

10. Examples of Goryō Shinko survive to modern Japan. Kyoto has two ancient temples that remain devoted to Goryō Shinko: the Upper and Lower Goryō Shrines.

In life, Izanami was a mere bearer of children with no real drive or personality beyond wife and mother. She was subjected to the will of her husband and vulnerable to his spurning. She could be disposed of if no longer desired. In death, however, she transforms, assuming the full strength of her soul, her *reikon*. In death, Izanami becomes something fearsome; something powerful; something dangerous.

Izanami, being a goddess, may not technically qualify as the foundational character for yūrei. But there is another character who meets all necessary qualifications, one who was championed by author Umehara Takeshi.

A controversial figure, Umehara promoted the idea of the "uniqueness" of the Japanese people and believed that their history, culture, art, and philosophy could not easily be understood by outsiders. Umehara was born in 1925 in Miyagi Prefecture. By no means was he a contemporary of Lafcadio Hearn, but his work ran parallel to Hearn's research into the Rule of the Dead. In 1973, in what he called his Umehara Thesis, Umehara stated that the pacification of vengeful spirits has been the constantly running theme throughout the history of Japanese civilization. Instead of Izanami, Umehara proposes a woman called Lady Rokujō as the foundational character of vengeful yūrei.

The Tale of Genji, referred to as the world's first novel, is attributed to Murasaki Shikibu and was thought to have been written sometime in the early eleventh century during the height of the Heian period. To say that it is a classic work of Japanese literature would be a massive understatement. *The Tale of Genji* is *the* classic work of Japanese literature. Written in chapter installments, it follows events from the life of Shining Prince Genji, the son of an emperor, and a low-ranking imperial concubine. Although Genji later gains respect and responsibility, much like Shakespeare's *Henry V*, he is a bit of a cad and a reprobate in his younger years. Genji carouses and disgraces his station with the sensual joys of wine, women, and song.

Such unrestrained pleasure cannot long go unpunished. Genji becomes caught between two women: his legal wife Aoi no Ue, translated as Lady Aoi, and his mistress, Rokujō-no-miyasudokoro, translated as Lady Rokujō. In a display of something rare even in Japanese folklore, Lady Rokujō's extreme jealousy and wrath allow her to tap into the power of her reikon, her soul, while still alive. Unknowingly even to herself, she transforms into an *ikiryō*, a living ghost, which then possesses and eventually kills Lady Aoi.

Lady Rokujō was a popular character. Her story of transformation and vengeance was made into a play for noh theater, titled *Aoi-no-Ue*.

The title is a bit misleading; Lady Aoi never actually appears onstage but is instead represented by an empty long-sleeved kosode kimono. The central story is the ikiryō of Lady Rokujō as she battles with the priests who attempt to contain her fury.

Although there is a gulf of more than 1,300 years between the stories of Izanami and Lady Rokujō and the stories of modern yūrei such as Kayako Saeki from *Ju-on* (2000), they would have no trouble recognizing each other as sisters of vengeance. Hearn's Rule of the Dead and Umehara's Umehara Thesis are confirmed by modern storytellers who use new technologies to tell essentially the same parable about the dangers of death and the explosion of power brought on by a transformed yūrei.

Author Izawa Motohiro[11] agrees with the Umehara Thesis. He bases his theory not so much on evidence, but on purely philosophical terms. Japan's onryō run contrary to the influences of the ancestor cult imported from China and thus must be native to Japan. Izawa argues in his 1993 book *Gyakusetsu no Nihonshi* (An alternate explanation of Japanese history) that the dangerous nature of improperly worshiped ghosts is quintessential to Japanese culture.

This is no abstract philosophy. The concern for the dead is very real. At the end of World War II, scholar Nambara Shigeru was worried about reprisal from the students who died during the war only to see their country conquered. He led The Ceremony to Console the Souls of the Battle Dead and Those Who Died at Their Posts in an attempt to pacify their souls.

British author Richard Lloyd Parry was also confronted by this when researching the 2011 tsunami that killed nearly twenty thousand people in a single swipe of the ocean. Investigating the aftermath, Parry was surprised at reports of yūrei and possession in the damaged zones. A wife told of her husband rolling around in the mud like a crazy person, shouting that "everything must die and be lost!" Others returning home in the aftermath told stories of phantom figures in their bedrooms leaving behind wet footprints. Fire stations got midnight calls summoning help to houses that no longer existed.

What surprised Parry the most was how seriously the situation was taken. Buddhist priests set up emergency exorcism shelters and performed rituals to pacify those killed in the tsunami. Mediums were brought in to communicate with the dead. They urged them to let go

11. Both Izawa Motohiro and Umehara Takeshi are famous for another reason. They are notorious Japanese nationalists who deny Japan's World War II atrocities.

of their resentment and attachment and to transform into protectors of Japan and its people.

Parry had heard about such customs in Japan, like placing offerings before graves and the Obon Festival of the Dead. But he had assumed these were just quaint traditions left over from a more superstitious time—it never occurred to him that the people of modern Japan actually believed in yūrei. Parry discovered that the dead of the disaster must be cared for as much as the survivors. He learned there is a compact between the living and the dead—an obligation that must be fulfilled.

I experienced this relationship firsthand, although in a very different manner. When I proposed marriage to my wife, she said I first had to go to her father, talk the matter over with him, and make sure that he was OK with the marriage. I would, after all, be taking his only daughter to a faraway country, and there was no telling when we would be able to come back and see him again. It did not matter in the slightest that her father had been dead for decades and that I made my petition to his grave—to even suggest that her father could not hear me would have been unforgivable.

Because what Lafcadio Hearn wrote more than a hundred years ago still holds true:

"Most strikingly did they formulate the rule of the dead over the living. And the hand of the dead was heavy: it is heavy on the living even today."

Chapter 5

THE WORLD OVER THERE
あの世

"How I regret that you did not come sooner. I have eaten of the hearth of Yomi. But O, my beloved husband, how honored I am that you have come here! Therefore I will go and discuss for a while with the deities of Yomi my desire to return. Pray do not look at me." Thus saying, Izanami went back in to the hall, but she was gone so long that Izanagi could no longer wait. So he broke off one of the large end-teeth of the comb he was wearing in his left hair bunch, lit a fire, and entered the hall to look. Maggots squirmed and rolled; on her head sat Great Thunder; on her breast sat Fire Thunder; on her belly sat Black Thunder; and on her right foot sat Reclining Thunder. Altogether, eight thunder deities were there.
Upon seeing this, Izanagi became afraid and turned and fled. Then his spouse Izanami said, "He has shamed me."
–translated and excerpted from the *Kojiki*, 712,
by Ō no Yasumaro

The existence of life after death presumes some sort of afterlife. The early Japanese gods were the all-powerful spirits of the dead, wielders of the typhoon and the earthquake. But where were they? Was there a heaven, a hell, or a purgatory? If Dante Alighieri were to have scripted his *Divine Comedy* in Japan instead of Italy, if his guide through the realms of the dead had been the haiku master Matsuo Bashō instead of the poet Virgil, what would he have seen? Where did these spirits go?

In ancient Japan, the dead went nowhere. Dying was not an event that was synonymous with a journey. The spirit had transformed and become powerful, but there was little consideration given as to exactly where it went. It was still considered to be physically linked to the Earth. There was nowhere else for it to go. There was no concept of somewhere beyond the physical realm. Here was everything: this mountain, this rice field, this ocean—all you could see was all that was.

The spirits of dead humans existed in *anoyo*, meaning literally, "That world over there." Human beings lived in *konoyo*, meaning literally, "This world right here." Anoyo was thought of as quite close to konoyo. Where exactly "over there" could be found was sometimes relative to your profession. For a young fisherman, anoyo might lay across the vast and changing ocean. For his farmer cousin, anoyo might border the misty and unreachable mountains that surrounded his village. Water was always a pathway, via the salt water of the sea or the various mighty rivers that inevitably traveled down from the steep mountains. But these were just generalizations, not actual locations. Anoyo was vaguely somewhere else. It was nowhere you could gesture toward.

This still holds true. Try this experiment: Ask a Japanese person to point to anoyo. The results can be surprising. If you ask anyone, Japanese or not, to point to hell, they will inevitably point down. Ask that same person to point to heaven, and they will most likely point up. But then ask them to point to anoyo and be prepared for a seriously quizzical look in response. Anoyo is not up or down, nor in nor out. It is simply—yonder.

As the heaven/hell directions suggest, yonderness has grown more and more complicated with changing times and with contact with other nations. The Japanese concept of the afterlife morphed under a mélange of religious influences—anoyo became terribly hard to define. A mix of Chinese, Indian, Korean, and native mythology has left the country with countless conflicting concepts of heaven and hell—including the Western Christian concepts which have become popular.

The *Kojiki* talks of Yomi no Kuni,[12] the Land of Yomi, which is an underground sort of Hades filled with corpses and rotting flesh. Essentially, it is the land of the tomb, a place where bodies rot eternally, and souls are trapped with no release.

Unlike the Greek Hades or the Christian Hell, there are no gods or demons in the Land of Yomi, just the dead, still trapped in their fleshly bodies and forced to endure the slow process of decay. It is the type of place that one might imagine if they dug up a corpse, saw exactly what decomposition had done to a former beloved and believed that the spirit still reposed in that ghastly shell.

According to the *Kojiki*, the entrance to the Yomi no Kuni can be found in Izumo Prefecture, which is now called Shimane Prefecture.

12. Yomi no Kuni (黄泉) literally translates as The Land of Yellow Springs. This is a Japanese reading of the Chinese land of the dead, Huángquán.

The door to it was closed by a giant ston, placed there by Izanagi, when fleeing his rotting sister-bride.

Like the *Kojiki* itself, this was a bit of clever political maneuvering by the Yamato clan. Izumo was the home of the clan's chief rivals, the Soga, and parking the gateway to hell right in Izumo's backyard showed exactly what they thought of them. They also appropriated the Soga clan's chief kami, Susano'o, and cast him in the role of Amaterasu's petulant younger brother, a nuisance who needed to be taught his rightful place in the heavenly order. However, this foul afterlife in Yomi no Kuni is described in the *Kojiki* and then rarely mentioned again in Japanese folklore.

Alongside the *Kojiki*, the second great book of old Japan is the 720 *Nihon shoki*, also known as the *Nihongi* and often translated as "The chronicles of Japan." While it has its share of mythology, the *Nihon shoki* is considered a more factual and reliable account of ancient Japan than the *Kojiki*. According to the *Nihon shoki*, Buddhism arrived in Japan in 552,[13] when the king of Baekje, one of the Three Kingdoms of Korea, sent monks across the Sea of Japan to bring enlightenment and the teachings of the Buddha to its wayward neighbor.

The Buddhist mission showed Japan something it had not conceived of before—a statue of Buddha. To have a physical representation of a spiritual being that could be felt with hands and seen with eyes was a revelation. Along with this was the process of cremating the dead. In Japan, the body had always been thought of as a vessel for the soul and was left empty after death. Cremation meant that the body and soul could journey together to the afterlife. For the first time, the dead in Japan began to have physical form.

Buddhism also brought a punishment/reward system associated with dying, something that had never existed in Japan before. However, it was not in a straightforward form. Buddhism is not a religion with a single holy text or a single deity. There is no "Bible" per se, and even no "Buddha," but rather, there are many different ascended beings who all have claim to the title and all have different mythologies surrounding them. Instead of a single holy text, Buddhism has what are called sutras. Only those with great knowledge of Buddhism could write new sutras and depending on what sutras you chose to follow and which Buddha you identified with, your concept of Buddhism could be the polar opposite of someone else's.

13. Possibly 538, according to the history of Gangōji Monastery.

One of the most commonly accepted sutras, and one that most affected Japanese afterlife traditions, was the fourteenth century *Bussetsu Jizō bosatsu hosshin innen juō kyō* sutra. It states that a dead soul must face a series of ten judges, in a similar path to the ancient Egyptian journey to Duat.

The first judge is met on the seventh day following death; the final judge, known as Emma-ō, on the forty-ninth day. Like the Egyptian Osiris, Emma-ō had a set of scales to weigh souls, as well as a magical mirror that reflected your true appearance—not the one you tried to project to society. By the time the monk Kyōkai wrote the *Nihon ryōiki*, this series of judges was well known—several of the stories in his collection describe firsthand encounters with the dread judge Emma-ō, also known by his Sanskrit name Yama.

Japanese funeral customs used this sutra, along with a mish-mash of older rituals coming from ancient Japan, mixed with a few dashes of who-knows-what-from-who-knows-where, to create the lengthy and complicated multi-year, multi-day funeral system still in practice. It is the *Bussetsu Jizō bosatsu hosshin innen juō kyō* sutra that accounts for the forty-nine-day waiting period in modern Japanese folklore when a person can manifest as a yūrei.

It was in China that the concept of *naraka*, or hell, which the Japanese called *jigoku*, became associated with Buddhism. Naraka had previously been a part of the Hindu religion. And, as in Hinduism, rather than a single boring old fiery Hell, the Chinese attached as many jigokus as they needed, by some accounts hundreds of thousands. Each jigoku had a different number of years a soul must serve before they were allowed to be reborn. In fact, going to jigoku was in and of itself a form of reincarnation—you were said to be "reborn" into the underworld and could be "reborn" again in a nicer place when your sentence was finished.

The cold jigoku of Arbuda was a frost-bitten land where one wandered naked and alone, doomed for the exact length of time it would take to empty a barrel full of sesame seeds if only a single seed was removed every hundred years. The hot jigoku of Sanjiva was a world of super-heated iron where one is attacked and killed and revived relentlessly for the entire term, lasting 162×10^{10} years. And these are the two most pleasant and least punitive of the jigokus.

Japan eventually settled on a system of eight hot jigokus and eight cold jigokus. But each of these jigokus could have sub-levels, leaving room for infinite variety.

A few of these horrible hells were captured on film by director

Nakagawa Nobuo in his magnum opus *Jigoku* (1960). A devout Buddhist, as well as Japan's first true horror-genre director, Nakagawa used the vehicle of film in the same way as Kyōkai intended his *Nihon ryōiki*—didactic education disguised as mass entertainment. The characters in *Jigoku* face the fierce Emma-ō, who consigns them to various punishments based on their karmic imbalance. People are sliced and diced, boiled, and burned, all in Nakagawa's visual demonstration of the terrors that await those who do not walk truthfully the Eightfold Path of Buddhism.

This was more than fantasy. Japan, being a highly volcanic country, pumps out enough steam and molten lava that more than a few people were convinced the gateway to these Buddhist hells lay in the country itself.

When the Buddhist monk Jitaku Daishi stumbled upon the desolate landscape of Mount Osore in 862—known as *Osorezan* in Japanese, which literally translates as "Mount Fear"—he felt he had discovered hell on Earth. The poisonous Lake Usori was a perfect recreation of the *Sanzu-no-kawa*, the "River of Three Crossings" that souls must pass over on their way to the afterlife. Jitaku Daishi declared Mount Osore to be the actual entrance to hell and established a bodai temple there to help the dead on their way. And although the tradition is fading, Mount Osore is the last home to the blind shamans known as *itako*, who ply their trade by the banks of Lake Usori, offering communication with the dead for a fee.

Another supposed entrance to hell lies in southeastern Toyama Prefecture, on Mount Tate, also known as Tateyama, whose name translates as "Standing Mountain." Mount Tate has a long history of ghosts and the supernatural. Along with Mount Fuji and Mount Haku, it is one of the *Sanreizan*, or "Three Holy Mountains" of Japan, and was the center of its own religious cult from the Heian period to the end of the Edo period.

Mount Tate was supposedly "discovered"—in the Buddhist sense known as *kaisan*, specifically denoting the discovery of a sacred mountain—by Saeki Airyori sometime in the ninth or tenth century (or as early as 710, by some accounts). The story goes that Saeki was hunting bears near his village, Ashikura-ji, at the foot of the mountains. He shot a bear with an arrow and then tracked the wounded beast higher into the mountains than anyone had ever gone. Just as he was about to finish the bear off with another arrow, it transformed into a Golden Buddha before Saeki's eyes. Saeki became a saint, known as Jikō Shōnin, and Mount Tate was declared sacred.

A much-later pilgrim discovered something less wonderful near the summit of the holy Mount Tate. In about the eleventh century, a traveling Buddhist priest encountered a young woman who said she had fallen into the jigoku of Mount Tate. The priest made his way to the summit and discovered the pulsating, volcanic horror of Jigokudani— Hell's Valley. The place earned its name due to the desolation of its volcanic rock surface and the sulfurous steam that pours out of vents in the mountain. There are also several mineral-laden pools of boiling water that are a deep red color and called *chi no ike* (lakes of blood). This references a specific level of hell in Japanese Buddhist mythology; there are several *chi no ike* across Japan.

Mount Tate figures prominently in several kaidan-shū of the period, appearing in three stories in the *Konjaku monogatarishū* as well as in the Heian-period *Dai Nihonkoku hokke genki* (Miraculous Japanese tales of the lotus sutra) and the 1853 *Kyōka hyakumonogatari* (Poems of one hundred tales).

Of course, all hell and no heaven is not much of an incentive for anyone. The introduction of a land of spiritual punishment necessitated the introduction of a land of spiritual reward. In the eleventh century, Honen Shonin introduced the school of Pure Land Buddhism, which featured the concept of the western Pure Land, known as *Jōdo* in Japanese. Jōdo, ruled over by the Amida Buddha, isn't well defined. It is a standard-issue paradise, sometimes envisioned as a perfect garden lying somewhere in the west.

For a time, the learned of Japan considered this Jōdo to be a physical location, something that could be entered from Earth. Like twelfth-century European pilgrims searching for the mythical Prester John and the Garden of Eden in Ethiopia, Buddhist monks hunted for the true path that would lead them to Jōdo.

Around the Heian period, a religion sprang up based on the Tateyama Mandala, which showed a map of the mountain that included pilgrimage sites. Someone walking the true path would find themselves in the welcoming arms of the Amida Buddha. Itinerant priests and ascetics would carry copies of the Tateyama Mandala with them to preach the faith, and, through a form of sympathetic magic, guide the faithful through the map of the mountain, which was said to have the same benefit as making the pilgrimage itself.

Stories sprang up and the faithful created a religion called Tateyama Shinko. One of the most popular legends included bands of yūrei taking the trip together to the far mountain, said to be the shore of the afterlife.

It is implied from most of these stories that the dead are on their way to the Jigokudani instead of the merciful arms of Amida. But you shouldn't feel too bad for them—later variations of the Tateyama Shinko placed the ever-helpful deity Jizō, god of children and savior of souls in hell, in the Jigokudani, allowing the suffering a final way out of their plight and into Jōdo.

As time passed, entrance into Jōdo became easier and easier. In the original rules, as laid down in the *Muryo-jukyō*, or *Infinite Life Sutra*, one had only to ask the Amida Buddha ten times to guarantee an entrance ticket. The request must take the form of a chant, *Na mu ami da bu tsu*. The chant has no meaning in Japanese, being a rough pronunciation-equivalent of the original Sanskrit phrase, which translates as "total reliance upon the compassion of Amida Buddha."

However, wise scholars argued that if the Amida Buddha were truly a being of infinite mercy, he would forgive absolutely anything and entrance to his Jōdo would not be denied to anyone at all who asked even once to be let in. Some believed that even asking was not necessary—all are guaranteed entrance due to the divine grace of Amida. Needless to say, Pure Land Buddhism became a popular religion. It remains the largest of all Buddhist sects in Japan.

But Jōdo and jigoku aside, the oldest version of the afterlife, and the one most directly associated with yūrei, is still anoyo. And like most Japanese concepts of yūrei, the world over there was never replaced by new ideas, merely redescribed.

Whatever your interpretation, it was not difficult for the dead to take the trip across to konoyo. In fact, in practice, there were no boundaries at all. The dead could see you and interact with you, with no need for an evocation. They were also personal, being the souls of dear departed family members rather than just anonymous deities. Each ancestor looked after its own family and was cared for by that family in return. Little was asked for: a bowl of rice, some fresh-brewed sake, a remembrance and a dance during the summer Obon Festival of the Dead. That was about all you needed to make a spirit happy and garner its protection.

Making the trip over to anoyo was slightly more complicated.

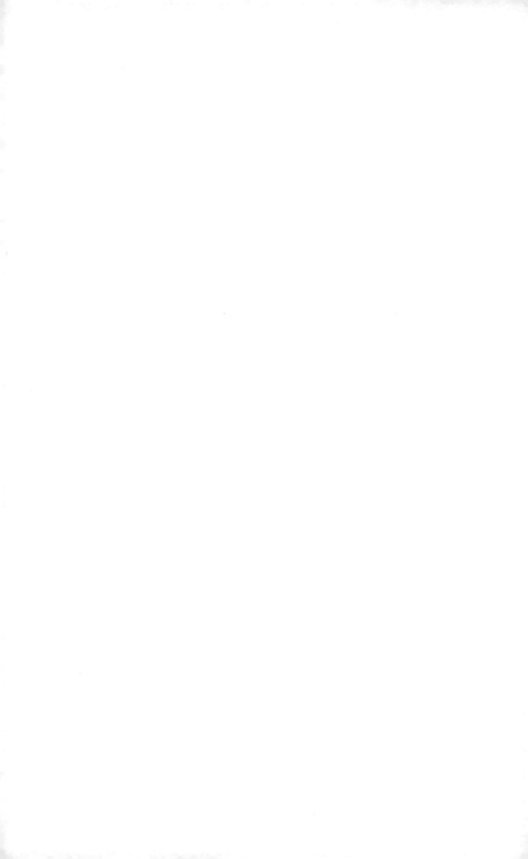

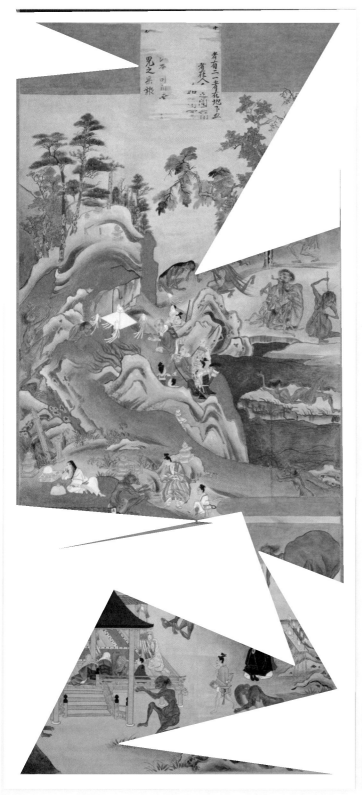

Realm of Hungry Ghosts,
Hirotaka School

In the Buddist-influenced
afterlife, there are many heavens,
many hells. This is the realm of
the Hungry Ghosts who died in
lust for worldly things.

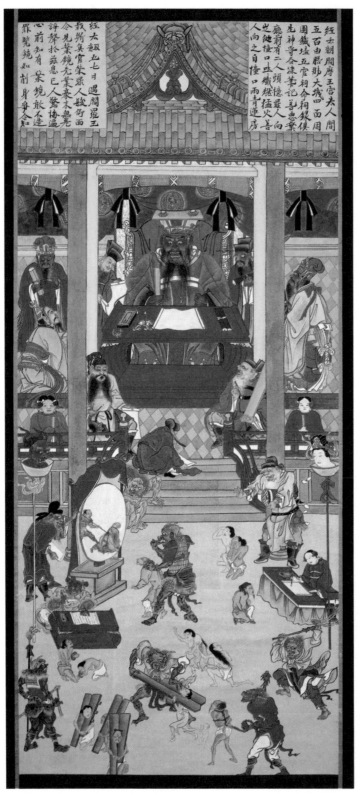

経去朝閻摩王宮夫人間
五百由胎那大城四面周
團鐵墻五官祠令祠銀俱
生神等令凍筆記善惡業
廳前有二人頭纏羅人
此徳憧口坐爐爐猛火善人
人向之自憧口而青連房

経太頴血七月遇閻羅王
我所真官衆人皴何面
令見業鏡先業豪未兒
諍辞於兹悲已人驚悔溫
心前知有業鏡敢不達
羅覧鏡如前身争令知

Court of King Emma in Hell,
Hirotaka School

The lord of hell, Emma Dai-o,
judges souls with his magic
mirror before sentencing them
to Jigoku.

A Ghost (Ubume),
Tsukioka Yoshitoshi

A touching portrait of an ubume, who cradles her living baby to her dead flesh. Only the blood and lack of feet gives away her ghostly nature.

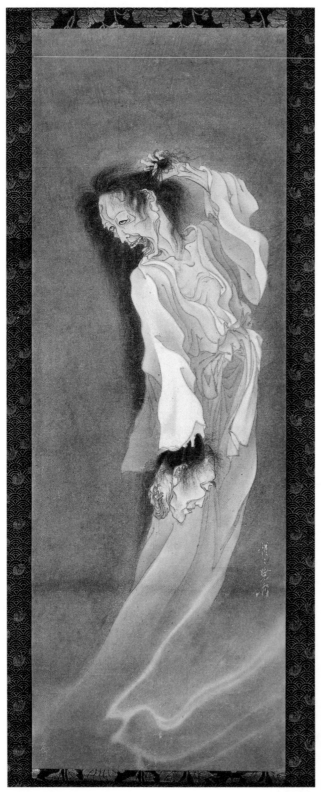

Female Ghost,
Kawanabe Kyosai

The artist Kawanabe Kyosai found a severed head in a river as a young boy, and it haunted him all his life. This is one of many portraits of yūrei carrying severed heads.

Takagi Umanosake and the Ghost of a Woman, Yoshitoshi Tsukioka

One of Japan's legendary warriors, Takagi Umanosuke is unconcerned at being confronted by a yūrei. Her face shows the clear influence of kabuki aiguma makeup.

opposite page:

Shimobe Fudesuke and the Ghost of the Woman in the Waterfall, Yoshitoshi Tsukioka

In a romantic scene, Shimobe Fudesuke prays to see his lost love Hatsuhana and she appears before him in a waterfall. From the *Wakan Hyakumonogatari.*

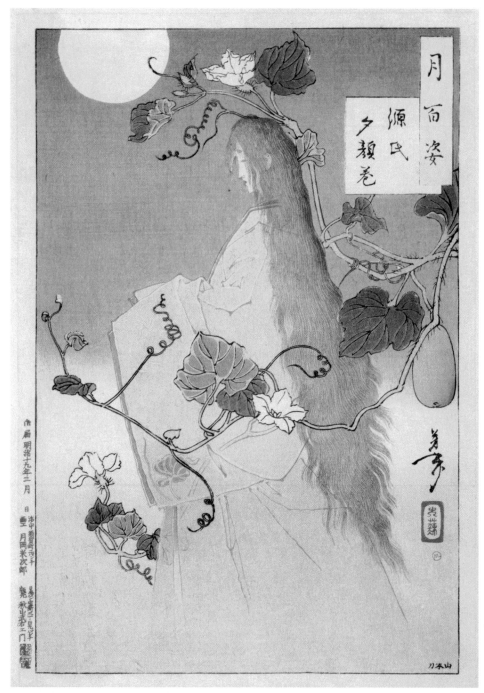

The Ghost of Genji's Lover, Tsukioka Yoshitoshi

One of the many yūrei of the *Genji Monogatari,* this is the lovely Yugao, who was murdered in a jealous rage by the spirit of Lady Rokojo, and who then herself became a yūrei.

opposite page:

Travelling Ronin Receiving his Child from the Ghost of his Wife, Utagawa Kuniyoshi

A ghostly mother delivers her still-living child to her husband in this classic scene of an Ubume.

Chapter 6

A Good Death
良い死に方

"…Either it has become an unworshiped spirit, or owing to some atrocious injury in life, stays to wander the Earth, and to secure vengeance on the living perpetrator. In most cases this is effected by the grudge felt or spoken at the last moment of life. The mind, concentrated in its hate and malice at this final crisis, secures to the Spirit a continued and unhappy sojourn among the living, until the vengeance is secured, the grudge satisfied, and the Spirit pacified"

–excerpted from *Tales of the Tokugawa Volume 1*, 1916, by James S. De Benneville

It is time for you to die. You are lying there, at peace, waiting for your well-deserved entry into Jōdo. You have put your affairs in order; you've said your farewells; all is as it should be—and then suddenly, right before you go, a stray question creeps unbidden into your carefully ordered mind: "Did I forget to feed the cat?"

That's it! No Jōdo for you! Instead your yūrei will manifest in the pantry that very night, making sure that Mr. Snuggles has a full bowl. Your task finished, it is back to riding the cycle of reincarnation, hoping you can do better next time.

Western souls, when we die, slip freely from our bodies into the afterlife. It takes something extraordinary to hold us to the Earth as ghosts. Japanese souls, on the other hand, have sharp edges like shards of broken glass or the ragged teeth of serrated knives. There is every chance that these sharp edges will snag in the fabric of this world, becoming entangled in a place they should no longer be part of.

Death is a dangerous time. The journey from life to death is not so very different from birth. A baby does not come easily into this world and often requires a doctor or other caregiver's skill and vigilance to ensure a safe arrival. Without this, birth can become death for both the

child and its mother. In the same way, the dead cannot freely pass over to anoyo, the world over there. Ritual. Tradition. Respect. These are the tools used to grind down those sharp edges, smooth over the snags and hooks, and leave a spirit free to journey to anoyo.

With the addition of Buddhist elements to Japanese folklore, like Jōdo and jigoku, the original Japanese afterlife anoyo took on the role of a sort of purgatory, acting like a waiting room where the spirits rest before their final sentence. Taking their cue from earlier practices, in which a dead person's soul waited between eight to fourteen days in the living world, the period of stay in anoyo was determined to be forty-nine days, per the *Bussetsu Jizō bosatsu hosshin innen juō kyō* sutra.

This waiting period in anoyo is a particularly dangerous time for the newly dead. If proper respect and ritual was shown to the spirit during this holding period, the rough edges smoothed away, and if there was no pressing business back on Earth, then the soul could move on to the next stage.

But if something was amiss, if rituals were not obeyed, or if emotions bound the spirit to the living world, then the reikon would not move on. Desires and unfinished business are anchors; they hold you fast to the living world and prevent you from making the journey to anoyo.

Even if you have lived your life virtuously and without stain—eating vegetarian, buying and freeing captive animals,[14] participating in a pilgrimage to Mount Tate and walking the true path of the Tateyama Mandala—you are still in harm's way. All your good works can be undone in a flash with a stray thought on your deathbed. All is decided in a single moment—the exact instant of death.

At least that was the lesson taught by the monk Genshin in his 985 magnum opus *Ōjōyōshū*, or "Essentials of birth in the Pure Land." One of the most revered and influential religious figures of his time, Genshin emphasized the importance of visualization during your last second of life. In the *Ōjōyōshū*—essentially a guidebook on getting into Jōdo (and staying out of the jigoku)—he claimed that holding the image of the Buddha at the moment of death outweighed a hundred years of karmic debt. Alternately, a single desire could damn you, transforming you into a yūrei and barring you from paradise for this incarnation.

Basically, Genshin said everyone's life had a photo finish; whatever your last thought or feeling at the exact instant of extinction, so you will become.

14. The buying and freeing of captive animals was a particularly holy activity. The *Nihon ryōiki* is filled with tales of sinners relieving some of their karmic debt by this activity.

This is evidenced in countless kaidan. In the story "The Yūrei Who Wanted to Say Thank You," a palace noblewoman is awoken one night by a servant girl tapping on her window. The servant girl enters the noblewoman's room, says "thank you"—and disappears. The noblewoman barely remembers the servant girl from life and has no idea what she should be thanked for. But clearly, at the exact moment of death, the servant girl's thoughts were something along the lines of "I forgot to thank my mistress."

People—especially the clergy and the aristocrats of Heian-period Japan—became obsessed with dying properly and with clear minds. They were terrified that a stray thought might invade their consciousness at the exact wrong time, undoing a lifetime of good work and earnest actions. Heian-period funerals were already complicated affairs thanks to the influence of the Goryō Shinko religion. Now these heady rituals extended to the pre-mortem condition.

The dying were sequestered in isolated, undecorated rooms, away from any distractions or desires. They would be faced west, aimed towards the Pure Land, maybe with an icon of the Amida Buddha to concentrate on. Sometimes they were given a special cord tied to the image, to aid in concentration and help establish a link.

For those who could afford it, special "death midwives"[15] called *zenchishiki*, or "good friends," could be recruited to help the dying on their way. They were usually hired—sometimes an actual friend could perform the task, but most people wanted to leave it to the professionals. Zenchishiki performed a number of tasks, such as reciting sutras near the dying and keeping them focused or barring the room from intrusive visitors. When the dying slipped into unconsciousness, a zenchishiki would match their own breathing to the breath of the dying, muttering out sutras in a form of sympathetic magic, transferring their piety and guiding the newly released reikon to the Pure Lands.

Beginning in the Heian period, deathbed services like these evolved, continuing into the late Edo period. New manuals for dying were written well into the eighteenth century, advising zenchishiki on the appropriate use of talismans such as mandalas and the types of permissible cords (The best cords, apparently, were twisted by children. They transferred less residual karmic stain.). There was also advice on what not to do, how to keep the dying from attaching to the Earth. Friends

15. Perhaps "midwives" is not the best term, as almost all zenchishiki were male. Women were considered too dangerous, arousing desire, emotions, and attachments.

and family were forbidden. The smell of food was taboo. You didn't want anything to remind them of the pleasures of living.

And of course, the single most dangerous question you could ask a dying person was: "Is there anything you want?"

Obviously, not everyone could afford or plan for such a pleasant death. Dying in a bed, a zenchishiki by your side, chanting you into the Pure Land, was a luxury. Many people died unexpectedly, of accidents—or murder. And odds are, if you wound up in a kaidan told around the flickering candlelight of a game of hyakumonogatari kaidankai, it meant you did not die well.

These practices extend to the present day, specifically with Japanese prisons and state executions. The condemned are brought to a waiting room with polished wood floors described as looking like a Noh theater. Buddhist sutras are piped into the room, and an alcove holds a statue of Kannon, the Goddess of Mercy. Her face is the last they will see. There necks are put into a noose and they stand above a trap door. Three guards push three buttons simultaneously, set on a randomized switch so none know who was responsible. Then the trap door opens, the prisoner disappears down the hole, their bodies dangling in a basement room known among prison guards as Yoni no kuni.

Should these precautions fail, the one consolation was that it didn't last eternally. No matter the death, yūrei don't haunt forever. Yūrei are purpose-driven creatures. Their desire or purpose binds them to the living world. In many ways, the yūrei is their purpose manifested in physical form. As the monk Jien wrote in 1220, when a yūrei's task is done, its emotions satiated, it dissipates, releasing its hold.

While all yūrei get an eventual reprieve, it is important to note that not all yūrei are created equal. Some, like the servant girl who wanted to thank her mistress, are a mere whisper of vitality—just faint echoes of the living person. Some, however, are elemental forces. It all depends on what they want.

Jien wrote that a yūrei is only as powerful as its reason for appearing. And nothing is as powerful as love and hate. Emotions, particularly strong emotions, provide an unbreakable bind for yūrei. Love and hate—and their companions loneliness and jealousy—hold tightest, causing those sharp edges of every Japanese soul to become barbed and even more persistent in snagging in the fabric of this existence.

Japanese folklore is full of yūrei bound to this world, to konoyo, by the strong emotions of love and hate. In one story, a woman falls instantly in love with a beautiful young samurai she spies one day and

then dies longing for him, wrapped in a kimono she had made specifically to catch his attention. The kimono becomes cursed by her longing spirit, killing all who wear it ever after. In another story, a man promises his wife on her deathbed that he will never remarry. Soon after her death, he breaks that promise and finds his new bride's head ripped off by his old wife's angry spirit.[16]

Exorcising these emotionally bound spirits requires more than simple ritual. They will not be appeased by a Buddhist monk reading calming sutras and sending them off to anoyo accompanied by the pleasant scent of wafting incense. They must be more directly satisfied.

16. These two stories are respectively "Furisode" and "Ingwa-Banashi," from Lafcadio Hearn's *In Ghostly Japan.*

Chapter 7

GHOSTS OF HATE
怨霊

Now I have nothing but hatred for you, Iyemon, and hate for the
house of Kihei—hatred for the Itō family.
 None of you shall ever escape to a life of peace. The more I think
about it, the more my heart is filled with bitter, bitter, hatred.
–from *Tōkaidō yotsuya kaidan,* by Tsuruya Nanboku IV, 1825
(trans. James T. Araki)

Ghosts of love, ghosts of hate. Which has the more powerful motiva-
tion? The woman who was disfigured and murdered by poison, nailed
to a wooden door and then dumped into a fast-flowing river by an un-
scrupulous husband who wanted to clear the way for a younger and
richer woman? Or a lonely young maiden who never had a chance to
fall in love?

Amongst all these ghosts of love and hate, two women in particular
felt their emotions more deeply than almost any other yūrei in Japanese
history—Oiwa, the dreaded onryō, a ghost of hate, and Otsuyu, the
lonely ghost of love.

Oiwa and Otsuyu, together with Okiku, the star of Chapter 9, are
known in Japan as the *San O-Yūrei* (三大幽霊), meaning the Three
Great Yūrei. Their stories have been told and retold for centuries.
Something about Oiwa and Otsuyu resonates with the Japanese psyche
more than any other kaidan. Since they made their first appearances—
Otsuyu in 1666 and Oiwa in 1825—they have been a constant part of
Japanese storytelling, perennial characters re-invented and re-told for
each successive generation.

Is there a Western equivalent to such perennial tales? There is, and it
is also a ghost story: Charles Dickens' *A Christmas Carol,* published in
manuscript form on December 19, 1843. The first film adaptation ap-
peared little more than fifty years later in 1901, titled *Scrooge or Marley's
Ghost.* Since then, *A Christmas Carol* has been filmed an average of once

per decade, with a total of at least twenty film adaptations and several television adaptations and allusions by other media. Each generation requires its own version of *A Christmas Carol*, just like each generation of Japan needs its own version of Oiwa and Otsuyu. Clearly, some ghosts have staying power.

Oiwa and Otsuyu. Ghosts of love and ghosts of hate. First we will start with hate.

As the Pashtun proverb goes: "Revenge is a dish best served cold."

In the West, ghosts generally obey this ancient proverb. They haunt in the cool, autumn months, especially during the October festival of Hallowe'en. Western ghosts are creatures of the harvest, manifesting when a bloated, fungoid moon hangs heavy in the sky, and the icy death of winter looms large.

Japan, however, serves up tales of ghostly revenge piping hot. Yūrei appear in the oppressive and stifling heat and humidity that accompanies a Japanese summer—the traditional season of the supernatural.

Stepping out your door on a summer day in Japan is like walking into a thick wall of human sweat. The humidity clings to your body and you cannot escape. The entire country is thrown into a state of lethargy and agitation. Relief comes in the form of telling "chilling" tales, yūrei stories and other kaidan that would send a shiver down your spine and provide a few moments of delicious respite.

In addition, Japan's festival of the dead, Obon, takes place during August, when the walls between anoyo and konoyo are thinned. The summer months were and remain the traditional time for kaidan. Even in modern Japan, when the calendar turns and the weather heats up, movie theaters and airwaves are flooded with programs of a ghostly nature.

In the Edo period, the summer months also meant big business. Audiences seeking relief from the heat would crowd into dark theaters, looking for that chill that could only be provided by a truly horrible tale of ghostly revenge. Every summer, rival kabuki theaters rolled out new performances, hoping to earn the lion's share of the audience.

Competition was fierce; one sure way to win over your audience was by promising the most vicious acts of retribution, the most gruesome and blood-curdling tales. The more violent and bloodier your story, the more you could count on ticket sales. No one understood this more than the playwright Tsuruya Nanboku IV.

Born in Edo, modern-day Tokyo, Tsuruya Nanboku IV was the son of a dyer—and that's about all we know about his childhood. He first

appears in the history books in 1776 (the same year as Ueda Akinari's masterpiece *Ugetsu monogatari*), listed as an apprentice to Sakurada Jisuke I. How the connection was made we do not know, but it was an advantageous apprenticeship. The man who would become known as Tsuruya Nanboku IV studied the art of kabuki from one of the leading playwrights of the day. Jisuke I specialized in dramas of contemporary life, something that would mold and influence Nanboku IV's own flamboyant style.

Initially taking the name Sakurada Heizo after his master (as is common in the world of kabuki and other traditional Japanese arts), Nanboku IV began his professional career working at the Nakamura Theater in Tokyo. His efforts during this time were unspectacular and mostly unnoticed. Then in 1780, at the age of twenty-five, he moved another rung up the ladder. He was either prestigious enough or handsome enough to marry Oyoshi, the daughter of Tsuruya Nanboku III, the man from whom he would eventually inherit his title.

Although Nanboku IV worked steadily, it would be almost another twenty-five years before he had his first bona fide hit—his production of *Tenjiku Tokubei ikoku banashi* (Tokubei of India: Tales of strange lands) in 1804. This production catapulted both his career and his creative juices. In 1811, he finally succeeded to the name Tsuruya Nanboku IV and proceeded to write more than 120 plays.

Nanboku IV was a total gore-meister. He was a taboo-breaker and a boundary-pusher. In terms of modern film makers, he could have easily kept stride with Miike Takashi and his ultra-violent *Ichi the Killer* (2001) and *Audition* (1999), Hideshi Hino and his notorious *Guinea Pig* series (1985–1988), or Eli Roth and his "torture porn" *Hostel* series (2005–2011).

In one of his popular plays, *Sakura hime Azuma Bunshō* (Evil split of Princess Sakura; 1817), Nanboku IV openly portrays such taboos as homosexual relationships between monks, sexual abuse, and forced prostitution—and even a mother smothering her own illicit child. From plays like this, Nanboku IV was thought to possess an innate sense and deep knowledge of the human psyche and the darkest depths of human nature. He knew what scared people. And he knew how to expose an audience's own illicit desires to make them afraid of themselves.

One of Nanboku IV's secrets was to take events from real, modern life and then twist those events into a supernatural story. These "ripped from the headlines" stories gave a sense of verisimilitude and authenticity. Nanboku IV was a patchwork quilt maker in storytelling. He took

pieces from here and there and sewed them together into a single, effective tapestry.

Early in his career, Nanboku IV had created the genre known as *kizewa mono*, or living domestic plays. Drawing influence from his first master, Sakurada Jisuke I, kizewa mono focused on the drama of everyday life in Edo-period Japan. A master of two genres, Nanboku IV would take the accessibility of his kizewa mono and transform them into the horror of kaidan mono.

Nanboku IV combined the daily lives of non-aristocratic people with bloodshed and supernatural ghostly elements. Prior to Nanboku IV, most kaidan dealt with the lives of temple priests, samurai lords, or faraway, mystic China and India. Plays like Nanboku IV's own early hit *Tenjiku Tokubei ikoku banashi* kept a layer of separation between the supernatural and the audience. Magic happened, but it happened far away, or it happened to monks in ancient temples. Nanboku IV tapped deeper into people's fears by bringing the ghosts of Japan out of the temples and the aristocrats' mansions into the homes of the common people—the exact people who made up his audience.

In 1825, Nanboku IV unleashed his unquestioned masterpiece, *Tōkaidō Yotsuya kaidan* (The strange story of Yotsuya on the Eastern Sea Road). The play debuted at the same Nakamura Theater where Nanboku IV began his professional life. In a move not uncommon at the time, *Tōkaidō Yotsuya kaidan* was scheduled as a double-feature with the popular play *Kanadehon chushingura*—later shortened to just *Chushingura*—known in English as *The Loyal 47 Ronin*.

What was uncommon about this double-feature was its staging. Normally, with a kabuki double-feature, the first play is staged in its entirety, followed by the second play. However, in the case of *Tōkaidō Yotsuya kaidan*, Nanboku IV interwove the two stories with a full staging over two days. The first day started with *Kanadehon chushingura* from Act I to Act VI, followed by *Tōkaidō Yotsuya kaidan* from Act I to Act III. The following day started with Act IV of *Tōkaidō Yotsuya kaidan*, followed by *Kanadehon chushingura* from Act VII to Act XI. Finally Acts IV and V of *Tōkaidō Yotsuya kaidan* concluded the program. This was a deliberate choice by Nanboku IV. When writing a new play, kabuki authors must determine the *sekai*, meaning the setting, or world which was to be depicted. Nanboku IV boldly chose the sekai of *Kanadehon chushingura* and linked his new play with historical events. By then, the facts of the forty-seven *ronin*—meaning samurai who had no master— had passed into legend. The story was widely celebrated as an example

of true loyalty. The ronin were considered national heroes for both their revenge against Kira Yoshinaka Kōzuke no suke, who the ronin believed had caused the death of their master Asano Naganori Takumi no kami, and for their subsequent honorable suicides via seppuku.

However, Nanboku IV noted that Asano had over three hundred samurai in his service, only forty-seven of which chose to remain loyal. Nanboku IV reasoned that some of the remaining 250-plus warriors must have had adventures of their own and decided to create the story of an unloyal ronin and his unfortunate wife.

With the sekai established, Nanboku IV pieced together the rest of his story from various sources, both real and fantastic.

In an area of Edo called the Four Valleys, or Yotsuya in Japanese, legend told of a woman named Oiwa from the House of Tamiya whose onryō almost destroyed the family fortunes. Oiwa's grave is supposedly located at Myogo Temple in Yotsuya, with a grave marker of February 22nd, 1636—although there is no guarantee that this is the true Oiwa. Her story was set down in the *Yotsuya zatsudan-shū* (Idle talk of Yotsuya), a document believed to have been published almost a hundred years after the actual events, in 1727. *Yotsuya zatsudan-shū* was kept at the Oiwa Inari Shrine, which had been built over the ruins of the Tamiya family mansion. The shrine still stands today.

According to the *Yotsuya zatsudan-shū*, the samurai Tamiya Matazaemon was a minor vassal of the first shōgun, Tokugawa Ieyasu. Matazaemon had come to Edo from Sunpu (modern-day Shizuoka) and brought with him his daughter, Oiwa. She was married to a low-level samurai named Iemon,[17] who had subsequently been adopted into the Tamiya family as a son—a common practice for families with no male heir.

However, Iemon was not happy with the match. He constantly bullied and harassed his wife Oiwa. Finally one night, in a frenzy, she fled the family home and ran off into the streets. Oiwa was never seen again. Local gossip said that Iemon had a mistress in the neighboring house of Itō, and that he had actually murdered his wife in order to clear a path for his mistress. But nothing was ever proved.

The fortunes of the Tamiya house rapidly declined after that night. Oiwa's unhappy spirit was considered to be the cause of the family's troubles, and eventually, the decaying mansion was made into a shrine

17. Depending on the romanization, his name can be spelled either "Iemon" or "Iyemon." Either will do, but it shouldn't be confused with "Lemon." Iemon is not a citrus fruit.

for Oiwa. With this act of contrition performed, the Tamiya family re-covered its full strength and continues successfully to this day.

In the *Yotsuya zatsudan-shū*, Nanboku IV found his story, casting Iemon as his faithless ronin and Oiwa as his wife. Nanboku IV then pulled off his favorite trick and incorporated two sensational, real-life murders into his play. The first involved two servants who had murdered their respective masters. They were caught and executed on the same day. The second murder was by a samurai who discovered his concubine having an affair with a servant. The samurai had the faithless concubine and servant nailed to a wooden board and thrown into the Kanda River.

In the hierarchical society of Edo-period Japan, both crimes were shocking and unthinkable. Those "below" did not have affairs with those "above," much less kill them. This shook the natural order of Japanese society and provided the perfect taboo foundation for Nanboku IV to build his story.

Tōkaidō Yotsuya kaidan was an instant success, beyond Nanboku IV's wildest dreams. Something about the bloody spectacle struck a chord with audiences, and theater owners forced the producers to schedule extra out-of-season performances to meet demand. Oiwa became an overnight celebrity.

For more than 150 years, Oiwa has haunted the imagination of the Japanese people. In comparison, Tsuruya Nanboku IV's other ghostly creations from his more than 120 plays have faded into obscurity, re-membered only by fevered kabuki fans and kaidan enthusiasts. Mention the name "Princess Sakura" to most people and you will get blank stares, but everyone knows Oiwa. All you have to do is whisper "Oiwa" to Japanese children and inevitably they will reach a tiny finger up to their face and pull down their eye in an imitation of Oiwa's poison-ravaged face.

Oiwa's face. Her most memorable feature. And proof that good char-acter design goes a long way.

Ethereal beauty is often associated with yūrei. Before they die, the women in kaidan stories are inevitably described as more beautiful than average—capable of invoking those strong emotions of love and jeal-ousy. Oiwa, by contrast, was never a great beauty. In fact, some versions of her story describe her as pockmarked and hideous to behold.

Even her name is not beautiful. Most female characters in Japanese folk legends have pretty names, evocative of nature. Female names from the Edo period and before are often proceeded by the honorific "O-," which had an elegant and feminine sound. In most kaidan you have

names like O-yuki, meaning "snowfall," or O-kiku, meaning "chrysanthemum," or O-tsuyu, meaning "dewdrop." By contrast, O-iwa translates as "the rock."

The small amount of beauty Oiwa did possess was taken from her. When Iemon went to kill her, he was not careful enough with the dosage of the poison. His first attempt did nothing more than cause the left side of her face to droop and run like molten candle wax. One of the most emotional scenes of *Tōkaidō Yotsuya kaidan* is when the newly disfigured Oiwa attempts to comb her hair, only to have it fall off her head in massive chunks.

This scene took on special significance in the play, not only due to the supernatural association with women's hair, but also due to the use of the comb. The Japanese word for comb is *kushi*, which is said to sound like the word for suffering (*ku*) combined with death (*shi*). An ancient Japanese proverb states, *"Kami wa onna no inochi,"* meaning "A woman's hair is her life"—here was Oiwa's life being pulled from her head by suffering and death, all because she was not pretty enough and wealthy enough to satisfy her greedy husband. She was nothing more than a means to an end for Iemon; when Oiwa ceased to be convenient, she became disposable.

However little Iemon valued her, Oiwa proved to be a goldmine for Japan's artists. A cottage industry sprang up around Oiwa. Her horrific and misshapen visage was carved into the woodblocks of countless ukiyo-e artists looking to capitalize on the demand.

Hokushū Shunkōsai was one of the first to take advantage of Oiwa's popularity, producing *The Ghost of Oiwa* in 1826, about a year after the play's debut. This print does not show much imagination—it is a classical yūrei-e, not far from *The Ghost of Oyuki*. Shunkōsai showed kabuki actor Onoe Kikugorō III as the white-robed and footless Oiwa standing alone. Only the drooping face gives away the character.

Other artists got more creative with Oiwa. Many preferred a particular scene in *Tōkaidō Yotsuya kaidan* in which the spectral Oiwa's face appears in a lantern to torment Iemon. This became the de facto image of Oiwa. The famed artist Hokusai Katsushika—he of *The Great Wave off Kanagawa*—created one of the most famous images of Oiwa in his 1830 *Hyakumonogatari* series.[18] Hokusai's Oiwa is a giant face emerging

18. Based on the hyakumonogatari kaidankai game that was still wildly popular at the time. During the Edo period the term "hyakumonogatari" became synonymous with "ghost story."

from a lantern, dwarfing the tiny Iemon who tries to draw his sword to defend himself from her attack. Another master, Kuniyoshi Utagawa, produced a diptych of Oiwa and Iemon in 1836, showing Oiwa's descent from the lantern to confront a cowering Iemon.

Yoshitoshi Tsukioka, famed for his "Bloody Prints" featuring gory scenes of war and bloodshed, created one of the most memorable images of Oiwa in 1892. He is one of the few artists to show her still alive and happy, playing comfortably with her son. Only a snake descending from the ceiling foreshadows what will become of her.

Filmmakers have always been particularly fond of Oiwa and have kept her story alive through the centuries. The first movie adaptation of *Tōkaidō Yotsuya kaidan* was a filmed version of the kabuki play, made in 1912 by an unknown director. A new version has followed at least once a decade ever since.

The popularity of the 1912 adaptation was such that *Tōkaidō Yotsuya kaidan*—usually shortened just to *Yotsuya kaidan*—was remade several times in the immediate years (possibly eighteen different versions) between 1913 and 1937. All were essentially filmed adaptations of the kabuki play, with various famous kabuki actors fulfilling the roles. Unfortunately, all the films of this early period have been lost, except for rare snatches and fragments, and the productions are known today only by title and reputation.

One of the more notable adaptations filmed during this lost period was the 1928 *Shinpan Yotsuya kaidan* (New version of the Ghost of Yotsuya), by famed director Itō Daisuke. Itō was widely regarded in the late 1920s and early 1930s as one of Japan's most inventive and foremost directors, admired by both audiences and critics alike. Although Itō primarily adapted kabuki plays as was typical of the times, he was a Western-influenced and rebellious filmmaker, introducing such exotic elements as the music of Frédéric Chopin (in his 1927 yūrei film *Ikiryō*). We can only guess what he did with Oiwa.

In 1949, director Kinoshita Keisuke attempted to bring Oiwa into the modern era by removing the ghostly elements from the story for his adaptation *Yotsuya kaidan, I and II* (1949). Kinoshita presented Oiwa as nothing more than a manifestation of her murderous husband Iemon's guilty psyche, resulting in his suicide. This didn't last, and in 1959 Nakagawa Nobuo filmed the most popular and seminal adaptation.

Nakagawa Nobuo, who directed the film *Jigoku* (1960) described in Chapter 5, was Japan's first genuine horror director. Under contract at Shin Toho studios, Nakagawa was charged with churning out gory

grindhouse B films. Nonetheless, he attempted to infuse his creations with some artistry and morality. A devout Buddhist, Nakagawa saw the kaidan genre as a good vehicle to tell stories of karmic revenge. He wanted to show Japan how those who do bad things come only to bad ends.

Nakagawa experimented with both storytelling and special effects techniques, discovering how to bring kaidan to life on film. His first attempt was his 1956 *Kaii Utsunomiya tsuritenjo* (*The Ceiling at Utsunomiya*). A year later, he revised the classic legend of *Kaidan Kasane ga fuchi*[19] (*Ghost Story of Kasane Swamp*). Nakagawa reversed the gender of the original story, presenting a rare tale of a male onryō. In this case, a murdered blind masseur, disfigured in a way similar to Oiwa, haunts the samurai who killed him. Next, in *Bōrei kaibyo yashiki* (*The Mansion of the Ghost Cat*, 1958), Nakagawa experimented with special effects and techniques intended to highlight the ghostly elements on film. Then in 1959, he made *Tōkaidō Yotsuya kaidan*.

Nakagawa's experiences with previous kaidan films prepared him to create the seminal adaptation of the seminal Japanese yūrei story. He had developed the technical skills necessary to summon Oiwa to the screen in all her ghostly splendor. He also saw in the story the karmic notion of "you reap what you sow," which Nakagawa so passionately believed in.

Nakagawa's version of *Tōkaidō Yotsuya kaidan* is an altered version of the kabuki play, leaving out those elements that connect the play to the legend of the forty-seven ronin. Nanboku IV's sekai was abandoned in favor of a more concentrated story. Iemon is actually made even more despicable.

Seeing a chance for advancement in marrying Oiwa, a match which the girl's father opposed, Iemon schemes with Oiwa's father's servant Naosuke to kill the old man and thus leave the path open to his two daughters. The deed done, Iemon lays claim to Oiwa, and Naosuke takes her innocent younger sister, Osode. Planned advancement and opportunity not coming his way and lacking income, Iemon forges an alliance with a wealthy merchant neighbor to marry the merchant's daughter, but first, he must rid himself of his current wife. Working again with Naosuke, Iemon poisons and then kills Oiwa, strapping her

19. Another popular kaidan. First published in 1860 by author San'yūtei Enchō, *Kaidan kasane ga fuchi* has had several film versions since its first adaptation in 1926 by Mizoguchi Kenji under the title *Kyōren no onna shishō* (The Passion of a Woman Teacher).

to a wooden board and setting the stage for Oiwa's righteous vengeance. The imagery of Nakagawa's *Tōkaidō Yotsuya kaidan* is particularly effective, with scenes such as the ghostly Oiwa summoning the river she was thrown in to rage through Iemon's house. Oiwa herself is a classic figure, with a face like dripping candle wax, white robes and wild black hair.

Even with such a powerful vision of the *Tōkaidō Yotsuya kaidan* on film, Japan's directors cannot help but take their own shot at the perennial story. Fukasaku Kinji, director of films such as *Battle Royale* (2000) and the *Battles without Honor and Humanity* series (1973–1974), reunited Oiwa with the loyal forty-seven ronin in his 1994 film *Chushingura gaiden Yotsuya kaidan*, known in English as *Crest of Betrayal*. Based on a novel by Tsurumi Shunsuke, Fukasaku's film combined the stories of *Yotsuya kaidan* with *Chushingura*, paying homage to the original double-feature as the story debuted in 1825 at the Nakamura Theater.

Nakata Hideo, director of the film *Ring* (1998), has said that he modeled the appearance of his onryō Yamamura Sadako on the traditional image of Oiwa. Looking at pictures of them side by side, the connection is instantly apparent—Sadako's drooping eye and tangled black hair could only be Oiwa.

Ninagawa Yukio filmed a version called *Warau Iemon*, or *Smiling Iemon*, in 2004, and Miike Takashi released a new version in 2014. Clearly, the modern world is not yet done with Oiwa.

Nor is Oiwa done with the modern world. Modern-day performances of *Tōkaidō Yotsuya kaidan* are said to carry her curse.

As far back as the first Edo-period productions, Oiwa was thought to haunt performances. Before taking the stage, actor Bandō Kichiya was known to warn the audience that the yūrei of Oiwa was amongst them right now, and if the audience did not show proper appreciation for the play, it would anger the already-angry spirit. Clearly, this was in large part mere showmanship, but it was also true that the actors in the production would pay a special pilgrimage to Oiwa's shrine in Yotsuya to pray for her blessing.

Nor was this confined to theater alone. When writing the introduction to his translation of *The Yotsuya Kwaidan* or *O'Iwa Inari*, James S. De Benneville apologized to Oiwa. The book, which made up the complete first volume of his 1916 two-volume series *Tales of the Tokugawa*, is probably the first appearance of Oiwa in English. Interestingly enough, De Benneville lists the author of *Yotsuya Kwaidan* as Shunkintei Ryō, a storyteller of the Yoshiwara pleasure district. De Benneville seems unaware of Oiwa's kabuki origins. Not entirely convinced it is a true

story as Shunkintei related it to him, nonetheless, De Benneville says it is better to bow to tradition than to risk the consequences, so he begs Oiwa's forgiveness for re-telling her tale.

Those who ignored Oiwa paid a heavy price. A 1976 performance of *Tōkaidō Yotsuya kaidan* at the Iwanami Hall in Kanda, Tokyo, was beset by disaster after disaster, including illnesses, accidents, and even deaths. The playwright Ichiai Kiyohiko was hospitalized with stomach issues, then fell and cracked his head in the hospital. The actor playing Oiwa was at dinner with four friends, and when the waiter brought out six orders of tea, they wondered why the extra cup. The waiter said it was for the woman sitting beside them. There was no woman. There were more incidents, including multiple falls and broken bones. Finally, when the mother of the actor playing Iemon died suddenly, the cast knew they were cursed.

It is a common story. Many TV and theater productions of *Yotsuya kaidan* report incidents of fires, mechanical trouble, and other accidents. Modern-day movie productions still follow the tradition of visiting Oiwa's shrine religiously—especially the actor playing Oiwa. She (or he, if a kabuki production) is considered to be in the most danger from Oiwa's wrath.

A warning to those seeking out Oiwa's grave, however. Legend also says that those who go to her grave out of sheer curiosity and do not give proper homage to Oiwa will suffer a further curse. Their face will become swollen, and their right eye will droop in imitation of Oiwa's own poison-ravaged face.

The custom of visiting Oiwa's shrine and grave is unique. Most yūrei are single-minded and purpose-driven creatures; by the laws of custom and folklore, Oiwa should have gone on to anoyo long ago, after her revenge was complete. But such is her grip on the Japanese mind that people are still fearful of her today and believe in her power. In Oiwa's case, it is the people of Japan who will not let her go.

Chapter 8

GHOSTS OF LOVE

恋霊

Hand in hand the two rose lightly from the earth. Like vapor, they passed through the unguarded window. The samurai called "Come beloved," for the third time. He was answered, "Lord, I come."

In the grey morning Hagiwara's servant found his master cold and dead. At his feet stood the peony lantern burning with a weird yellow flame.

–excerpted from *The Moon Maiden & Other Japanese Fairy Tales*, by Grace James (1923)

In the human brain, hate is generated in the putamen and the insula, found in the subcortex of the brain. There is a "hate circuit" that can be triggered, which overrides large parts of the cerebral cortex—the area of the brain associated with judgment and reasoning. Studies have shown that merely looking at a picture of someone you hate is enough to switch on the hate circuit and can cause irrational, extreme behavior. Of course, the putamen and insula also induce another emotion—one that overrides the cerebral cortex to an even greater degree, causing an all-consuming passion that leaves little brain function for rationality. The same physics of the brain responsible for Oiwa's unstoppable hatred also create the drowning sensation of romantic love.

The thin line between love and hate is thought to be evolutionary. The same area of the brain that makes you cling to a mate also raises your hackles at the danger of a rival and makes you defensive of what is "yours." And these circuits can become easily switched; many are the kaidan in which love transforms into hate, and betrayal twists sweet affection into something bitter. Oiwa certainly loved her husband Iemon before he had her nailed to a door and thrown into a river.

Some love, however, is on a different level. Some love is pure enough and strong enough to anchor a spirit to *konoyo* and become the purpose that fuels a yūrei. Maternal love is one such binder. There are many

stories of a mother's devotion binding her spirit as a kosodate yūrei. This ghostly mother continues to care for her child after her death, the ultimate expression of love. And of course, romantic love will serve as well.

Maruyama Ōkyo's dead lover, from *The Ghost of Oyuki* could be such a love-driven yūrei. Her purpose remains a mystery. Perhaps she wanted to bring Maruyama peace from his longing. Perhaps she knew that her portrait would secure his eternal fame and cause books to be written about him 250 years later. In either case, it was clearly love that brought her back, not revenge. She held no grudge against Ōkyo.

Love comes in many flavors. The love a kosodate yūrei bears for her child[20] is different from Oyuki's love for Ōkyo. Even then, there are yūrei whose love is less…chaste. Sex with the dead—with yūrei—has long been a part of Japanese storytelling. As far back as the *Konjaku monogatarishū* story "In Which a Wife, after Her Death, Meets Her Former Husband," tales have been told of faithful wives who take their husbands to bed one last time. In the case of "The Yūrei Wife Who Came to Bear a Child" from *Inga monogatari*, a dead wife goes so far as to live with her husband for three years after her death and even bears a living child.

Sex is the cornerstone of "Botan dōrō," the tale of Otsuyu and the Peony Lantern. The taboo nature of the tale is designed to titillate, not frighten. And that has kept the story alive for centuries. Of all the kaidan told and re-told in Japan, "Botan dōrō" has stayed relevant the longest. Because sex—especially when combined with death—never goes out of style. Sex has propelled "Botan dōrō" across the three-hundred-plus years since it was written by Ryōi Asai back in 1666.

Or is that accurate? In truth, it is difficult to say if Ryōi Asai should technically be called the "author" of "Botan dōrō." Because the tale is older still.

Not the most original writer, Ryōi Asai liked to work with source material, something he could take apart and rebuild, rather than creating from scratch. For his kaidan collection *Otogi bōko* (1666), he looked east. Like so many others before him, he went to China for inspiration. Ryōi took a collection of "naughty" Buddhist morality tales, the 1378 *Jian deng xin hua* (New tales under the trimmed lampwick) and adapted the more entertaining tales from the collection to make his own "good parts" edition—although, seeing as how little resemblance

20. In most cases the kosodate yūrei is the mother, but at least one case, the *Yūrei of Zenroku*, it is the deceased father who came back to care for his child.

his stories bear to the originals, it might be more properly put that he was "inspired" by them. *Otogi bōko* is a completely different book than *Jian deng xin hua*.

Written by Qu You at the beginning of the Ming dynasty (1368–1644), *Jian deng xin hua* was a collection of erotically tinged tales disguised as Buddhist moral lessons. Qu fancied himself a gifted writer and was disgusted that he was forced to write popular and pandering tales to make a living. He did not appreciate his own work. Writing in the Tang style, Qu's work showed his lack of effort and is somewhat poorly written—even though it was popular largely due to the erotic content. Sex sells, it appears, even in ancient China.

Qu's original version was titled *Mudandeng ji*. Like "Botan dōrō," this translates directly into English as "peony lantern."[21]

Mudandeng ji is a story told in two parts. It begins with the familiar tale of a man who has been seduced by a ghost and then dies. But there the similarities end. Qu introduces the character of a Taoist priest who summons the officials of the underworld and brings the ghosts of the woman and man to a moral trial. Each of the ghosts is flogged as punishment and then forced to write confessional statements of their sins. After they are finished, the two unlucky ghosts are promptly sentenced to one of the fierce Buddhist jigoku to serve out the reminder of their sentence.

Jian deng xin hua—and *Mudandeng ji*—had made the trip across the water before. Supposedly, the book was brought to Japan by a Buddhist monk who purchased a copy from a vendor while on a pilgrimage to the Huzin Temple in Ningbo, China. During the 1650s, an unknown author translated *Mudandeng ji* and two other stories from *Jian deng xin hua* for the kaidan-shū collection *Kii zotanshu*, or "Collection of miscellaneous strange tales." Unlike Ryōi Asai's later, more liberal interpretation, this author translated the stories directly. This was not an easy task. Many of the terms in the *Mudandeng ji* were specific to Chinese and could not be translated; the author provided copious cultural footnotes for readers who would not be aware of Chinese customs and terms.

Ryōi Asai had no interest in obscure Chinese customs or otherworldly judges and moral punishment. He wasn't looking to give a sermon. Ryōi moved the setting to Kyoto and jettisoned all of the didactic elements,

21. The eponymous peony lantern of both stories was a gaudy affair, a display of crepe-silk artificial flowers cascading over an old-style paper lantern. These types of lanterns are no longer made.

including the whole second half of the story. The removal of the religious and moral elements of the story is particularly interesting when you consider that Ryōi Asai himself was a Buddhist priest.

Ryōi Asai was a bit of a bohemian for his time. Although he was an educated aristocrat, he was also an active participant in the upstart literary movement called *kanazōshi*.

As mentioned in Chapter 2, in 1593 the printing press finally gave Japanese society cheap access to the written word—books that could be read for pleasure by the masses instead of delicate hand-painted scrolls that were pored over by dusty scholars in mist-covered mountain shrines.

Not only did the general public not have access to these expensive and treasured volumes coveted by the scholars and elite, they could not read one even if they had the chance. Much in the same way that Latin was the scholarly and religious language in medieval Europe, Chinese was the language of the educated classes.

With the printing press came a revolution—the creation of the kanazōshi. Written in simple Japanese, known as *kana*, these slim volumes amounted to Japan's first commercial literature. Although they were still relatively expensive and had small print runs of a few hundred copies, they were far more accessible than the precious, hand-copied volumes of scholarship written in Chinese.

Many kanazōshi were anonymous vulgarities, parodies and humorous stories written by amateurs—slice-of-life tales of townspeople, brothel and travel guides, and other urban follies. Publication eventually evolved into literary movements like *ukiyo zōshi*. *Ukiyo* is a catchall phrase heard often in relation to the Edo period, meaning "the floating world," and used to describe the decadent pleasures of idle people of the time. Another popular genre was called the "dog books," which took elegant and classical works of Japanese high society and rewrote them from the point of view of the lowly.

For example, Shōnagon Sei's study of the sensual and beautiful, called *Makura no Sōshi* (*The Pillow Book*), was rewritten as "The Dog's Pillow Book." Shōnagon's "List of Elegant Things" became a "List of Disagreeable Things." Whereas Shōnagon touted the qualities of dainties such as "duck's eggs" and "a pretty child eating strawberries," the anonymous author of "The Dog's Pillow Book" touted "a woman who falls asleep after making love" and "a long-staying guest on a night when one has other matters on one's mind." Included in "The Dog's Pillow Book" is a "List of Things that Stand One's Hair on End"—the first entry of which is "talking about yūrei."

While the authors of the kanazōshi were often amateurs, they were not all uneducated. Many of them wrote anonymously because of their status as Confucian scholars, Buddhist priests, doctors, samurais, and other intellectuals. The format of the kanazōshi allowed them release from the stiff and rigid society that they were part of and allowed them to indulge in vulgarity. In such a free-for-all environment, the cream usually rises to the top, and some kanazōshi authors began to gain fame for the quality of their work. Like Ryōi Asai.

Starting life as a member of the aristocratic samurai class, Ryōi Asai somehow lost his master and became a ronin. In the 1650s, he entered the Buddhist priesthood in Kyoto, where he wrote the majority of his kanazōshi that have survived to this day.

Ryōi was an unusual kanazōshi author, not only in that his writing was more literary and captivating in style, but also in that he was not ashamed to sign his name as the creator of his works. Ryōi's quality as well as his boldness increased his fame until he became one of the first people in Japan able to support himself by his writing alone.

By the time Ryōi wrote his most famous work, *Otogi bōko*, he was already a famous and accomplished author. His previous work, *Ukiyo monogatari* (*Tales of the Floating World*, 1666), had been a great success, telling the story of a rambling young roustabout who blusters his way through the pleasure quarters of Kyoto, escaping various intrigues of sex, gambling, and vice before becoming a samurai and entering the service of a *daimyō*, or samurai lord.

Ukiyo monogatari was a light-hearted jaunt—although decorated with Buddhist morals as demanded by official censors. *Otogi bōko*, on the other hand, was a much darker and psychological work. The title, usually translated in English as "Hand Puppets," supposedly refers to a type of small doll that was set next to the pillows of young children to ward off bad spirits and nightmares.[22] It seems to be a somewhat ironic title, as the stories of *Otogi bōko* are much more likely to cause bad dreams than to ward them off.

Otogi bōko collects sixty-eight different stories of supernatural tales, eighteen of which were adapted from *Jian deng xin hua*. Ryōi completely transformed the stories. Unlike the earlier translation in the *Kiizotanshu*, which carefully preserved the feeling of "otherness" brought on by the

22. The otogi bōko dolls also reference the haniwa figures used in funerary customs during the Kofun period (third to sixth century CE). Small clay figurines were placed in and around coffins and burial mounds, possibly as companions for the dead.

exotic Chinese landscape, Ryōi plopped the ghosts right into the back-yard of the readers, linking them to real settings and locations. Of these sixty-eight stories, only "Botan dōrō" survived beyond Ryōi's own meager lifespan. Other tales from *Otogi bōko*, like "The Yōkai Kitsune" and "The White Bones," have faded with the passing of time. But "Botan dōrō" would not survive unchanged. Just as Ryōi adapted the story from Qu You's original moralistic fable, the Meiji-period peony lantern would be passed to San'yūtei Enchō.

San'yūtei Enchō was a master of a theatrical storytelling style called *rakugo*, which is the Japanese equivalent to a one-man play. The rakugo storyteller sits on a cushion in front of his audience and, using nothing more than his voice, gestures, and a folding fan, leads the audience through an imaginative story. Enchō performed during the Meiji period, a time of enlightenment when contact with the Western nations had brought new scientific advancements. The intellectuals of Japan—and the government—were embarrassed by Japan's "backwards" beliefs in the supernatural and claimed that yūrei were nothing more than "nervous disorders" (*shinkei byo*).

In 1859, Enchō had created the previously mentioned story *Kasane ga fuchi*, later renamed *Shinkei Kasane ga fuchi* (The Ghost Story of Kasane Swamp). An ardent believer in yūrei and the supernatural, San'yūtei mocked the modernizers of the Meiji period with the name. The term *shinkei* had a double meaning of "true story" as well as "nerves." Enchō was saying that the yūrei of Japan were the "true story."

Enchō liked a sense of karmic balance. One of the parts of "Botan dōrō" that troubled him was its lack of closure. Ryōi's version made no mention of how Otsuyu died or why she fixated on her living paramour Ogiwara Shinojo. Atypical of Japanese yūrei tales, Otsuyu is neither a wrathful spirit nor a former lover. She never even knew Ogiwara when she was alive. The bond that barbs her spirit and prevents her from crossing over to anoyo is love, or more properly, a desire to love and be loved. Otsuyu longs for that which she did not experience in life; it is not until she fulfills her purpose and gains a lover that she is able to move on.

In 1884, Enchō debuted his version of "Botan dōrō," redubbing it *Kaidan botan dōrō*, a name by which the story is still known. Being a live performer, Enchō's version was flexible. It differed in almost every telling. Possibly his first adjustments were changing the setting from old-fashioned Kyoto to the Nezu district of the more metropolitan Edo. He also transformed the lonely, widowed samurai Ogiwara Shinojo into

a young and handsome gallant named Hagiwara Shinsaburō. Otsuyu remained Otsuyu, as she does in most adaptations.[23] But in Enchō's version, she is alive and captivated by the beautiful Shinsaburō, who comes calling to her house one day.

There are a variety of contrivances Enchō uses to get Shinsaburō and Otsuyu together and then to separate them. In one telling, Shinsaburō is a young student who accompanies a doctor friend to tend to the sick Otsuyu. Realizing the instant attraction between them and fearing for his own life should Shinsaburō's father discover that he is the cause of the matchmaking, the doctor contrives to keep the two lovers apart, until Otsuyu dies of loneliness. In another, Shinsaburō is a rich dilettante who loses a prized shuttlecock over a bamboo fence during a game of battledore with his friends. When Shinsaburō goes in search of the shuttlecock, he finds it in the hands of a beautiful young Otsuyu, with whom he falls instantly in love. Shinsaburō returns home for the night but is unable to find Otsuyu's house again until it is too late, and she is dead.

Whatever the set-up, certain points of the story remain the same— Shinsaburō and Otsuyu are reunited on the night of Obon; each claim that they thought the other was dead; and each offers prayers for their beloved's departed spirit. The remainder of the story unfolds in much the same way as Ryōi's *Otogi bōko* with the addition that when Shinsaburō is found dead intertwined with Otsuyu's rotting corpse, his face is radiant and blissful.

That happy death for Shinsaburō has as much to do with the age Enchō lived in as his own tastes. Ryōi Asai was writing for the Edo period; his audience craved gore and chills more than anything else. Enchō was writing for Western-influenced Meiji-period audiences. These were people who had seen such things as Shakespeare's *Romeo and Juliet* and demanded a more romantic tone. They especially were moved when the love was tinged with sorrow.

Enchō's rakugo of "Botan dōrō" holds a further distinction—it was the first spoken-Japanese performance transcribed for the written word. In 1882, Tsunaki Tagusari created a Japanese shorthand technique that was fast enough to copy down speech as quickly as it was spoken. After training others in his method, in 1884, Tsunaki and his student stenographers recorded a commissioned performance by Enchō. They were amazed to discover that they could now read the words exactly as they

23. With the notable exception of Ryōi Asai's version, in which she is named Iyoko.

had been performed. Copies of this were printed and published in serial form over a period of months, and it became the definitive version of the rakugo. Enchō's fluid performance had solidified at last. As with most popular kaidan of the Edo period, "Botan dōrō" eventually found its way to the fire pots and painted faces of the kabuki stage. In 1892, Kawatake Shinshichi III adapted Enchō's rakugo and debuted it at the Kabukiza Theater in Tokyo. Kawatake's kabuki was a mostly faithful adaptation of the rakugo, although he turned the pathos up another notch. In the kabuki version, Otsuyu and her maid Oyone commit suicide when the two lovers are separated.

Lafcadio Hearn saw the kabuki play *Kaidan botan dōrō* sometime in the mid-1890s. Hearn, with the help of a friend, translated the story into English for the first time for his book *In Ghostly Japan*. Hearn was most interested in the Buddhist aspects of the story and titled his version "A Passionate Karma." Shinsaburō and Otsuyu were depicted as lovers not only now, but across several lifetimes, bound by karma to be joined in spirit if they could not be bodily together.

"Botan dōrō" proved as popular with Western audiences at it was with Japanese. It has received countless English printings since Hearn's original. One of the more fanciful interpretations was done by Grace James in her 1923 book *Green Willow and Other Japanese Fairy Tales*. James was not interested in preserving the integrity of the story. Because she was writing fairy tales for children, she removed most of the sexual/horrific aspects of "Botan dōrō." She even went so far as to call Otsuyu by the romantic title of Lady of the Morning Dew—a literal translation of Otsuyu's name.

Otsuyu proved a popular subject for Edo-period ukiyo-e artists, although not to the same extent as Oiwa. Whereas Oiwa's strange appearance made her a natural for the visual medium of woodblock prints, Otsuyu's strength lay in her story.

As one of the *San O-Yūrei*, Otsuyu was included in many artists' ghost portfolios. Yoshitoshi Tsukioka (1839–1892) included Otsuyu in his *New Forms of Thirty-six Ghosts* series. This image shows the nature of the peony lantern, which was not a typical lantern with a peony painted on the side, but a special lantern used for the Obon festival with a paper-mache peony set on the top. Utagawa Toyokuni went straight to the point, showing Shinsaburō mid-coitus in an 1823 erotic *shunga* print. He was hardly the only artist to take this direct approach. And years later, film also found a reason to celebrate the sexual nature of "Botan dōrō."

The first version of *Kaidan botan dōrō* was filmed in 1910, and film-makers kept going from there. Makino Shōzō, known as "the father of Japanese film," made his own version in 1914. Born in Kyoto in 1878, Makino was raised in the theater lifestyle due to a mother who ran a local kabuki theater. Makino's connections with kabuki theater eventually led to his working in the fledgling film industry, including discovering and promoting Matsunosuke Onoe, Japan's first true movie star. Not surprisingly, Makino also filmed a version of *Tōkaidō Yotsuya kaidan* in 1912.

Numerous straight adaptations of *Botan dōrō* have followed over the decades, such as the 1955 version by Nobuchi Akira, *Kaidan botan dōrō*, or the 1968 Yamamoto Satsuo film of the same name. They are all slightly different; "Botan dōrō" is a flexible story. *Tōkaidō Yotsuya kaidan* arrived in full and complete form on the kabuki stage, but there is no definitive version of "Botan dōrō."

Is it Qu You's original sexually laced Buddhist cautionary tale? Or Ryōi Asai's night-time fairy tale? Many sources list San'yūtei Enchō as the author of "Bōtan dōrō," unaware of the previous versions. Because of this, filmmakers have been able to take much more liberty with adaptations of "Botan dōrō" than they have with *Tōkaidō Yotsuya kaidan*.

Television sets first entered the retail market in Japan in 1939. Their proliferation did not really affect the Japanese movie industry until the late 1960s and early 1970s. By that time, they had become so ubiquitous that far more houses had television sets than didn't, and the vast movie-going audience began staying home for its entertainment. A similar crisis in the US led to the development of widescreen projection, first seen in the 1953 film *The Robe*. Facing bankruptcy, movie studios in both Japan and the US needed to dramatically change their output, creating a product or experience that could not easily be found on the new medium of television.

Where the US went big, Japan went pink. Nikkatsu Studios coped with this crisis by the creation of the genre called *roman porno*, or romantic pornography.

Nudity has never had the same taboo status in Japan as it has in most Western countries. Adult movies, called "pink films" in Japan, had been developed years before, with the first true pink film being Kobayashi Satoru's 1962 movie *Nikutai no ichiba* (*Gates of Flesh*). The only challenge to the genre came in 1964, when maverick kabuki director Takechi Tetsuji switched to film and directed the big-budget *Hakujitsumu* (*Daydream*), which resulted in obscenity charges for

Takechi. The dismissal of these charges left the gate wide open.

What separated roman porno from your average pink film was the use of experienced directors and actors operating with full studio backing and budget. The films were considered legitimate productions that happened to have a prescribed number of sex scenes rather than low-budget sleaze flicks. It was only natural that "Botan dōrō" would be the first pink kaidan.

Director Sone Chūsei filmed a sexualized version of "Botan dōrō" in 1972 under the name of *Seidan botan dōrō* (translated alternately into English as *Hellish Love* or *Immortal Love*). Aside from increasing the level of nudity and sexuality as required by the roman porno genre, Sone merged the Ryōi version with the Enchō version. In *Seidan botan-dōrō*, Shinsaburō is neither a handsome student nor a wealthy dilettante but a poor ronin who assembles and repairs umbrellas for his meager living. One Obon night, Otsuyu comes wandering by, and the two fall desperately in love. Otsuyu's father disapproves of the match, due to Shinsaburō's poverty, and the rest of the story follows.

As times changed, so did the story of "Botan dōrō." Attempts were made to leave pink films behind and update the story to contemporary settings. A 1990 version under the unwieldy title of Tokyo Ghost Story: Kiri no Yoru, Kanojo wa Yattekuru (Tokyo Ghost Story: On a foggy night, she came to do it), also known by the shorter title of 1990 Botan Dōrō, was directed by Itsumichi Isomura. Taking the story out of ancient Japan, Itsumichi sets it in the contemporary rock scene of Tokyo, with Hagiwara Saburo as a band manager pursued by the ghostly Otsuyu.

A few years later, in 1998, Tsushima Masaru updated the story even further with his film *Otsuyu: Kaidan botan dōrō*. Taking Lafcadio Hearn's version of karma-fated lovers who had been destined for each other across several lifetimes, Tsushima portrays Shinsaburō as a man bound by a past betrayal. When Shinsaburō falls asleep in a shrine, he has a dream that he promised to commit double suicide with a girl but instead left her to die alone. Seeing the same girl on the side of the road one day, he falls deeply in love, but circumstances prevent their marriage. You know the rest.

Tōkaidō Yotsuya kaidan persists in large part due to the horrific nature of Oiwa. Her poison-ravaged face is what has set her apart from so many other onryō who suffered equally horrible deaths and revenged themselves in equally spectacular ways. Otsuyu, however, taps into a far more primal aspect of human nature.

In his 1920 book *Beyond the Pleasure Principle*, pioneering Austrian psychoanalyst Sigmund Freud identified what he saw as the two main drives for human beings, drives which he called by the Greek names of Eros and Thanatos. Sex and Death.

Freud probably never read "Botan dōrō," but he would have seen in the story confirmation of his theories. Sex and death are at the very core of the story, and no matter what form it takes, no matter which version of the tale is being told, the primal elements of sex and death are always there in tension. Shinsaburō does not simply love Otsuyu with some sort of chaste affection; he takes her to his bed. The snooping neighbor that uncovers the two lovers does not catch them at greeting or farewell, but fully *in flagrante delicto*. The juxtaposition of Shinsaburō's healthy human body having intercourse with Otsuyu's decomposing corpse is always the climax of the tale.

Other ghosts have followed in Otsuyu's footsteps over the years. Akinari Ueda included a sexual ghost in his 1776 masterpiece collection *Ugetsu monogatari*. One of the tales, "Asaji ga yado" ("The Reed-Choked House"), tells the story of a husband who abandons his wife then returns home years later full of regret for his misdeeds. To his surprise, the man finds his wife still alive in their old house, but after a night of making love, he awakes to find himself embracing only her bones.

Lafcadio Hearn collected a similar story, which he titled "The Reconciliation." Hearn's version, perhaps based on Akinari's original story, was published in his 1900 collection *Shadowings*. "The Reconciliation" was later adapted by filmmaker Kobayashi Masaki for his 1964 film *Kwaidan*, which was based on the stories of Lafcadio Hearn's writings. Kobayashi re-titled the story *The Black Hair* for his film.

Authors as recent as novelist Murakami Haruki have included a sexual ghost in their stories. The 2005 book *Kafka on the Shore* features a scene in which protagonist Tamura Kafka has sex with a yūrei, though he remains uncertain if it was real or a dream.

Unlike Oiwa and Oyuki, it is rarely claimed that Otsuyu was a true story. One can go to Japan and visit both the shrine and grave of Oiwa and the well where Okiku died (several of them, actually, depending on whose story you believe; more on that soon) but the same cannot be done for Otsuyu.

Lafcadio Hearn did not know this, however, and asked to be taken to see the side-by-side graves of Otsuyu and Shinsaburō as described in the story. The same friend who helped him translate the story took him to a local cemetery in the Nezu district and showed him some graves. Hearn

marveled at seeing the conclusion to the famous tale right in front of him, until he reasoned from the names and dates on the graves that they could not possibly be connected. After chiding his friend for misleading him, Hearn's friend said that he had only done it because Hearn was so insistent on seeing the graves. "After all," Hearn's friend chided him back, "You did not suppose the story to be true, did you?"

Ghosts of love, ghosts of hate. The yūrei of Oiwa and Otsuyu have haunted the Japanese psyche for centuries and show no sign of fading. Whereas most yūrei are satisfied once their purpose is fulfilled, these two alone have continued unsatisfied. Well, not exactly alone. There is one more: the Ghost of Okiku.

Chapter 9
THE GHOST OF OKIKU
お菊の幽霊

Wan, frail, the beautiful anguished, evil face of a girl could be seen through the long tangled hair framing it. Slender to the emaciation of great suffering, she knelt before the pile of plates she was counting. "One. Two. Three. Four. Five. Six. Seven. Eight. Nine…"
The wild, chilling scream froze men and women.
–excerpted from *Tales of the Tokugawa, Volume 2,* 1916,
by James S. De Benneville

For want of a single plate, Okiku was lost forever. For want of a single plate, a beautiful—and perhaps innocent—young girl ended her life soaking in the deep water at the bottom of a well. Broken and drowning, she breathed out her final breath. But Okiku was not pining for revenge. She had a more pressing issue occupying her mind. Where? Where could it be?

Okiku is the ghost in the well, the third in the triumvirate known as the *San O-Yūrei*—Three Great Yūrei of Japan. Her haunting image can be seen in a thousand Japanese comics, haunted houses, stage plays, movies, and any other artistic media. If you have seen Yamamura Sadako rise from her well in the film *Ringu,* then you have seen the legacy of Okiku. And yet of the three great ghosts, Okiku's motivations remain the most obtuse.

Otsuyu's desire to be loved and Oiwa's lust for revenge are universal—easily understood, transcending time and place. But Okiku only wants to find that missing tenth plate.

The plates, it must be said, were exceptionally rare and fine. Some say that the ten heirloom plates came from China, an exquisite example of artistry from a country famed for its ceramics. Some say they were delicate porcelain from Korea. Some even say that the plates came from faraway Holland, bartered for at the artificial island of Dejima in the port of Nagasaki on the southern island of Kyushu, the only port open

to foreign trade in all of Japan. In other versions of the tale, the plates were a gift from Tokugawa Ieyasu to the samurai Aoyama Sūzen in recognition of his loyal service to the first of the new shōgun.

No matter their origin, the rarity of the plates raised their value far beyond their weight in gold. Gold, after all, if spent or lost, could be mined and replenished. But the exquisite beauty of these ten plates could never be replaced. By comparison, Okiku, a poor servant girl, was less than worthless. She lacked even the value of the mud from which the magnificent plates were originally formed.

Mud is exactly from where Okiku seems to have sprung, or at least directly from the soil of the many islands of Japan. Otsuyu and Oiwa may be more terrifying, but there is no yūrei more quintessentially Japanese than Okiku. After all, "Botan dōrō" is adapted from a Chinese story, and Oiwa was created for kabuki theater by a single author. Only Okiku is a true folktale.

In his book *Nihon no sarayashiki densetsu* (Japan's legend of the Plate Mansion; 2002), scholar Ito Asushi identifies at least forty-eight variations of the Okiku legend spread across Japan. From as far away as Kanra in Gunma, to Lafcadio Hearn's hometown of Matsue in Shimane, to Hata in Kochi on the small island of Shikoku, and all the way down to the Gotō archipelago off the coast of Nagasaki, any village with a medieval castle and an old well seems to have its own Okiku legend. They are known collectively by the name *sarayashiki*, meaning plate mansion.

Each sarayashiki tale is slightly different from the others. One version, claimed to be set in Ushigome Gomon Banchō in Tokyo, close to the Yotsuya valley that gave rise to Oiwa in *Tōkaidō Yotsuya kaidan*, has Okiku entering the service of a samurai named Aoyama Shuzen. When one of the treasured heirloom plates of the Aoyama house is found broken, someone must be blamed, and Okiku, knowing that she is the most likely suspect, throws herself down a well.

In a further variation of this same story, Aoyama severed one of Okiku's fingers in an attempt to get a confession, only to have his next child born missing the same finger. In yet another, it is Aoyama's wife who broke the precious plate and blamed Okiku to hide her own guilt. A common motif found in many village legends is to have the samurai, most often named Aoyama, attempt to seduce Okiku. Upon Okiku's refusal, Aoyama hides the plate and then threatens to have Okiku blamed if she does not come to his bed. Okiku again refuses and again finds herself dead at the bottom of a well. In some versions on this general theme, Okiku commits suicide to escape Aoyama by jumping into the

well. In others, she is first beaten and murdered, and then her corpse is flung down.

Not all variations involve the plates. The Amagasaki version, also in Hyogo Prefecture, finds Okiku in the service of one Aoyama Harima. Unique in having no connection with the valuable dinnerware, the Aoyama in this version has Okiku tossed living into the well for the unforgivable crime of accidentally allowing a needle to fall into her master's evening meal.

But aside from these outliers, most versions follow similar patterns: the girl is usually named Okiku (a name that means "Chrysanthemum" in Japanese), and Okiku almost always winds up at the bottom of a well. Also common to most versions is that at the hour of the ox, between one and three in the morning by the old system of telling time, Okiku's yūrei rises from the depths of her well to count the remaining plates, always hoping to reach the number ten.

More often than not, the man responsible for Okiku's fate is a samurai named Aoyama. How the Aoyama clan got saddled with this misdeed is mystifying. The clan originated in Kōzuke Province, modern day Gunma Prefecture near Tokyo, and would not have been a common name at the time of the legend. The only known daimyō to arise from the Aoyama clan was Aoyama Tadanari. Made lord of Musashi Province in 1600, his reign would not last. His son Aoyama Tadashi lost the title due to disfavor with the shōgun. The Aoyama clan gives its name to Aoyama, Tokyo—a place that has no native Okiku legend.

But storytellers rarely let pesky facts get in the way of a good legend. Even lacking an Aoyama clan presence, cities and villages all across Japan are only too happy to lay claim to the Okiku legend.

Many of the older Okiku legends from Tokyo were set in the Ushigome neighborhood. In an anecdote recorded in *Tosei chie kagami* (Examples of modern wisdom; 1712), author Madoka Shishido tells about a murder of a man's mistress by his jealous wife. According to the tale, the mistress accidentally broke one of the house's heirloom plates. The story ends with the mistress' death and her onryō taking revenge. According to local legend, the ghostly occurrences continued until 1732 when the Saramyojin (Plate Shrine) was established to pacify the angry spirit, where it stands to this day.

In 1758, professional storyteller Baba Bunko saw an opportunity to expound upon the Okiku story and link it to Lady Sen, the oldest daughter of Tokugawa Ieyasu and the wife of Toyotomi Hideyori. Lady Sen had led an adventurous life and was a popular figure in Japanese

history and literature. When Bunko wrote his *Sarayashiki bengiroku* ("A Doubtful Record of the Plate Mansion"), he relocated the story to the burnt-out shell of a mansion once occupied by Lady Sen in the Banchō district.

Bunko's story became the template for all other Tokyo-based versions to follow, where the Okiku legend is known by the name *Banchō sarayashiki*. This translates simply as "The Plate Mansion of Banchō." The word *banchō* is made up of two kanji: *ban*, meaning "number," and *chō*, meaning "block" or "street," and refers to the district outlying the shōgun's castle in Edo, where the daimyō kept their urban residences.

There are many other supposed locations of the sarayashiki, many showing physical relics of the tale. In Myōgi City, Gunma Prefecture, you can visit the supposed grave of Okiku, as well as an Okiku shrine. At the Kyōkyū Temple in Hakone, Shiga Prefecture, you can see the plates themselves. The temple claims the plates were a gift from Okiku's mother, who attempted to mend the broken plate to appease the spirit of her unfortunate daughter. Sōyouji Temple in faraway Wakayama City also claims an Okiku shrine. And of course, various "Wells of Okiku" can be found all across Japan. One of the most unlikely locations that claims to be the true well of Okiku is found on the grounds of the Canadian embassy in Tokyo, on land formerly owned by the Aoyama family.

But ask your average Japanese citizen where the well of Okiku lies, and you will get only one answer. Each year hundreds of thousands of visitors photograph themselves next to "Okiku's Well" in the courtyard of the famous and photographic Himeji Castle in Himeji City, Hyogo Prefecture. A nearby sign relates the story, and you can't help but lean over the dark and sinister hole, straining your eyes to catch a glimpse of the ghost as she whiles her time until nightfall, when she can emerge to count the plates.

Dominating the landscape on a high hill overlooking Himeji City, Himeji Castle makes a striking setting for the legend. The first Japanese National Cultural Treasure to be registered as a UNESCO World Heritage Site, Himeji Castle is one of the most recognizable and visited landmarks of Japan.

Himeji Castle was a trophy of war given to Terumasa Ikeda by Shōgun Tokugawa Ieyasu following the decisive 1580 Battle of Sekigahara.

Terumasa leveled the existing castle, then called Himeyama Castle, and in 1600 began the nine-year project of creating what would be one of the most beautiful and enduring examples of the Japanese art of castle-building. Said to resemble a white heron in flight, the castle was

a full military structure, although it never had to prove itself in battle and even managed to escape the Allied bombings of World War II that destroyed so much other classical Japanese architecture.

Here is where those pesky facts get in the way again: The problem with making Himeji Castle Okiku's haunting grounds is that the legend is far older than the castle itself.

According to the Okiku shrine, located inside the larger Juninshojin shrine in Himeji City, the story dates back to the Eisho period (1504–1520), almost a hundred years before the construction of the modern Himeji Castle even began. It is possible that the story originated at the older Himeyama Castle. However, nothing but the East Gate of one section of the second bailey remains from that original structure. The famed Okiku's Well within the castle is almost certainly of a later origin.

Blame the theater for choosing Himeji Castle as the backdrop for Okiku's story. Like all famous Edo-period kaidan, Okiku eventually moved from oral folklore to the stage, debuting in 1720 in a kabuki performance in Osaka. This production failed to make any lasting impact, however, and is only known as a name recorded on a playbill. The legend of the sarayashiki in Himeji Castle didn't really take off until July 1741, in an adaptation by playwrights Asada Icchō and Tamenaga Tarobei I. Asada and Tamenaga set their production in Himeji Castle and highlighted the regional differences by titling it *Banshū sarayashiki*, a name that references the private bodyguard of the lord of the castle and their residences—the name under which it is still performed in the Himeji and Kansai regions.

And there was another difference besides the name: This kaidan was not written for the gaudy and painted kabuki stage. Instead, Okiku rose in the more austere world of carved wooden puppets and black-clothed handlers called *bunraku*.

Bunraku, also known as *ningyō jōruri*, is a combination of two arts into a single stage performance. The first art, called *jōruri*, is a style of chanted narrative accompanied by shamisen. Jōruri has its roots in both the style and the name of biwa performances from the Muromachi period (1392–1573), a period of strife and civil war that also gave birth to such wonders as the Golden and Silver Pavilions of Kyoto. The biwa, a style of lute, was often used to accompany ancient tales sung by a skilled chanter, one of the most popular of which was the legend of Princess Jōruri. This performance was so popular that all tales in the same chanted narrative style came to be known simply as jōruri. The second art in bunraku is the manipulation of *ningyō*, which means

"puppet" in Japanese. Unlike Western puppet theater, which attempts to maintain an illusion of the puppets as living things, in bunraku the puppeteer is fully visible, with only assistants being clothed all in black so as not to distract from the appearance of the puppet and its manipulator.

As with San'yūtei Enchō's theatrical adaptation of *Botan dorō*, the stage version of *Banshū sarayashiki* needed to be longer than the original folktale. Asada and Tamenaga added details and intrigues along with a new cast of supporting characters.

The ningyō jōruri of *Banshū sarayashiki* is a far more complicated affair than the simple folktale. In this version, the samurai, called Asayama Tetsuzan, has a rival named Hosokawa Tomonosuke. Both are vying to succeed the dying Hosokawa Katsumoto as lord of Himeji Castle. Hosokawa plans to send the ten heirloom plates to the Tokugawa Shōgun in order to buy his favor, something which Asayama cannot permit. Asayama attempts to recruit Okiku, a servant of the castle and wife to loyal retainer Funase Sampei, as a spy and helper in his intrigue. But Okiku wants nothing to do with Tomonosuke's murder or with Asayama's other more lascivious requests. Enraged by Okiku's refusal and vowing his vengeance upon her, Asayama frames Okiku for the destruction of one of the plates and has her tortured, beaten with a wooden sword, and lowered into a well until she finally dies. Okiku then rises from her well, setting in motion the wheels of her redemption and revenge.

Banshū sarayashiki lasted exclusively as a bunraku puppet-play for almost a century. In 1850, it was adapted once again to the kabuki theater as a one-act play by Segawa Joko III. Under the unusual title of *Minoriyoshi kogane no kikuzuki* (Minoriyoshi's gold in the ninth month), the adaptation debuted at the same Nakamura-za theater that had seen the first appearance of Oiwa in 1825. Even though the play featured kabuki stars Ichikawa Danjuro VIII and Ichikawa Kodanji IV in the roles of Tetsuzan and Okiku, it was not popular and quickly folded. It was not until several years later that Okiku would finally make an impact in the realm of kabuki, under the guiding hand of Okamoto Kidō.

The world into which author Okamoto Kidō was born was one that teetered on the brink between the past and the future. Commodore Matthew Perry had forcibly ended Japan's isolationist policies in 1853, leaving the country open not only to the import of new technologies and products, but also to ideas and ways of living that would have been unthinkable only a few years prior.

These new ideas and technology caused changes far beyond the

monetary results anticipated by Perry. The populace of Japan swung back and forth between being wildly pro-Western and being vehemently opposed to anything new. Groups came into and left power, like the three-hundred-member-strong blue-coated *Shinsengumi* that did battle on the streets of Kyoto, defending the Western-friendly military government against supporters of the emperor who used "*sonnō jōi*" ("revere the emperor, expel the barbarians") as their battle-cry.

Eventually, the Imperialist faction won, resulting in the overthrow of the Tokugawa shōgunate on November 9, 1867. On January 3, 1868, the official restoration of Imperial power was completed as then fifteen-year-old Mutsuhito, who would eventually become known to the world as Emperor Meiji, ascended the throne.

Despite the anti-foreigner slogans shouted during battle, Emperor Meiji's government was even more in favor of importing Western ideas and technology than the previous Tokugawa shōgunate. Foreign embassies opened. Art and industry were exchanged. Anything Western was fresh and interesting, captivating the populace.

This cultural exchange was a two-way street. In 1871, Okiku first appeared in English as one of a collection of tales for the book *Tales of Old Japan*. A book with an interesting pedigree, *Tales of Old Japan* was written by A. B. Mitford, who, from 1866 to 1870, was an attaché with the British Legion at Edo (modern-day Tokyo) and one of the first foreign diplomats to Japan. He served as translator for the young Meiji emperor and became intimately familiar with the country and its language.

Upon his return to Britain, Mitford became discouraged and disappointed by Western media reports of the Japanese people, portraying them as an uncouth people lacking in morals or character, with vicious men and wanton women. Mitford set out to correct that error by writing *Tales of Old Japan*, showing the moral heart of the country through Japanese legends and fairy tales, showing what they admired, what they aspired to, and what they feared. He included the story of "Okiku and the Nine Plates."

Okamoto was born a year after Mitford's book was published in 1872. This was four years into the Meiji period, during a time of Japan's most enthusiastic Westernization. In 1891 he got his first job as a reporter for *Tokyo Nichi Nichi Shimbun* (Tokyo daily newspaper). Like Lafcadio Hearn before him, who also began his career as a reporter, Okamoto looked for ways to supplement his income by writing. In 1908, he began writing plays for young kabuki actor Ichikawa Sadanji II. This collaboration would see Okamoto write over two hundred kabuki plays during

his lifetime. In the 1910s and 20s, Okamoto even branched out and wrote a popular series of Sherlock Holmes-influenced detective stories that collectively became referred to as *Hashinichi torimono-cho* (*The Curious Casebook of Inspector Hashinichi*).

An influx of Western dramas during this time captivated the public, making the overly theatrical kabuki performances seem old-fashioned and no longer relevant. In an attempt to revive the public's interest and save their art form, kabuki actors like Okamoto and Ichikawa Sadanji II, who had studied theater in London and Paris, created what they called (*new* kabuki). In 1916, Okamoto scripted the kaidanmono *Banchō sarayashiki* for the shin kabuki stage.

One of the main differences between shin kabuki and kabuki is the motivation of the characters. Kabuki overflows with loyalty and revenge. Shin kabuki, however, tried to be more in tune with the newfangled Western ideals of love and romance as prime motivators. Okamoto's shin kabuki version of *Banchō sarayashiki* is considerably different from the previous bunraku puppet-play adaptation.

Aoyama Harima, a *hattamoto*—meaning samurai in direct service to the shōgun—is desperately in love with a beautiful young servant girl named Okiku. In spite of their differences in rank, Aoyama has promised to marry her.

One day an aunt brings Aoyama the prospect of an auspicious marriage that would advance his wealth and prospects. Aoyama swears to Okiku that he will refuse and keep his vow to her, but Okiku doubts him and purposefully breaks one of the ten precious plates that are heirlooms of the Aoyama household. The traditional punishment for breaking one of these plates is death, as Okiku well knows, but she planned it as a love-test to see if Aoyama would actually have her executed.

At first Aoyama pardons Okiku, thinking it was an accident. But when he learns that she broke the plate on purpose to test his love for her, Aoyama is enraged and kills Okiku himself, throwing her body down a well. As demanded by tradition, Okiku rises from the well as a yūrei and nightly counts the plates. At first frightened, Aoyama confronts Okiku's yūrei one night in the garden. Instead of the vengeful rage he expects, he sees only Okiku's calm and loving face. Taking strength from this, Aoyama commits suicide in order to be reunited with his love.

Okamoto's romantic image of Okiku dominated all future versions of her story and continues to do so in modern interpretations. Okiku is rarely played for horror or fear. More often she is sad and beautiful in her haunting. Okiku is a creature of pathos and pity.

As with Oiwa and Otsuyu, Okiku was a popular subject for Edo-period ukiyo-e artists. In 1830, Hokusai Katsushika, perhaps the most famous Japanese artist for his iconic image *The Great Wave off Kanagawa*, included an image of Okiku in his kaidan collection *Hyakumonogatari*. Hokusai's image is somewhat non-traditional, showing only Okiku's enlarged head accompanied by a trail of black smoke in the shape of nine plates as she emerges from a wooden well.

By far the most famous image of Okiku—and one of the most romantic—was supplied by Yoshitoshi Tsukioka for his series *Shinkei sanjurokkaisen* (New forms of thirty-six ghosts). Yoshitoshi's Okiku is colored in pale pink and appears to be crying into her sleeves as she rises from a stone well amongst the rushes and willow trees. First published in 1890, Yoshitoshi's interpretation pre-dates Okamoto Kidō's romance-tinged production by twenty-six years and could possibly have been an influence on Okamoto's unique take on the legend.

Okiku has not had nearly the film presence as Oiwa and Otsuyu. With only about six film adaptations, the last one in 1957, there must be some aspect of her story that is less compelling cinematically. Possibly it is because Okiku lacks both the horrific appearance of Oiwa and the sexual appeal of Otsuyu.

Like many Japanese stories of this era, *Banchō sarayashiki* first appeared on film in 1914 as a silent film kabuki adaptation, directed by Makino Shōzō. Other kabuki adaptations followed in 1918 and 1923, including one under the Himeji title of *Banshū sarayashiki*.

The first proper film adaptation was done in 1954 by famed director Itō Daisuke, who also made the kaidan films *Ikiryō* in 1927 and *Shinpan Yotsuya kaidan* in 1928. Itō titled his film *Banchō sarayashiki: Okiku to Harima* and based it on the Okamoto Kidō version of the story.

Three years later, in 1957, the most recent version of Okiku's story was filmed by Kono Juichi and called *Kaidan Banchō sarayashiki*. Kono's version also takes Okamoto's shin kabuki production as its base, adding only the twist that Okiku's lover, Aoyama Harima, is under the eye of the military government of the shogun and is seen as an ally of an insolent samurai who had been ordered to commit seppuku. In order to protect himself and his clan, Aoyama must accept an offer of marriage from a powerful family that could protect him. His duty to his family outweighs his love for Okiku. The remainder of the story follows Okamoto's version, including Aoyama's suicide at the end.

The persistence of Okiku is difficult to explain. Japan is a country with thousands of yūrei tales, many with far more interesting motivations and

resolutions than the sarayashiki. Yet there is something about Okiku that has captivated Japan for longer than any other yūrei. The answer, perhaps, lies in that old real estate mantra: location, location, location.

It makes a story all the more real when you can visit the well that Okiku died in or see her plates in a local shrine. Being able to stand next to the actual well, in front of a sign that loudly proclaims what you are looking at to be "Okiku's Well" and pose for memorial photographs makes for an unforgettable experience. But proper due must also be given to Himeji Castle.

It is the most visited castle in Japan. A multitude of people—Japanese nationals and foreign tourists alike—navigate its stone-stepped paths and climb its steep wooden staircases each year. Visitors file past the well, enclosed by a stone gate and complete with a sign and an overview of the legend of the sarayashiki. Anyone who didn't know the story of Okiku before visiting the castle will certainly be familiar with it when they leave.

And location means something more to Okiku. One thing you notice about Otsuyu and Oiwa is that they are able to travel. Oiwa in particular is relentless in her pursuit of Iemon, going wherever he can be found. But Okiku cannot leave her well. She is tied to her location in a way that the other yūrei are not. Because she is an entirely different flavor of specter than Otsuyu and Oiwa.

Okiku is a *jibakurei*, an earth-bound spirit.

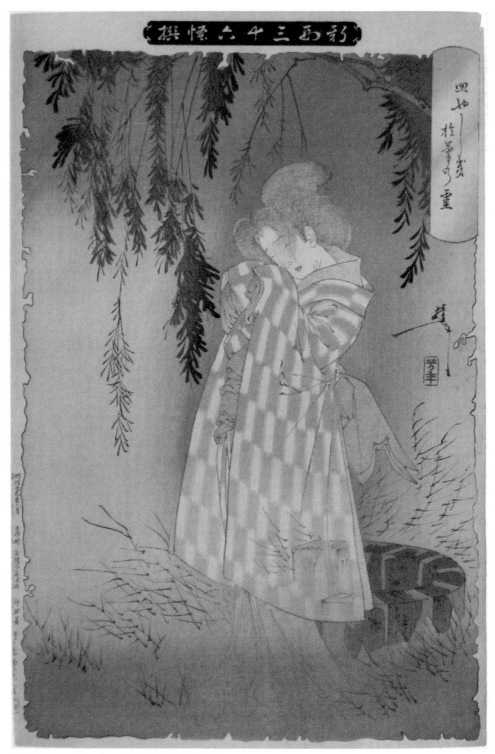

The Ghost of Okiku at Sarayashiki, Tsukioka Yoshitoshi

The most romantic vision of Okiku, who weeps as she emerges from the well, in despair over her final fate.

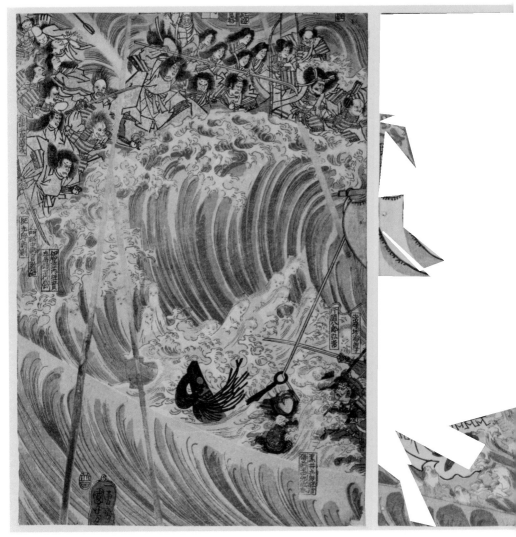

The Taira Ghosts attacking Yoshitsune's Ship, Kuniyoshi Utagawa
In this classic Heian period yūrei scene, the yūrei of the defeated Taira clan attack Yoshitsune's fleeing ship.

Kamiya Niyemon Terrified by Fire, Kuniyoshi Utagawa

A scene from *Tōkaidō Yotsuya Kaidan*, based on a poem of the play by Onakatomi no Yoshinobu Ason. Oiwa emerges from the lantern as a vision of smoke, fire and fury.

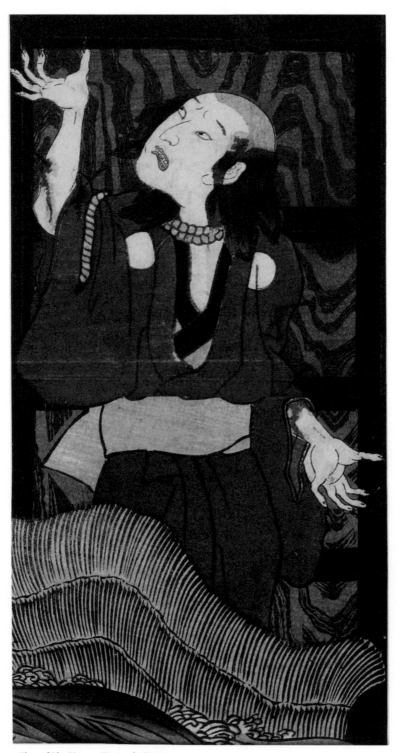

Ghost of Play, Yotsuya, Kuniyoshi Utagawa

Another scene of the Tōkaidō Yotsuya Kaidan, showing the faithful servant Kohai nailed to a board opposite his mistress Oiwa.

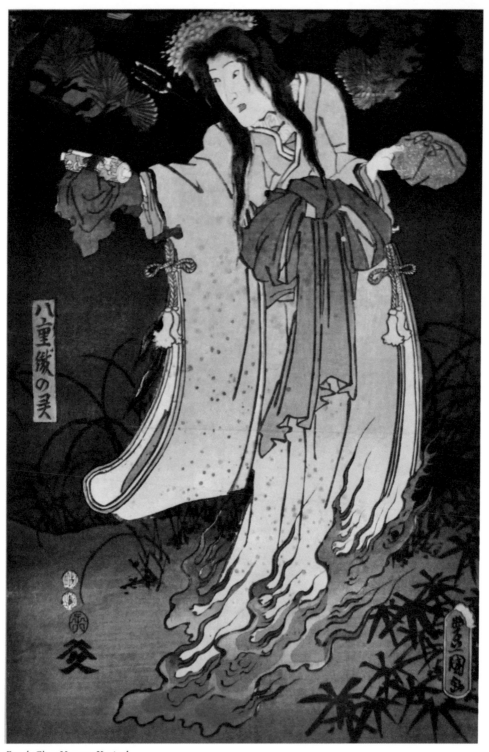

Female Ghost, Utagawa Kunisada

A kabuki portrait of Onoe Baikō as a yūrei in the play *Otogi banashi Hakata no imaori*.
This is the center image of a tryptich.

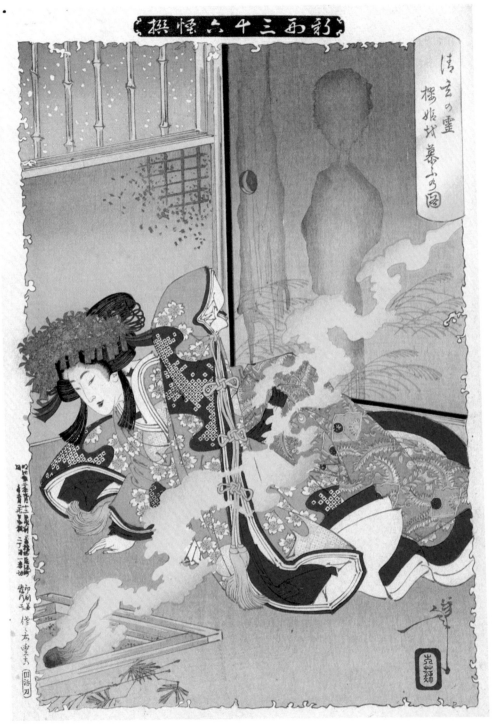

The Ghost of Seigen Haunting Sakurahime, Tsukioka Yoshitoshi

A gentle scene from a brutal play. The monk Seigen haunts Sakura in Nanboku IV's *Sakura hime Azuma no Bunshō*.

Chapter 10

THE EARTH-BOUND SPIRIT
地縛霊

The belief in ghosts appears to be as universal as that in the immortality of the soul, upon which it depends. Both in China and Japan the departed spirit is invested with the power of revisiting the earth, and, in a visible form, tormenting its enemies and haunting those places where the perishable part of it mourned and suffered. Haunted houses are slow to find tenants, for ghosts always come with revengeful intent; indeed, the owners of such houses will almost pay men to live in them, such is the dread which they inspire, and the anxiety to blot out the stigma.
 –excerpted from *Tales of Old Japan*, by A.B. Mitford, 1871

Most yūrei are guided missiles. They are purpose-driven entities driving towards a specific goal. They are mutable and can overcome obstacles. They travel. They adapt.

Oiwa's vendetta is not assuaged by distance. No matter where her betraying husband Iemon flees—even as far away as the holy Snake Mountain Hermitage—Oiwa is there. And she takes her revenge slowly. She assaults him psychologically as well as physically. Oiwa takes away everything he loves.

The *airyō* Otsuyu, the ghost of love, also wanders freely from the graveyard to her lover's house, carrying her peony lantern. She is able to talk and reason her way around the ofuda talismans that block her entry to her beloved. She begs and pleads until he relents.

By contrast, Okiku is like a piece of film that has been looped to endlessly repeat itself. She rises each night and counts the plates with little variation. She cannot alter her pattern. She is bound to her well. In fact, Okiku's particular brand of yūrei should be immediately familiar to most Westerners but is comparatively rarer in Japan.

Okiku is a haunting.

"Haunting" is not a word that occurs easily in the Japanese language.

The most common way to describe the appearance of a yūrei is to say *"yūrei ga deteru,"* meaning a yūrei has come forth or appeared. This phrase can be used in almost any circumstance. There is another word, however, which more appropriately captures the feeling of what Westerners call a haunting, and that word is *tatari*.

Tatari is a terrifying word in Japanese. It's a corruption of an ancient word, *tachiari*, which translated as something like "manifestation of a deity"—with the understanding that when a deity appeared in front of you, it probably wasn't going to be good. In ancient Japan, all calamities and illnesses were blamed on spirits and onryō. During the time of Goryō Shinko, tatari was battled with ritual and prayer. In modern Japan, tatari has come to mean something along the lines of "cursed," but it can equally be translated as "haunting." In fact, both the 1963 and 1999 film versions of Shirley Jackson's famous haunted house story, *The Haunting at Hill House*, were released in Japan under the name of *Tatari*.

Instances of tatari incite more fear than your average yūrei. Whereas onryō have almost unlimited powers and drive to enact vengeance on those who did them wrong, they generally seek only their target—or those connected by circumstances. A tatari, on the other hand, is not so selective. Anyone unfortunate enough to walk onto the haunted area becomes irrevocably wrapped inside the curse.

Modern Japan has its share of cursed and haunted buildings. It is hard to walk by the Sunshine 60 building in Tokyo—built over the ruins of the World War II Sugamo Prison—without suppressing a shudder. There are many other buildings scattered throughout all of Japan with dark reputations and rumors of tatari.

Possibly the most recent and popular film adaptation of tatari-style yūrei is in the movie *Ju-on* (2003), directed by Shimizu Takashi. This film features several yūrei, all trapped inside the house where they died. Anyone entering this house falls under the curse and, after death, joins the collection of tatari-bound yūrei.

The reach of tatari can be long, generational even. There is a story of a tatari on the Asai clan that lasted six generations. A wife, jealous of her husband's concubine, told her husband that his concubine had taken another lover. In a fit of rage, the husband smashed out the concubine's eye with a candlestick. With her dying breath, she pronounced her curse upon the house of Asai. Shortly after, the husband lost his eye in an accident and died. From then on, it was said that sons of the Asai clan would lose their eyes and die before forty, the age of the husband when he cruelly murdered his concubine.

Tatari can extend to objects as well as locations. Lafcadio Hearn captured this in the story "Furisode" in his book *In Ghostly Japan*. In the tale, a girl falls in love with a beautiful young man she chances to meet on the street one day, while he is wearing a striking kimono. The girl commissions a duplicate kimono to be made for herself, in which she walks the streets looking for her love. The girl never finds him and wastes away and dies in the expensive furisode (long-sleeved) kimono. As was the custom at the time, the kimono was given to a local temple, which sold it at an auction. The kimono's buyer soon wasted away and died as well, complaining of a haunting spirit that hung about her. Again, the kimono was sold, and again the buyer died. Finally, a decision was made to burn the cursed kimono. However, sparks from the fire leapt to the temple walls and the entire district was consumed by flames.

A similar tatari was repeated in the story *Ring*, first in the 1991 novel by Suzuki Koji and then in the 1998 film adaptation. In this case, however, instead of a beautiful furisode kimono, the onryō Yamamura Sadako's grudge is transferred by a videotape, which kills all who watch it. Her curse is irrevocably bound to the physical objects of the tapes.

A cursed house. A cursed kimono. A cursed tape—all are tatari.

Of course, not all haunted places and objects are so grim. Like all yūrei, the primary driving emotion determines what flavor of spirit you are going to get.

There is another word of much more modern origin for yūrei who haunt a location—*jibakurei*, the earth-bound spirit. Unlike the ancient tatari, jibakurei has a more unlikely pedigree. The word comes from the 1970s comic book *Ushiro no hyakutaro* (Behind the hundred Taros) by Tsunoda Jiro. Tsunoda used the word jibakurei to describe yūrei who are bound to something or somewhere instead of someone. Usually these were unnatural deaths, such as suicide or murder. Tsunoda believed these deaths somehow linked the yūrei to their location. He said they projected a psychic resonance that caused others to die in the same manner, which is how suicide spots accumulate across Japan.

Opposed to the jibakurei, Tsunoda identified the *fuyūrei*, the wandering spirits. These were people who had died suddenly and unexpectedly, such as in a car crash or in modern war. Unlike in the older days, when skill and honor among swordsmen ruled a battlefield, modern soldiers had their lives ripped from them in the blink of an eye. They may not even be aware that they are dead.

The words jibakurei and fuyūrei may be relatively modern inventions, but the concepts are not. After all, Tsunoda was merely giving a name to

something he saw often in folklore. Okiku is a prime example of a jiba-kurei—she is confined to her path from the well to the plates. There are other examples: The most famous is "The Story of the Futon of Tottori," recorded by Hearn in his first Japan book *Glimpses of Unfamiliar Japan*. In the tale, two brothers are victims of a cruel landlord. They freeze to death trying to warm themselves with a futon that eventually becomes their haunting ground.

An ubume legend out of Kakegawa City in Shizuoka Prefecture could also be considered an example of a jibakurei, although in this case, the spirit is bound even more tightly than normal. The Yonaki Ishi (Night-weeping Stone) is a rock said to be possessed of the spirit of a dying mother who cried for her baby. This stone, which was popular enough to be the subject of an ukiyo-e print by Hiroshige Utagawa as well as a silent film, *Sayo no Nakayama yonaki ishi* (The night-weeping stone of Sayo no Nakayama; 1915) directed by Kobayashi Yaroku, can still be seen on display. Although, like Okiku's well, at least two locations claim to have the authentic stone.

Both terms, fuyūrei and jibakurei, owe much to Western Spiritualism—not the kind involving crystals and "spiritual, but not religious" status updates, but the quasi-religious movement from the 1880s that brought us séances and mediums. The idea of ghosts as lingering, undefined beings and spiritual energy was imported along with other new ideas during the Meiji period. The terms are favored in modern Japan by mediums, ghost hunters, and legend trippers in-fluenced by Western ideas of ghosts. Along with this came the idea of yūrei spots.

Turn on the TV in Japan, especially around the summertime, when the yūrei roam the country, and you are almost guaranteed to see a program about a late-night visit to a yūrei spot, also known as a *shinrei* spot. These are essentially haunted locations—scenes of murder, suicide, or horrific accidents. These spots are where the ghost hunters go with their night vision goggles and electronic recording equipment, hoping to catch a physical glimpse of the other world.

Although they are relatively new, yūrei spots can be seen as a modern version of the hyakumonogatari kaidankai game. They are fueled by urban legends, personal encounters, and strange phenomena. They can be found all across Japan and in every place, from training crossings to bridges. Some of the more famous yūrei spots are ancient battlegrounds, graveyards, tunnels, and the sites of horrific incidents or mass killings. Hirata Atsutane would have recognized yūrei spots as a modern update

of the Inō House phenomenon described in chapter two.

And just like the hyakumonogatari kaidankai boom of the Edo period, the yūrei spot boom is fed by commercialism. There are yūrei spot tours in many major cities. You can take ghost tours of Tokyo in the same way you can of London and Seattle. Television, in particular, loves yūrei spots, as do teenagers, out to prove their bravery by visiting one in the dead of night.

You can see instances of cultural transference in modern yūrei spots and urban legends. The phantom hitchhiker tale from old England has made its way almost completely intact to modern Tokyo, where it is swapped amongst taxi drivers. In the middle of the night, a mysterious passenger requests you take her to a specific location. Upon arrival, you turn around to collect your fare, and she has vanished. Later, you learn that the location she had you take her to was the spot where she died.

There are hundreds, if not thousands, of yūrei spots spread across Japan. In Tokyo, there is Sendagaya tunnel, which winds beneath the cemetery of Senjuiin Temple. Or Shirogane tunnel, where legend has it that screaming faces are silhouetted against the tunnel's pillars and through which the *shinigami*—the spirit of Death itself—is said to pass. But perhaps the most famous yūrei spot in modern Japan is the forest of Aokigahara that surrounds the base of Japan's most sacred mountain, Mt. Fuji.

Also known as the *jukai*, the Sea of Trees, Aokigahara was described as "the perfect place to die" in Wataru Tsurumui's bestselling book *The Complete Manual of Suicide*. Close to a hundred people a year kill themselves in the jukai, traveling from far away to die in this destination suicide spot. Aokigahara is considered one of the most haunted places in Japan. By Tsunoda's standards, the accumulated jibakurei create an inescapable mass of ghostly energy, drawing you in to join them in suicide.

As the fame of Aokigahara spreads, the number of suicides only increases. Signs emblazoned with messages such as "Please reconsider" and "Please consult the police before you decide to die!" are nailed to trees throughout the forest. However, the woods have such a reputation that these minor deterrents do little to stop the determined. Local residents say they can always tell who is going into the forest for its stunning natural beauty, who is hunting after the macabre, and who is planning never to return.

At least tourists to Himeji Castle aren't consumed with a sudden desire to throw themselves down the well to join the yūrei of Okiku. But whether you call her tatari or jibakurei, Okiku is unable to leave the

ground of the castle that she haunts. She can only rise nightly from the bottom of the well where she died.

But there is one more important detail of the story of Okiku. And it has to do with what sits at the bottom of the well. For wells are full of water, and water has always been a path to anoyo, the world *over there*.

Chapter 11

THE FESTIVAL OF THE DEAD
御盆

As I touched the stones again, I was startled by seeing two white shadows before me; but a kindly voice, asking if the water was cold, set me at ease. It was the voice of my old landlord, Otokichi the fishseller, who had come to look for me, accompanied by his wife.

"Only pleasantly cool," I made answer, as I threw on my robe to go home with them.

"Ah," said the wife, "it is not good to go out there on the night of the Bon!"

–excerpted from *In Ghostly Japan*, Lafcadio Hearn, 1894

For three days out of every year, the wells and waterways of Japan—both the underground aqueducts and the visible surface rivers—transform into crowded superhighways for the dead.

Hundreds of millions of yūrei come flying back home from anoyo ready to spend the holidays with their families. A country filled with ghosts might seem like the setup for the ultimate horror movie, but these spirits are greeted with open arms by the living. They are welcomed into homes and celebrated and given honored seats at the family table. The yearly return of spirits from anoyo to konoyo is known as Obon.

Depending on the source, Obon is translated into English as either The Lantern Festival or The Festival of the Dead. Both translations describe aspects of the festival, but the true meaning of the name is as obscure as the origins of the festival itself.

The kanji for Obon—盆 (bon)—literally translates as "tray." This refers to any kind of flat plate, like a serving tray used for meals or plates set under plants to catch their water. Westerners might be familiar with this kanji from the term 盆栽 (bonsai), which are small trees (-sai) planted in trays (bon). Most people stop here and are content with saying the name Obon comes from the serving trays used to set out small dishes of food and drink that welcome home the returning

departed to their feast.

Some dive further into speculation, following the etymology along a deeper and murkier path. It starts with the Sanskrit word *ullambana*, which means "hanging upside down" and carries the implication of suffering for spirits who have not peacefully reincarnated. Ullambana is approximated phonetically in Japanese as urabon; it is possible that urabon could have been shortened to read simply Obon. But which of these is the true origin, the simple or the complex, is unknown.

What is known is that since ancient times, summer is the traditional season for yūrei. During summertime, the walls between anoyo and konoyo grow thin. Even those who made the passage long ago—with no hooks left in konoyo and who long ago completed the slow transition to sorei ancestor spirits—can return during this brief three-day window.

When exactly this three-day window occurs depends on where you are in Japan. For centuries, Obon was traditionally celebrated on the fifteenth day of the seventh month of the lunar calendar. This meant the holiday occurred on a different calendar date every year. Obon was a movable feast, in the same way Easter is celebrated in the Western world.

However, when the Gregorian calendar was adopted in Japan on January 1, 1873, all festival dates needed to be re-scheduled according to the more accurate solar calendar. There was no universal agreement; different parts of Japan calibrated differently, which led to the situation as it stands today.

On the mid-northern and more urban half of the main island of Honshu—in metropolitan centers such as Tokyo and Yokohama, as well as the Tohoku region—Shichigatsu Bon (July Bon) is observed around July 15. In the Kansai area, home of Osaka, Kyoto, and Nara, Hachigatsu Bon (August Bon) is observed on August 15. This date carries the additional weight of being *shūsen-kinenbi*, the official day of the surrender of Japan to the United States at the end of World War II. In addition to the usual Obon observations, August 15 is an official day for mourning of war dead and praying for peace.

In the more rural regions of Japan, in the far north of Honshu and the southern islands such as Okinawa, Kyu Bon, meaning Old Bon, is observed as it was before. These areas never adapted to the solar calendar and Kyu Bon is still celebrated as a movable feast on the fifteenth day of the seventh month of the lunar calendar.

Whatever the date, Obon is one of the most important holidays in Japanese life. The dead are acknowledged and celebrated, rituals are

observed, and traditions upheld. People generally do not work over the holiday. Businesses are closed, and many return for the event from the urban centers where they work to the rural homes of their ancestors. This echoes the way that the dead themselves return home to their ancient homes. There, the graves of their ancestors are washed clean, and fresh offerings are placed before them. Respect is given.

Despite surface similarities, Obon is very unlike the Celtic festival of Hallowe'en. Although both share the thinning of the walls of the living world and the afterlife, Hallowe'en is a time of danger and evil spirits, when the living must protect themselves with costumes and amulets such as the Jack o' Lantern. Obon is a time of restfulness and peace, of appreciation and celebration for loved ones who have protected them over the years. There is simply nothing frightening about Obon, and thus the festival makes a poor setting for kaidan.

However, the season is not completely without its dangers. Friendly as these spirits may be, they are still spirits of the dead. Which means that during Obon, people are cautioned to stay out of the water.

Water flows deep underground. And wells are deep with magic and mystery. European folklore taught that gods, spirits, faeries, and a host of frog princes lived in the bottom of wells. Toss in a few coins, and they granted you favors—a custom that continues to this day. Ancient Norway saw magic in the Well of Wisdom, where Odin sacrificed his eye to gain the power to see the future and the knowledge of why things are the way they are. Yggdrasil, the World Tree of Nordic mythology, draws its waters from this well.

In Japan, however, only one thing lies at the bottom of a well—a swiftly moving path to anoyo. Woe betides him who seeks to draw more than water up from the hole; and woe betides anyone who goes seeking down to the bottom.

According to the ancestral religion of Japan, the path to anoyo lays over the water. As an island nation, Japan is surrounded by the ocean on all sides. In the days before ocean-going travel, the misty realms that lay across the impassable oceans must have seemed a perfect place to serve as a dwelling for ancestral spirits.

The ocean, of course, was also filled with monsters. Being an island nation, Japan has an impressive menagerie of sea monsters known collectively as *ayakashi*. Many of these monsters spring from legends of drowned sailors. Those who died in the ocean itself were a special class. While it might seem an ocean death would grant you an express ticket to anoyo, instead, the souls became bound to the water like jibakurei.

They transformed into funayūrei, a type of monster/ghost that lives beneath the surface of the ocean and tries to drag other sailors down to share its fate.

But the mysteries of the ocean did not stop at the shore. These all-encompassing waters were linked by the system of rivers, wells, and aqueducts that flowed over and under Japan. These waterways also served as conduits to anoyo.

Some said that those teetering on the brink of death, in comas or hot with fever, could be saved by calling their name down a well.[24] If the soul had left the body, it would naturally seek water as a pathway to anoyo—but it could not move on until the body died. Calling the name of the inflicted ensured an attachment to konoyo and lured the dying person's soul back into their body where they could be healed. This was a dangerous prospect, however—it was possible for the body to die and the soul to linger as a yūrei.

Water as a path to the dead is a common sight in modern Japanese horror films. Aside from the aforementioned *Ring*, which uses the well motif of Okiku, there are numerous examples. Most prominent amongst them is the film *Honogurai mizu no soko kara* (*Dark Water*, 2002), directed by Nakata Hideo, who also directed *Ring*. In the film, the presence of a yūrei is shown by dripping water. Almost all yūrei films show some variation on this, including *Shikoku* (1999), *Mizuchi* (*Death Water*, 2006), and even Nakagawa Nobuo's *Tōkaidō Yotsuya kaidan* (1959), which has the terrible Oiwa emerging from the river where she was killed. This water-connection is so strong it has led to some referring to yūrei as Japanese water ghosts.

As shown in chapter five, the Japanese afterlife is a mix of traditions. While the native religion was content with oceans and mountains for their otherworlds, the introduction of Buddhism complicated the Japanese afterlife. This new, complex world of the dead incorporated the ancient tradition of water as a pathway to anoyo in the form of *sanzu no kawa*, or the Sanzu River, which separates konoyo from anoyo.

The dead must cross over the Sanzu River, much like the Greek River Styx, in order to reach the realms beyond.[25] In some traditions, people were said to make the crossing on the seventh day after their death. This

24. This particular legend can be seen in the Kurosawa Akira film *Red Beard* (1965), as the women of the village call desperately down a well, hoping to save the life of a dying boy.
25. The spirits of stillborn and aborted children are unable to cross on their own and get help from the deity Jizo. They are known collectively by the euphemism *mizuko*, meaning "water babies."

corresponds to *shonanoka* in the traditional Japanese funeral system. It is also believed that spirits come home on the seventh day as their final farewell before crossing over. Once the Sanzu River is crossed, they won't be coming back. Hopefully, they will merge with the sorei ancestor spirits and become ghostly guardians, only returning for the ritual of Obon. Of course, let it never be said that Japan's concept of the afterlife is in any way consistent.

Whether or not they have crossed the Sanzu River, whether or not they have merged with the collective guardian spirits, everyone gets to come home for Obon. During those three days in the summer, Japan shows just how much it continues to respect and revere the dead.

Obon is a festival of elements, of fire and water. The event is sometimes translated as The Lantern Festival because candles are lit to guide the souls to konoyo, where the people of Japan are waiting to welcome and thank them for kindly watching over their families and country. This observation can be as simple as a candle on the family altar or as fantastic as the ten thousand lanterns that light Nara Park or the giant bonfires that glow on the sides of mountains in Kyoto.

Almost all Shinto shrines in Japan are decorated with stone lanterns, but it is only on the nights of Obon that they are fully lit. Japan during Obon is one of the world's most beautiful sights, alive with candlelight— so long as one can shake off the sensation that the world is thick with invisible yūrei, traveling up the waterways and floating freely through the air as they return to the places they once walked in life.

Lanterns have a long association with yūrei. The story of Otsuyu and her peony lantern in "Botan dōrō" is an obvious example. Another was the glamorous courtesan Tamagiku of the red-light district of Edo. Tamagiku was a woman so famous for her beauty that she inspired her own lantern festival. When she died in the 1700s, everyone was so heartbroken they held the Tamagiku-dōrō, the Lanterns of Tamagiku, in her honor. The festival was celebrated annually on Obon for as long as the pleasure quarters existed.

There are other aspects to Obon. During the festival, yūrei love to be entertained. Obon features a traditional folkdance called the *bon odori*, performed for the spirits' pleasure. There are as many variations of the bon odori as there are towns and villages in Japan. Children are taught the dance, and it is handed down year after year across the centuries. This dance is one of the few traditions that has been exported overseas. Anywhere there is a significant Japanese population, they dance the bon odori to honor and entertain the dead.

Now, yūrei are like any relative. While the dead are met with open arms during Obon, it wouldn't do to have them outstay their welcome. It would be even worse to have them become lost on their return to anoyo. The custom of *toro nagashi* is meant to guide them—candle-lit lanterns float down the rivers and out to the sea for the spirits to follow home.

Toro nagashi is an old custom. Lafcadio Hearn describes it in his book *In Ghostly Japan* in the story "At Yaidzu." Hearn's story is atmospheric and creepy as he swims amongst the souls making their journey home. The people of Japan would advise against this action, however: It is the custom of the country not to swim during the three days of the Obon festival—the spirits might mistake you for one of their own and take you back to anoyo with them.

Water flows in one more direction not accounted for in the festival of Obon—down from the heavens in the form of rain. Perhaps this is what Ueda Akinari was thinking of when he wrote the greatest kaidanshū of all time, *Ugetsu monogatari*—*Tales of Moonlight and Rain.*

Chapter 12

TALES OF MOONLIGHT AND RAIN
雨月物語

Master Luo compiled Water Margin and sired three generations of deaf-mutes. Lady Murasaki wrote The Tale of Genji and fell for a time into a dreadful realm. No doubt it was for their wrongful actions that they suffered so. Look at their writings: each depicts many ingenious scenes and stories; their silences and songs are true to life; rising and falling, their language rolls smoothly along; and so their work resonates like fine music in the reader's heart. Even after a thousand years, the events of those times show clearly in the mirror of the present. I, too, have scribbled down some idle tales for a time of peace and contentment. A pheasant cries, dragons fly: I know that these tales are flawed and baseless; no one who skims them will find them believable. How, then, can I expect retribution, whether in the form of harelips or flat noses? In the late spring of Meiwa 5, on a night with a misty moon after the rains have cleared, I compose this at my window and give it to the bookseller. The title is "Tales of Moonlight and Rain."
 – excerpted from *Ugetsu monogatari*, Ueda Akinari, 1776[26]

Ugetsu monogatari—*Tales of Moonlight and Rain*—is a title shared by two of the greatest works of Japanese art, which are the finest examples of yūrei and kaidan storytelling. One is a book written by a most remarkable man, and the other is a film by one of Japan's greatest filmmakers. The movie *Ugetsu Monogatari* is possibly the most beautiful ghost story ever filmed. And the book *Ugetsu Monogatari*—well, that is something unique in all the world.

Published in the year 1776, *Ugetsu monogatari* was much more than just a book. It was more than the greatest kaidanshū ever written, even more than one of the masterpieces of Japanese literature. It was a vehicle

26. From Anthony C. Chambers' wonderful modern translation of Ugetsu monogatari.

of transformation. *Ugetsu monogatari* was crafted by a man who would reach his crab-clawed hand down into the mud and soil where the commoners lived and lift the yūrei up to the realms of high art. Like some alchemical miracle, author Ueda Akinari took the base material of kaidan and yūrei and transformed it into shining gold. In the process, he hoped, he would simultaneously transform himself, rising from the station into which he had been born and purchasing a ticket to the refined world of the literati, a place of education and privilege.

Born to an Osakan prostitute and with no known father, Ueda Akinari did not come into this world with a promising future. Indeed, the phrase "social climber" would have been entirely unknown in 1734 Japan, a time when your birth determined everything about you from the number and quality of toys you were allowed to play with as a child to the way you could wear your hair to how your body would be treated after death.

Akinari's birth in 1734 Japan was in the 101st year of the locked-country policy of the Tokugawa shogunate. The four-tiered class system, known as *shi-nō-kō-shō*, was the law of the land. Modeled after the Chinese Confucian system, this system locked people into the station in life to which they were born. At the top were the aristocratic samurai (*shi*), constituting about six percent of the population. Next, the food-producing farmer (*nō*) was the largest group at more than eighty percent of the population. The third group was the product-producing crafts-man or artisan (*kō*), and on the bottom rung was the merchant (*shō*), who lived off the buying and selling of other men's work. Together the craftsmen and merchants made up about ten percent of the population.

There was one form of life considered even lower than a merchant. The hidden fifth class was known as the *hinin*, which literally means *non-human*. Considered the lowest of the low, this class included those itinerant people who wandered from place to place, making their living as they could. Actors, musicians, street cleaners, and prostitutes like Akinari's mother—all belonged to this outlawed caste. Falling into the ranks of the hinin was as low as you could go in Edo-period Japan, and it was a quagmire from which there was thought to be no escape.

Akinari's birth mother, Matsuo Osaki, was from a poor rural farmer family in the Yamato Province (modern-day Nara Prefecture). She had come to Osaka to seek her fortune amongst the merchant classes. Much as it remains today, Osaka was a grimy place of dark alleys and waste, of commerce and industry. Far from the refinement and arts of the flower-and-willow world of the Kyoto geisha or the government and politics

in Tokyo, Osaka was a more tangible world. It offered an opportunity to disappear into the crowds where, by your wit and luck and skill with money, you could potentially carve out a better life.

Sadly, Matsuo lacked all of those necessary qualities. It was not long before she fell into less pleasant circumstances. Selling the only thing she had of value just to survive, Matsuo joined the ranks of the hinin as a prostitute, living and working in the red-light district of Sonezaki, Osaka. There, she gave birth to a child she named Akinari.

Nothing is known about the first few years of Akinari's life other than he must have shared the misery of all of his caste. Though his fate should have been sealed along with his first breath, the kami of Japan seemed to have different plans for Akinari. Something truly wondrous happened to him at the age of four. Like some lucky orphan in a Charles Dickens novel, Akinari was lifted from the gutters of his birth and raised into the merchant class by means of formal adoption by the wealthy merchant Ueda Mosuke.

The reason for this miracle of transcendence is unknown. Akinari said that one day, his mother just seemed to abandon him, and the next moment, he was the legal child of Ueda. Although speculation has been put forth of Akinari being the illegitimate son of a samurai or perhaps even the child of Ueda himself, Akinari never romanced such high-born fantasies. He knew what he was.

For whatever reasons, in 1737, Akinari was recognized as Ueda Akinari, officially taking on the family name of his adoptive father. In the first of his remarkable transformations, Ueda Akinari was no longer a hinin, but a merchant.

Like all people in the Edo period, Ueda Akinari had no question as to the existence of the supernatural. The yūrei and other phenomena, the kami in their shrines, all of these spiritual beings were as real as the rocks and trees, as real as the birds and beasts.

Aside from this general belief, however, Akinari felt that his life was personally touched by the gods of Japan. For proof he needed to look no further than his misshapen hands.

Only a year after his adoption, it seemed that Akinari's short life was over. Stricken with smallpox, a lethal disease from which all logic of the time says he should have died, Akinari lay for many days at death's door. Mosuke and his wife prayed daily at the Kashima Inari Shrine, asking that their new child be saved.

Through what seemed a miraculous intervention from the spirits, Akinari recovered to full health but was left deformed. Several fingers on

both of his hands never grew to full size and remained small, nonfunctional appendages, like a child's fingers on a grown man's hand.

Akinari hated those misshapen fingers. They caused him trouble with writing in school and later in life, but they were also a constant reminder of his direct link to the supernatural world. All his life, he used pen names such as Ueda Muchō (Ueda the Crab) because of his hands' resemblance to a crab's claws, and Senshi Kijin, meaning "Pruned Cripple."

Despite the circumstances of his birth and the deformity of his hands, Akinari was brought up well by his adoptive father, Mosuke. The boy had the full privileges of an heir. Ueda Mosuke was nothing but kind to his new child, feeding and educating him.

For the most part, Akinari was a dutiful son, learning the family business and preparing earnestly for his role in life. He was thought to have attended the Kaitokudō School in Osaka, where he studied Japanese classics and poetry. There was some youthful dabbling in the arts, and at age twenty-one in 1755, Akinari published his first *haikai* poem.

Five years later, at the age of twenty-six, he married Ueyama Tama. This happiness was followed by sadness as, a year later, his adoptive father, Ueda Mosuke, died. Akinari, as expected of him, assumed the role of head of the family's oil and paper business and settled in for a prosperous but unhappy life as an Osakan merchant.

For ten years, Akinari played this role, doing what society expected of him and fulfilling his obligations. Akinari and Tama never had their own children, fulfilling their own obligations by adopting a daughter, Mineko. But the life of a merchant, prestigious as it was compared to the life of an illegitimate prostitute's son, did not satisfy him.

Escape for him came by way of the kanazoshi, those cheap publications sold by street vendors and authored by anonymous folk with pretensions of literary skill. It is highly likely that Akinari read Ryōi Asai's offerings, including later publications of the popular *Otogi bōko* (1666) and the dramatic tale of "Botan dōrō." At some point, reading alone was not enough, and Akinari began to make his own contributions to the literary floating world.

Akinari wrote two kanazoshi: first *Shodo kikimimi sekanzaru* (A worldly monkey who hears about everything) in 1766, and then *Sekentekake katagi* (Characters of worldly mistresses) in 1767. His attempts were successful, and Seken tekake katagi is considered the last significant entry in the kanazoshi style. But Akinari soon tired of the loose and informal format in favor of something pithier.

Taking up again what he had learned as a schoolboy, Akinari delved deeper into his study of Japanese classics and a new course of study called *kokugaku* (national learning). From this, Akinari published treatises on noted classics of Japanese literature such the *Ise monogatari* (Tales of Ise), the *Man'yōshu* (The ten thousand leaves, 759) and *Kokin-shū* (Collection of ancient and modern poems, 905). His studies were well received, although his pro-Chinese opinions brought him into conflict with some of the leading scholars of the time who wanted to purge Japan of foreign influences.

This would not be how his life continued, however. In 1771, the kami spirits would again intervene in Akinari's life, and as before, they took a heavy price for their assistance.

Late one summer evening, fire suddenly swept across Akinari's home and business, making ashes of everything he had inherited from his adoptive father, but leaving the lives of his beloved family intact. From the wreckage, a more bitter man emerged, but Ueda Akinari was finally free from his obligations of running the family business as a merchant. Moving his family to Kashima-mura, Akinari apprenticed for five years in both medicine and Chinese literature under Doctor Teishō Tsuga. During those five years, he also found an outlet for his bitterness and disappointment, and an entranceway into the elevated world he so craved.

Many times in history, publishing a book has been an act of defiance or revolution. The publications of Teishō and his protégé, Akinari, were defying the very glue of society, the rules of class as created and enforced by the shōgun.

By 1776, a time of change across the globe, those rules of class were already showing cracks in isolated Japan. The merchant class, supposedly the bottom of the official four classes, was gaining power through the control of wealth. The upper-class samurai were expected to disdain money as something dirty and worldly, but they soon found themselves in debt and unable to afford their lavish lifestyles. The merchant class was starting to test its power.

Teishō Tsuga and Ueda Akinari found themselves kindred spirits and came together with a group of thinkers who would become known as the *bunjin*, the cultured and educated literati.

The bunjin were non-conformists, outsiders, and artists who rebelled against their legally mandated social group and aspired to high ideals and aesthetics. Inspired by imported Chinese works, the group pressed against the social barriers that separated high art from low art. Bunjin

authors chafed at the light-hearted and disreputable nature of kanazoshi publications. They wanted to write books, not pieces of parody. Teishō himself would become a pioneer of a genre called *yomihon*, meaning "a book for reading," which relied more on text than the picture-heavy format of kanazoshi.

Akinari, perhaps remembering his own circumstances, sought to transform rather than escape. Kaidanshū, those collections of yūrei and other supernatural creatures so beloved by the players of hyakumono-gatari kaidankai, fell unquestionably in the realm of low art. Bound by the laws of the four-tiered class system, the upper classes were forbidden from indulging in the most popular bloody tales.

Thus, it was even a greater rebellion when Akinari published his own yomihon, *Ugetsu monogatari*, in 1776. Akinari published an unmistakably literary kaidanshū, one that artfully blended what should not have been. He removed boundaries thought to be permanent. Akinari forever linked the worlds of low and high art into a single bound format. In doing so, he helped to disassemble the class system.

The peace brought on by the firm laws of the Tokugawa shōgunate allowed for a propagation and refinement of the arts at a level that had never before been seen. Citizens looked for other ways to occupy their time and their interests. Idleness alone could not be tolerated.

The lower classes filled their peacetime hours with bawdy entertainments and long hours wasted at pleasure quarters like the Yoshiwara District or crammed into the seats of the local kabuki theater to catch Tsuruya Nanboku IV's latest gory yūrei thriller. In every town and village, at least one house could be seen glowing late at night with the hundred candles of the hyakumonogatari game, dimming slowly to the game's eventual conclusion.

The aristocratic samurai class, however, was denied such base pursuits. They might have begun the game of hyakumonogatari, but samurai could not legally show their faces at the kabuki theaters performing the latest variation of the stories or lower themselves to buying a copy of a newly published broadside kanazoshi. The kaidan boom and yūrei mania were bread and circuses for the masses, meant to distract those who toiled and lived in the dirt and mud.

This split of high and low culture can be found almost everywhere, and Japan is no different. The Japanese language represents this dichotomy with the two words *ga* and *zoku*. Ga is the world of refinement and elegance, of the learned intellect and the aristocracy. Zoku is the world of the common and vulgar, of the base animal emotions like

lust and revenge.

A samurai practitioner of ga might sit quietly in a sculpted garden, where every single branch and leaf has been molded by hand to suit the demands of aesthetics over the impulses of nature, and contemplate his infinitesimal place in an infinite universe and the ephemeral nature of existence as represented by a single fallen blossom of a cherry tree floating in his sake glass while the liquid reflects the sky above.

A merchant lover of zoku, on the other hand, would unashamedly pound his tatami mat-seat while howling in fear and delight as the unearthly vision of the dread onryō Oiwa rises from the kabuki floorboards, black hair wildly spilling below her as she points her dead eye at the cowering and betraying Iemon.

As a merchant, Akinari would have been more familiar with the diversions of zoku, being raised in that class and expected to follow the dictates of shi-nō-kō-shō. Education had opened his eyes to new worlds, new ways of thinking, but the majority of his formative years would have been spent in more earthy pursuits.

Yūrei also fell firmly into the camp of zoku. This was true from the early days of kaidan, when the twelfth century *Konjaku monogatarishū* was published. Although later mined as a source for kaidan during the Edo period, the *Konjaku monogatarishū* was never given the same level of literary respect and reverence afforded other works published at the same time. The book was a minor footnote at best. It was not until the publication of *Otogi bōko* in 1666 that the concept of literary kaidan had its initial seeds put down. And it was not until 110 years later that those seeds would bear fruit.

Ugetsu monogatari is without a doubt a Great Book, one of the finest achievements of Japanese literature. But to call a book "great" is not the same thing as calling a book "highly readable" or "enjoyable." In 1999, the Modern Library ranked the James Joyce novel *Ulysses* at number one on its list of the hundred best English-language novels of the twentieth century, yet *Ulysses* is notoriously difficult to read. Filled with literary allusions and unfamiliar vocabulary, *Ulysses* is a project to be tackled rather than a book to be read.

Ugetsu monogatari is the same. To read and fully understand the book in its original form, one must not only have a thorough knowledge of both the Chinese and Japanese languages, but also a complete background in the great works of literature of both countries. To say that it requires footnotes is an understatement. There are some "reader's guides" to *Ugetsu monogatari* that are almost three times larger than the book itself.

Part of this was just showing off on Akinari's part—a conspicuous demonstration of his education and refinement. Key example: The introduction to the book is written in Chinese. At the time, Chinese was the language of the educated classes in much the way Latin was the language of education and knowledge for hundreds of years after the fall of the Roman Empire. There was no real reason for Akinari to write his introduction in Chinese other than to demonstrate that he could.

Akinari also played with the zoku and ga within the book itself. He would peek inside the ramshackle home of a poor farmer only to find the farmer debating *waka* poetry with his neighbor. A group of battle-hardened warrior spirits would gather late at night to discuss aesthetics. This conspicuous demonstration of his education and refinement was typical of elite Edo-period entertainment. Although members of the hereditary samurai class were the de facto aristocrats, they never forgot their roots as gruff warriors and were constantly seeking to prove themselves as intellectuals and appreciators of the arts. One of the ways the samurai did this was by mastering disciplines that allowed them to demonstrate their mental accomplishments.

A good example of the demonstration of knowledge is the Japanese ritual known as *chado*, or the tea ceremony. Ostensibly a Zen Buddhism meditation ritual focusing on the here and now of everyday mundane activities, in practice it was an ostentatious display of refinement and knowledge. Along with serving the tea, the host would assemble rare and expensive tea artifacts such as cups, whisks and scoops, then pass them casually to the guests.

This gave the guests the chance to makes statements such as, "Ah, I see you have a Takayama tea whisk from the Yamato Province. If I am not mistaken, this is in the older Juko Murata style and not the one recommended by the great tea master Sen no Rikyu…" Of course, guests who were not aware of the provenance of the tea implements would betray themselves as ignorant and uncultured, while the more competitive guests would attempt more complicated and obscure counting of coup, spreading from the tea implements to the flower arrangements and the temperature of the water. Almost anything in the tearoom would become a part of this game of one-upmanship in which the samurai would compete to show themselves to be the most cultured and knowledgeable.

Readers of *Ugetsu monogatari* found themselves playing a similar game. One person reading the book might make note of the poetry of the language of a particular passage, while another reader could point

out that that passage is more than simply beautiful but makes a statement about a similar passage in the great *Genji monogatari* or perhaps contains a subtle clue regarding a certain *renga* poetry master who wrote exclusively in Chinese.

Further complex associations by Akinari gave depth to the work. This can be found in the title itself. Although *Ugetsu monogatari* can be translated quite satisfactorily into English as "Tales of Moonlight and Rain" and gives an instant feel of the supernatural substance to be found between the covers, that does not tell the whole story.

With the word *ugetsu*, Akinari made two important literary allusions. The first one was to the title of a noh play that shares the same name, *Ugetsu*, written by Komparu Zenchiku. The play features the Buddhist monk Saigyō mediating over a couple's dilemma involving a panel on their roof, wondering if it is better to leave the panel open so they can see the moon or to close the panel so they can better hear the lovely sound of autumn rain. Saigyō also appears as a character in the first story of *Ugetsu monogatari*, a further demonstration from Akinari to his readers that the allusion was deliberate.

The word *ugetsu* makes a further allusion to a passage in "Mudan dengji" from the Chinese collection *Jian deng xin hua* (New tales under the trimmed lampwick), the same story that gave birth to the "Botan dōrō." The line suggests that cloudy, rainy nights or mornings with a lingering moon are perfect conditions for the appearance of mysterious beings. So, in a single word, Akinari makes a connection to noh theater, the otherworldly realms, and Chinese literature.

Second, the word *monogatari*, which translates as "tales of…," makes two important connections. Although the word is common in Japanese titles, it links *Ugetsu monogatari* to the hyakumonogatari kaidankai game that was popular at the time of publication. Furthermore, the word *monogatari* has been attached to several of the greatest works of Japanese literature such as *Genji monogatari* (*The Tale of Genji*), from which the ikiryō of Lady Rokujō comes, and the twelfth-century kaidan collection *Konjaku monogatarishū* (Collected tales of times now past). By titling his collection *Ugetsu monogatari*, Akinari makes the bold statement that this book will join the ranks of such classics.

The connection to noh theater in the title is important. To transform kaidan and yūrei from zoku to ga, Akinari needed to escape the association of kaidanshū with the floating world of kabuki and ukiyo-e. His book required a more solid foundation. To link himself and his work to the elevated status of the samurai, Akinari selected the order of noh as

the structure of *Ugetsu monogatari*.

Noh is often called "ancient," even though its foundation can be traced back to the mid-1300s. This ancientness comes from being based on older theatrical forms such as *dengaku*, *shirabyoshi*, and *gagaku*. These traditions were in turn based on shinobigoto, a set of rituals of dance and poetry recitation intended to entertain the dead gods of ancient Japan. Shinobigoto predates other theatrical forms by thousands of years.

Noh in its present form did not arrive until the Muromachi period under the guiding hands of Kiyotsugu Kan'ami and his son Motokiyo Zeami. From its first incarnation, the new theatrical form was associated with both the samurai class and the supernatural worlds of anoyo. Kan'ami's patron was the third shōgun of the Ashikaga shōgunate, Ashikaga Yoshimitsu. The shōgun was so impressed with noh theater that he took Kan'ami's son, Zeami, as his lover and ward. Zeami eventually succeeded his father and added his own touches to noh theater, creating the movements and style that are still performed today exactly as they were first demonstrated so many centuries ago.

Japanese art, especially high art, or ga, often works within self-imposed limitations, like the 5-7 syllabic structure of the chōka long poem or the 5-7-5 syllabic structure familiar to most Westerners as haiku. The establishment of rules and boundaries both challenges and frees the artist, giving them a perfectly formed skeleton upon which to lay the meat.

For noh, this was the *jo-hya-kyū* structure, meaing roughly "beginning, break, rapid," that not only categorized the plays but also outlined the order for a full-day, five-play performance. Under *jo-hya-kyū*, things begin slowly, build speed, and then end as a rapid burst of energy. You can see *jo-hya-kyū* in modern Japanese film, resulting in a storytelling style like a box of dynamite with a long, slow-burning fuse.

Like the attending audience, the yūrei of noh were high-born and aristocratic. Rarely did a noh performance feature the petty vengeance of a servant girl, which was one of the chief draws of kabuki. The spirits of noh were handmaids of powerful lords of the castle or brave warriors who gave their lives in the Genpei Wars, perhaps even at the Battle of Dan-no-ura itself. These deceased warriors from the Genpei Wars actually made up a special class of yūrei, the warrior ghost who, tormented by his life of violence, requires the prayers of a priest in order to move on.

The creatures of noh come from three hundred years earlier, during the Muromachi period. At that time, there was no archetypical image of a yūrei. If anything, yūrei were thought to be indistinguishable from living humans. Many older kaidan use the trope of having the yūrei first

appear as humans—only towards the end is their true ghostly nature revealed. This is almost always the case in noh.

A further artistic limitation on noh is the number of actors, which rarely exceeds two. Most noh plays are written for a duo: the *shite* (primary actor) and *waki* (supporting actor). Of these two, the shite is the masked performer and often assumes the role of the supernatural character. In such cases, the shite is also a dual-performance, with the actor first appearing as a normal human, in the *mae-shite* version, before the grand reveal in the second half as the *nochi-shite*, in which the true supernatural nature of the character is shown. The waki does not change costume and serves as a sounding board and sometimes salvation for the shite character.

A typical noh play would have something as simple as a traveling monk (waki) coming to a place where a famous battle was fought. A local villager (mae-shite) describes the battle and disappears. In the second act, the villager would be revealed to be the spirit of a dead warrior, appearing in full armor (nochi-shite) and begging the monk to pray for him to be released from Ashura's Hell of Fighting.

Unlike the forbidden kabuki theater, samurai were not only expected to become appreciators of the esoteric theatrical form of noh but were also encouraged to act on the stage as participants in the drama. As much as being fluent in the tea ceremony, being a patron and participant of noh was a sign of elegance and refinement.

In *Ugetsu monogatari*, Ueda Akinari gives you nothing for free. The metaphors and associations are not immediately obvious, which is the same with the underlying structure of noh theater. First, there is the simple problem of numbers. *Ugetsu monogatari* has nine stories, instead of the five demanded by Noh. Like many innovators, Akinari worked within the structures and paid homage to them but was not mindlessly bound by the rules.

The nine stories of *Ugetsu monogatari* are in the following order:

Shiramine

The first story in *Ugetsu monogatari* describes an encounter between the monk Saigyō and the retired emperor Sutoku, who has embraced evil and become the lord of the tengu, a type of avian creature that features prominently in Japanese folklore. As the emperor was not considered a human being, but directly descended from the goddess Amaterasu, this story fills the rank of *kami mono*, stories about gods, which typically opens a noh play.

The Chrysanthemum Vow

This story is of two friends and possibly lovers who make an appointment to meet in autumn. One of the friends is detained and thus commits suicide so that his yūrei can bridge the distance between them and keep the appointment. An encounter between a human and a warrior ghost makes this a *shura mono* story, the second chapter of a traditional noh play.

The Reed-Choked House

In this story, a lonely airyō waits patiently for her husband, who has gone to seek his fortune but promised to return. This story takes the *katsura mono*, or women's story, position.

For the next section, Akinari expands the miscellaneous fourth act of a traditional noh play, making one selection from several available story forms.

The Carp of My Dreams

A devout Buddhist monk is granted one day swimming as a carp, during which time he is caught, chopped up, and eaten by his feudal lord. This story fulfills the *kyōran mono*, or madness story.

The Owl of Three Jewels

A monk journeys to the holy mountain of Koya-san, where he runs into an unusual party of long-dead warriors engaged in a poetry contest. Set in modern times, this story is a *genzai mono*.

The Cauldron of Kibitsu

The story of a worthless man who has a giving, loving wife. The husband abandons his wife for his lover, eventually causing his wife's death. Infused with her new post-death power, the wife seeks revenge on her husband and his lover. This story is clearly the *onryō mono*, or a vengeful-ghost play.

Akinari further contributes two stories for the *kiri nō*, or final play, position, telling exciting stories of yōkai and oni.

A Serpent's Lust

A monstrous white serpent takes human form and seduces a beautiful young man. The man flees from the serpent, fearing for his

life and soul, but the powerful serpent will not surrender easily.

The Blue Hood
A wise and just abbot succumbs to his desires when he takes a young boy acolyte as his lover. The boy dies, and the abbot is unable to release his hold on the boy, eventually consuming the body to have the boy inside him. This evil act transforms the abbot into a flesh-eating oni, who needs the help of an even more devout monk to save him.

The ninth and final story corresponds to what is known as a *shūgen*, a celebratory, light-hearted piece similar to an encore.

On Poverty and Wealth
This final, shorter story is of a conversation between a samurai and the spirit of money, discussing which brings more happiness, poverty or wealth.

The ordered structure of noh was thus adhered to, but in such a manner that required some thought on the part of the reader to put the puzzle pieces together. Like all the literary allusions in *Ugetsu monogatari*, it was enough for Akinari to wink to the reader and say, "I followed these rules on purpose. And now I will break the rules on purpose too." He was not, after all, writing a series of noh plays but only wanted the credibility and elegance brought on by the attachment and to show the reader that a low-class prostitute's son could speak the language of the samurai.

Akinari also made use of the shite/waki mode of the two-actor combination. Instead of the ensemble casts found in most kaidan, the stories in *Ugetsu monogatari* are mostly limited to two characters, one natural and one supernatural. In keeping with tradition, Akinari's yūrei appear human at first, before engaging in the grand reveal.

In addition to the noh elements, Akinari connected the worlds of court literature such as *Genji monogatari* with the common worlds of the *Konjaku monogatarishū* and popular kaidanshū. Akinari is said to have pulled from more than sixty Chinese sources and more than a hundred Japanese sources to create his nine stories. In some of these, he borrowed a basic plotline; in others, something as simple as the description of a house might echo a similar image from another literary work.

Further defying established conventions, Akinari grounded his stories

in reality by tying them to specific locations. Normally, fantastic stories were set in "a certain province," similar to the Western fairy tale's "far, far away." "A Serpent's Lust," for example, takes place in the Kii and Yamato Provinces (modern-day Wakayama and Nara), while the two samurai of "The Chrysanthemum Vow" plan their meeting for Harima (modern-day Hyogo).

There are many more layers in *Ugetsu monogatari*, such as the crescendo of violence that sees the stories gaining in dramatic horror from the somewhat harmless beginning of "Shiramine" to the gruesome vengeance piece "The Cauldron of Kibitsu," finishing off with the lighthearted "On Poverty and Wealth."

With the book's publication, Ueda Akinari had completed a final transformation. Yūrei had escaped the confines of zoku, the vulgar realms of the commoner, and entered the highest levels of refinement and ga. So had Akinari himself.

Unsurprisingly, *Ugetsu monogatari* has continued to have considerable influence on Japanese literature. The book is the apex of the kaidanshū style of writing, the end point in what would later become known as literary kaidan.

Lafcadio Hearn included two tales of *Ugetsu monogatari* in his books. Hearn changed the title of "The Chrysanthemum Vow" into "Of a Promise Broken," eliminating the overt homosexual overtones that were insinuated by the word "chrysanthemum," slang at the time for homosexuality due to the flower's resemblance to an anus. Modern Japan prefers to use the euphemism "rose," but the meaning remains the same. He also included "The Reed-Choked House," calling it "The Reconciliation."

Akinari's use of fantastic themes coupled with serious literary devices would influence writers as far-ranging as Izumi Kyōka, author of what would become known as *Japanese Gothic Tales*, to Mexican author Carlos Fuentes, and practitioners of magical realism. And of course, they would be adapted to film.

For most Japanese yūrei tales of note, there is a litany of cinematic adaptations. The tales are re-invented year after year, and the ghosts of Oiwa, Otsuyu, and Okiku are resurrected afresh for new audiences waiting to be chilled by their ghostly touch. For *Ugetsu monogatari*, however, there is only one. And it too is a masterpiece.

Many people rank the 1953 film *Ugetsu monogatari* as the greatest ghost story ever filmed. Mizoguchi Kenji saw something in the *Ugetsu monogatari* stories that suited his sensibilities. He went through the

process of interpretation rather than adaptation. Taking two of Ueda's tales, "The Reed-Choked House" and "The Serpent's Lust," he wove a single story involving two peasant men seeking to raise their level in life. One, an artisan, hopes to make enough fine-crafted pottery to sell at the market in town. The other, his friend, is a wastrel who hopes to capture the eye of a warrior lord and be elevated to the status of sword-carrying samurai. Mizoguchi's fusion of literary source material and cinematic technique inspires superlatives; it's a mist-shrouded masterpiece, a brilliant summation of motifs and visual poetry. One of the first recipients of the Silver Lion award at the Venice Film Festival, *Ugetsu* also appeared on *Sight & Sound* magazine's critic-generated list of greatest movies ever made and in 2000 was #29 on *The Village Voice*'s "100 Best Films of the 20th Century" list.

There was something magical about the years 1953 and '54 for Japanese film. Almost all of the motion pictures considered the "greatest" in Japanese film history come from this brief period. Ozu Yasuhiro's *Tokyo monogatari* (*Tokyo Story*; 1953) and Kurosawa Akira's *Ikiru* (*To live*; 1953) were followed by Honda Ishiro's *Gojira* (*Godzilla*; 1954) and Kurosawa again with *Shichinin no samurai* (*Seven Samurai*; 1954). Sixty-five-year-old director Mizoguchi Kenji also contributed three films to this age of wonder, each of them the apex of his already refined craft. *Sanshō dayū* (*Sanshō the Bailiff*) premiered in 1954. A year earlier, *Gion Bashi* (*The Bridge of Gion*) and *Ugetsu monogatari* were released.

Indeed, in the Western world, the fame of the film *Ugetsu monogatari* has all but eclipsed the original work from which it sprang. Reviewers are never stingy in their exultations for Mizoguchi's masterpiece, piling praise upon praise with great enthusiasm, but the name "Ueda Akinari" is rarely quoted and almost no mention is made of the eighteenth-century yomihon that shares the name. Mizoguchi Kenji has become the name synonymous with *Ugetsu monogatari*.

Adapting a written story to film is nothing new. There is something magical about watching familiar characters come to life before an audience. In Japanese film, however, there was always the middle step of kabuki. Turning a literary work into an active play was always based on the skill of the kabuki authors, whose work was then adapted again onto film by directors and producers.

By their very nature, noh productions are rarely adapted for film. The ancient style of chanting and obtuse storyline provides very little meat for filmmakers, who cannot present a two-hour movie of two actors standing in place and singing all their lines. A book based on noh

theater, especially one packed with literary allusions on every line, is an equally difficult task.

Mizoguchi's *Ugetsu monogatari* is almost an ode to traditional Japanese kaidan storytelling. Like Akinari's yomihon, Mizoguchi's film is pure ga, yet plays freely in the realms of zoku. The transition from "normal existence" to the spiritual world takes place when the two peasant protagonists cross a river, a visual signifier that is unmistakable to those who can read the signs of water as a path to the spirit world. To cement the metaphor, death is encountered on the mist-covered water in the form of a man who has been attacked by pirates and warns them not to cross as he dies. Once across, the men go their separate ways. One of them, Genjurō, is a potter who gets seduced by a wealthy woman who admires his craft and wants him to abandon his former wife for a life of luxury in her palace. The other peasant, Tōbei, is a wastrel who acquires armor and prestige through falsehoods and trickery.

Genjurō's story is adapted from "The Serpent's Lust," although instead of being a monstrous serpent craving a beautiful young lover, the mysterious Lady Wakasa is an airyō in the mode of Otsuyu. The noblewoman died before ever experiencing love and has chosen Genjurō to be her paramour. An additional twist in this story is Lady Wakasa's father, a dead man who haunts his own daughter's ghost. Lady Wakasa herself is a living image of noh theater, both in her movements and her face, which has been painted to resemble the masks so essential to the aristocratic drama.

After escaping from the clutches of Lady Wakasa, Genjurō returns to his village, poor and ashamed, but he is relieved to find his abandoned wife Miyagi still tending the home fires and reading in their marriage bed. He has sex with her and falls asleep knowing all is well.

With the return to his wife, Genjurō has entered the tale of "The Reed-Choked House," with its familiar ending. Miyagi was raped and murdered in his absence, but her obedient and faithful airyō has waited to bring her husband one last night of solace before moving on to anoyo.

Tōbei's story ends differently from Genjurō's and is based on different sources. Into the framework of Ueda's short stories Mizoguchi threaded an adaptation of French author Guy de Maupassant's *Décoré!*, translated in English as *The Decoration*. Tōbei's search for military prestige that he has not earned is one that works well within the class system of Tokugawa Japan and is a reminder not to seek above your station.

The concept of adhering to the class structure as a moral benefit makes Mizoguchi's *Ugetsu monogatari* all the more interesting when you think that the man who was the source of his film, Ueda Akinari, defined his

whole life by being a man who sought above his station.

Born in the gutters of Osaka, Akinari passed away in the elegant city of Kyoto in 1809 at the age of seventy-six. After the publication of *Ugetsu monogatari*, he retired from medicine and devoted himself full time to writing and scholarship. He completed only one other yomihon, *Tales of the Spring Rain (Harusame monogatari)* in 1802, although the full book would not see publication until 1951, when missing sections of the manuscript were discovered. Both books remain essential to the core of Japanese literature. Ueda struggled for status beyond the fate decreed to him by the situation of his birth and the stigmatism of his crab-clawed hand—and found it. He also ensured that yūrei would continue to the future.

Conclusion

THE PERSISTENCE OF YŪREI

As I was watching a movie the other day with my wife, I was struck by how little yūrei had changed over the centuries. The director was Nakata Hideo—the man responsible for the recent kaidan boom with his film *Ring*. Here was the man who had sent the obscure Japanese folklore creature called a yūrei crawling out of a television set and into the psyche of millions of unsuspecting viewers worldwide. And yet in this film, he had created an almost textbook presentation of a classic Japanese Edo-period kaidan.

The film was simply called *Kaidan* (2007), and it was but the most recent re-telling of the Kasane-ga-fuchi story first published in 1860 by San'yūtei Enchō. As many as 147 years and five filmed versions separated the original from Nakata's cinematic version, yet almost all the details have been preserved. Were it not for the distracting CGI, I might as well have been back in the Nakamura theater, listening to an accomplished storyteller twist a tale of love and betrayal and ghostly revenge delivered only as an angry onryō could do it.

Edo-period Japan came to an end in 1853, when Commodore Perry and his Black Ships dragged an unwilling Japan into the modern world. The country and its culture were forever altered.

An almost immediate consequence to Perry's intrusion was the end of the military government that ruled Japan. On November 9, 1867, Tokugawa Yoshinobu, the fifteenth and final Tokugawa shōgun, willfully stepped down as ruler of the country. Approximately two months later, on January 3, 1868, a fifteen-year-old boy named Mutsuhito, later to be known as Meiji the Great, ascended the Chrysanthemum Throne.

This ascension was followed by Japan's rapid modernization, as well as its contacts with the modern powers of the world. The Meiji government became ashamed of anything that made Japan seem backwards or stupid. An official government program began, banishing all references

to superstitions and the supernatural. Belief in the worlds of kaidan, of yūrei and yōkai, was seen as a mental illness needing treatment.

Scholars and the government worried about the public's obsession with violent entertainment. Efforts were made to banish the supernatural and move Japan into a modern, scientific era. However, these efforts were to prove in vain. Yūrei were too much a part of the Japanese psyche to run away from a government decree.

The literary status of Akinari's *Ugetsu monogatari* ensured that the yūrei and yōkai could not be completely banished. Although the Meiji government could close the kabuki theaters and ban the bloody presence of Oiwa, Otsuyu, and Okiku, they could not stop scholars from endlessly pouring over Akinari's kaidan masterpiece. By transitioning the yūrei from zoku to ga, Akinari had given them respectability and an invulnerability to the changing tides of political whims.

Modernization brought other advancements, and the yūrei continued to advance as well despite the best efforts of the government. With the advent of cameras, yūrei moved from page to screen.

In 1903, Hearn rescued several tales from oblivion as he translated some of his favorite kaidan into English, many written down for the first time. The yūrei traveled abroad as part of his books *In Ghostly Japan and Kwaidan: Stories and Studies of Strange Things*. In 1912 a man named Yanagita Kunio and his partner Sasaki Kizen began wandering the backwoods of Japan, hunting for monsters and documenting them in their collections of *minzokugau*, or folklore studies. Like Lafcadio Hearn's collections, Yanagita's publication, *Tono monogatari*, preserved these legends for future generations.

Although the Edo-period kaidan mania was gone, yūrei were never long from the popular eye, experiencing another boom that saw the creation of a new genre: *kaidan eiga*, meaning simply kaidan movies, which were popular in the 1950s and 60s.

Then in 2003, the film *Ring* (generally known in the West as *Ringu* to differentiate from the American remake) burst into theaters and introduced the world to the yūrei Sadako Yamamura, looking for all the world as if she had just stepped out of Maruyama's painting with her white burial robe, long black hair, and pale face. A new kaidan boom was born, and the future of yūrei secured.

Most folkloric creatures have not fared so well. Take a look at the vampire and compare how different the horrific shambling corpse of early Slavic and other European folklore is from the suave, aristocratic sex-idol of modern vampire movies. The old-school vampires didn't

even drink blood, have fangs, fear sunlight, or have most of the other elements one would instantly associate with the word "vampire."

Even when looking at cinematic traditions, if one compares the rat-faced Count Orlok from F. W. Murnau's *Nosferatu, eine Symphonie des Grauens* (*Nosferatu: A Symphony of Horror*, 1922) with the teen-heartthrob and "vegetarian vampire" Edward Cullen from Catherine Hardwicke's film *Twilight* (2008), one could be forgiven for thinking they are two separate creatures entirely.

Like the old game of telephone, with each telling of the legends of the vampire, a small twist was added, a bit of flourish, a bit of panache, until ultimately, the creature on the screen bore no resemblance whatsoever to the frightening horror that once held such sway over people that they would dig up their own dead relatives, remove those dead relatives' heads, and brew soup from their long-dead hearts in order to protect themselves from haunters in the dark.

Yūrei, on the other hand, have passed through time rigidly, refusing to bow to zeitgeist and fashion. This immutability adds authenticity and a sense of reality. Scaring someone with a vampire has become difficult; they are too much monsters of the cinema and have long since disassociated from their roots. By contrast, a glimpse of a white face with dark eyes and darker hair, black and wriggling like Medusa's serpents, is enough to make even the most stalwart heart shudder.

The cultural authenticity of the yūrei ensures their relevance to the Japanese people. There is a sense that while Dracula and the Wolfman are clearly fictitious, yūrei are real. Real life is always scarier than fiction. With this heritage, it is no wonder then that modern Japanese filmmakers, writers, and artists are so adept at crafting stories of vengeful women and white-faced children, of haunted houses and enduring grudges. They are doing what comes naturally. They are re-telling the stories of their culture, and what appears new to Westerners is actually thousands of years old. I have no doubt that a thousand years hence, in whatever medium human beings are creating their stories, somewhere the yūrei will be there, almost unchanged.

As Lafcadio Hearn said, to understand yūrei and the Rule of the Dead—to understand the obligations of birth and death—is to understand much of Japan. To anyone who has lived there, many of Japan's customs and cultures, rituals and festivals, are incomprehensible without the missing puzzle piece—yūrei. Why do people put red hats and scarves on small statues of Jizō? Yūrei. Why do they take time off work in the summer to clean the family graves and put candles in the window? Yūrei.

But on the other side, not everything requires such depth and seriousness. As Ryōi Asai knew when he pulled the story of Otsuyu and "Botan dōrō" from the Buddhist cautionary tale of *Jian deng xin hua*, sometimes it is enough to just tell a good story.

And yūrei always make for a good story.

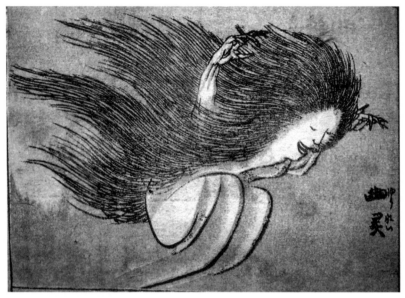

Manga yūrei, Hokusai Katsushika
A lighthearted drawing of a yūrei from the manga sketchbooks of Japan's most famous artist.

KAIDANSHŪ

Translations & Other Miscellanea
Relating to the Chapters

A note on the selections:

Some of these tales are important to the specific chapter indicated at the beginning of each section. Others are sample stories from famous books mentioned in the text. Some I just think are cool. I hope you enjoy them.

Ch. 2

WEIRD TALES
Stories from Japan's Ancient Kaidanshū

On a Skull that Was Saved from Being Stepped On
by Men & Beasts, Showing an Extraordinary Sign
& Repaying the Benefactor Immediately

Translated from the *Nihon ryōiki*,
from about the thirteenth year of Konin (822 CE).

There was a temple in Nara Prefecture called Kanko-ji, where a monk named Dōtō lived. He had come from Koma Province (modern-day northern Chosen peninsula) and was a tender-hearted and compassionate person. He noted one day that travelers had difficulty crossing the Uji River due to lack of a bridge, and so he supplied the funds from his personal savings to build a bridge for everyone's use. Acts such as this earned Dōtō the respect and honor of everyone who knew him.

One day, Dōtō was walking through the valley of Mount Nara with his disciple Maro. Quite by accident, Dōtō saw a skull on the wayside that had tumbled down from somewhere. The skull seemed to have had a hard time. It was covered in mud and looked like it had been kicked around by travelers on the road. There was little meat left clinging to the bone, and then only in small places. Dōtō felt sorry for the poor skull and commanded Maro to take the skull high up into a tree where he covered it with some branches to keep it hidden. This happened on the evening of the closing of the year, on New Year's.

Soon after, a man appeared before the gates of Kanko-ji.

"I have humbly come down from the mountains with a request to see the one they call Maro. Could you please bring me before him?"

The man was infallibly polite in his greeting and manners. And so the young monk tending the gate guided him to Maro. His face had an odd familiarity about it.

"I am deeply indebted to you." the man said. "You have done me a

tremendous service, and I would like to return your generosity. Although I have brought nothing with me now, I beg of you to return with me to my home so that I may properly repay you."

There was nothing for Maro to do except to accompany the man past the temple gates. After a long trek through the mountains, they arrived at the man's house. Maro was presented with a dazzling feast.

"Please, please…take only your favorites, and lots of them! Please!"

While saying this, the strange man began to enthusiastically gorge himself and encouraged Maro to do the same. Maro still wondered what he had done to deserve such rich rewards. When he asked the man how exactly he had been of service, the man silenced Maro's questions by shoving delicious delicacies at him. Maro, still a young man and given to worldly pleasures, was unable to resist. Never in his life had Maro tasted such delicious foods. Between the two of them, empty plates piled up like a mountain range.

Thinking it was time to relax, he was startled as he saw the man's face suddenly turn a violent shade.

"Honored Maro! My brother who murdered me has just arrived! There is no time to hesitate. We must flee! Come with me!"

Hearing this, Maro was shocked out of his pleasant repose and asked what he meant. His voice trembling, the man answered:

"Many years ago, my brother and I had a business together, and from this I was able to save 40 kin of silver [about 18 kilograms]. My brother himself saved nothing—he thought it easier to just kill me and steal my silver. For the longest time, my body rotted in the forest until nothing was left of me but my skull. People walking along the road who saw me would only kick my skull out of the way like an inconvenience. It was terrible. But then, beyond all hope, you came along and lifted me up from the dirt and saved me from my fate.

"I thought about how I could possibly repay such kindness. So I came to your temple this evening to invite you to my house for this feast."

At that time, the man's mother and elder brother entered the room. Seeing Maro, they shouted in fear. Maro explained how he came to be there and retold the story he had just heard. The mother listened intently to Maro's story and then looked down at her eldest son and told him in her strictest voice.

"You killed my beloved boy. It was not someone else's doing!"

She then directed Maro to eat and drink even more as thanks. With the feast done, Maro returned to his temple and reported what had happened to his master.

So you see, even a spirit of the dead or a bit of bone lying on the street can repay such an act of kindness. How can a person still living forget their spiritual debts?

How a Man's Wife Became a Vengeful Spirit & How Her Malignity Was Diverted by a Master of Divination

Translated from *Konjaku monogatarishū*

A man had abandoned his wife of many years for no particular reason. Perhaps he had simply gotten bored of her. In any case, he left his house to go adventuring, leaving the poor woman to waste away and die in their former home.

In death, however, the stubborn woman refused to leave. Her bones stayed together, and her long black hair only grew longer. At night, strange lights and sounds would come from the house, prompting neighbors to summon a Master of Divination to help them. The master told the villagers that she was waiting for her husband's return.

As soon as possible, the husband was brought back to the village. During the day, the husband entered the house, sat astride his wife's body like a horse and held onto her hair like reins. At nightfall, the body came to life and tried to buck the man off, but he held on tightly, and they flew out the window and rode roughshod over the entire countryside. When dawn finally came, the husband still clung tightly. The wife was overthrown, and her bones disintegrated to dust, leaving the husband undamaged.

So they say.

How Tosuke Ki's Meeting with a Ghost-Woman in Mino Province Ended in His Death

Translated from *Konjaku monogatarishū*

Tosuke Ki was traveling to his estate in Mino Province. While crossing the Seta Bridge, he encountered a woman in a kimono, who asked him to deliver a small box to a lady who sat at the bridge

in Kara Village.

Tosuke agreed and was warned not to open the box. On his trip, Tosuke forgot about the box and instead brought it home to Mino and placed it in his storeroom.

His wife, jealous in nature, thought it was a gift from a lover and opened the box secretly. The box was full of gouged-out eyes and sliced-off penises. Tosuke, being alerted by his wife to the nature of the box, immediately went to Kara Village to deliver it.

When Tosuke met the lady on the bridge, she was outraged that he and his wife had looked into the box, and he died as soon as he got home.

So they say.

The Yūrei Wife Who Came to Bear a Child
Translated from *Inga monogatari*

In Yamagata, in Ushishumogami, there lived a man named Reido. He had abandoned his wife in Kyoto in order to become a merchant in Yamagata. But to his surprise, one day his wife from Kyoto appeared on his doorstep. Reido divorced his new wife he had in Yamagata and soon was living happily with his wife from Kyoto. She bore him a single child.

One day business took him back to Kyoto, where he paid a visit to his old household and his father-in-law. The man was surprised to see Reido and sadly informed him that the wife he had abandoned had died three years ago. Hearing this, Reido replied vehemently:

"What nonsense! Your daughter has been living with me in Yamagata these past three years! We have raised a fine son together, and she is healthy and strong!"

The old man was shocked beyond belief and immediately accompanied Reido back to Yamagata to see his daughter. However, when he rushed into her room, he found only her mortuary tablet inscribed with her posthumous Buddhist name. They returned to Kyoto to open her grave and found that she had a lock of her child's hair clenched in her bony fist.

They thought that she must have been pregnant when he abandoned her, and she died those three years ago. The yūrei wife came to Yamagata to give birth to her baby and spent three years suckling him. Reido

admitted he had thought it was strange that he had abandoned his wife when she was seventeen, but she still looked seventeen three years later.

On Cutting a Spider's Leg During a Game of Hyakumonogatari Kaidankai
Translated from *Tonoigusa*

The brave young men had gathered together for a single purpose. "Tonight, we will exchange one hundred stories and see if the legends are true, see if something terrifying awaits us at the end."

They were ardent tellers of tales. As the night passed, they soon arrived at the closing of the ninety-ninth weird story. The room was thick with anticipation.

"Let us not be impatient," said one of the men. "A drink and some food together before the final tale is told." All in agreement, they produced lacquered boxes packed tight with delicacies. These were shared among the intimate gathering. They sat in a circle, enjoying the brief respite.

Without warning, a great hand appeared on the ceiling. It appeared to stretch wide, reaching its fingers out in a colossal grasp.

The frightened men were bowled over at the sight, except for a single stalwart who sprang to action. With a flick of his wrist, his sword flew from its sheath and struck at the hand. However, much to everyone's surprise, instead of a giant finger, the sword sliced off a spider's leg about three inches in length. One of the men chuckled, "I guess this was a true Test of Courage after all."

As for the spider, it appeared to be of the variety known as the orb-spinning spider. It would flatter it too much to call it a Joro spider (joroguma). Its color was not right to call it an earth spider (tsuchigumo). But it was no common pit spider (*anagumo*) either. After all, in its web it had killed a giant weevil, so it must have had a dreadful poison.

But its color was blue-green, like the kind of insect that could disappear between blades of grass. Perhaps it was a sea spider, blown here by an ocean breeze that carried it far from its home, floating in the air as if on the waves. It is pitiable; this spider carried so far from its home, trying to make do in its new environment, spinning a web on unknown surfaces. We should admire its perseverance. It was only sitting there,

sleeping in the summer heat, never asking for the intrusion of these storytellers. And here was its fine work undone.

Our own fine work is made of individual threads that can be pulled apart. We can be killed on the street walking home, joining Yorimitsu in the spirit realms. Or maybe tomorrow will come. It is not for us to decide.

Ch. 3

KABUKI AND YŪREI
Adaptations & Explanations of Famous Kabuki Yūrei

The Kabuki Ghost of Kohada Koheiji
Translated and adapted from *Fukushu kidan Asaka no nema*

What happens when a man who is a master of playing a yūrei in kabuki dies and becomes a yūrei himself? That is the question answered in the strange story of Kohada Koheiji, the kabuki actor who finally assumed the role he was born to play.

Kohada Koheiji was a third-rate kabuki actor struggling to make a living on the Edo kabuki stage during the time of Ichikawa Danjūrō II. Kohada lacked both natural talent and experiencee, and could not be cast in a role. Feeling sorry for him, Kohada's drama instructor bribed a director to cast Kohada in some role—any role. Just so that Kohada would finally be able to take the stage.

The director took one look at Kohada and saw that he bore a natural resemblance to the yūrei characters of kabuki. His skin was white, his eyes dark and sunken, and his hair long and unruly. The director thought he could save some money on make-up and costume and cast Kohada in the yūrei role of the play.

While it wasn't exactly his dream role, Kohada saw this as his big

break and threw himself into studying. He went to the morgue to observe dead faces and learned how to slack his face muscles and hold his body like a dead man. His diligence paid off, and Kohada was an overnight success. His fame spread; however, his skill was limited. He could only be cast in yūrei roles, which led his fellow actors to nickname him Yūrei Kohada.

Kohada had a wife named Otsuka whom he was deeply in love with. Otsuka, however, did not return the affection and thought Kohada was an embarrassing fool. Behind his back, she was having an affair with a fellow actor named Adachi Sakuro. Together they hatched a plot to get rid of Kohada.

When they were away together on a tour, Adachi invited Kohada to go fishing. Suspecting nothing, Kohada went out with Adachi on a boat into the Asaka Swamp. Once they were far out from shore, Adachi surprised Kohada, pushing him off the boat and holding him under the water until he drowned.

Adachi hurried back to let Otsuka know that he had cleared the path to their love. But he was not the only one. Kohada was not content to lie dead at the bottom of the swamp. He rose again as a yūrei and went to meet Adachi and Otsuka in Edo.

As might be expected, Kohada was a fabulous yūrei. More than any man alive, he had practiced enough to perfect the role. His new dead self looked exactly as he had on the stage, and he knew every trick to elicit terror in the cheating, murderous couple. He haunted them relentlessly, driving them mad and eventually to their own unnatural deaths.

Kohada Koheiji was a popular figure in Edo-period romance fiction and kabuki theater. His story and image appear in numerous plays and art, including Hokusai's famous portrait of his skeletal form peering over the mosquito net.

It was always assumed that the story was true. It was passed around town as an urban legend, with bits and pieces being gathered and attached here and there. The story was finally written by Santō Kyōden and published in 1803 with illustrations by Kitao Shigemasa under the title *Fukushu kidan Asaka no nema* (The strange story of revenge in Asaka Swamp). It was adapted for the kabuki stage in 1808 by the playwright Tsuruya Nanboku VI under the title *Iroe iri otogi zoku* (Colored nursery tales).

We know the details of Kohada Koheiji's story thanks to Yamazaki Yoshishige, a historical investigator who wrote the journal *Umiroku* (Record of the sea) from 1820 to 1837. Yamazaki investigated the story of

Kohada Koheiji and found that glimmers of the story began around the 1700s. Piecing everything together, he discovered the model for the story, a traveling entertainer whose name was actually Kohada Koheiji. Kohada had apparently been a terrible actor who killed himself out of despair for his lack of talent. His wife was not saddened by the loss and asked a friend to help cover up the embarrassing death, hoping to report Kohada as missing. They did not do a good job, and the deed was uncovered.

The real wife was rumored to have had an affair with the real Adachi Sakuro. Kohada's body was discovered in Chiba Prefecture in Inba swamp. When that story became news, it was only a small leap from the true story for townspeople to speculate that Kohada's wife and Adachi had actually killed Kohada. From there, the story gained traction; the details were filled in and the supernatural elements added. Like another kabuki ghost, Oiwa, Kohada is said to still be haunting the kabuki theater. He is said to especially haunt those who take on his role in kabuki adaptations. The only way to get out of this curse is to make an offering at his grave before taking on the role. Ever since the Edo period, actors taking on the yūrei roles were thought to take their lives into their own hands.

Of Women's Hair

Excerpted from *Glimpses of Unfamiliar Japan*, (1894), by Lafcadio Hearn

In Japanese folklore, women's hair has always been thought to have a supernatural quality about it. Much like the Medusa myth of ancient Greece, a Japanese woman's hair was thought to be able to transform into snakes, especially when the strong emotions of jealously and spite were involved. It was common in feudal Japan for powerful men to keep mistresses, and the wife and the mistress would sleep in the same room together in the women's quarters. In some cases, when the two women did not get along, it was said that the hair of one would reach over and strangle the other in the night while they were sleeping. Traditionally, the hair of dead women was arranged in a style called *tabanegami*, which was unornamented and tied together like a sheaf of rice. The long, loose hair of the yūrei is also thought to resemble the hanging branches of a willow tree, and that tree is considered to be a favorite location for female yūrei, where they can hide in the shadows and their ghostly hair merges with the shadows of the ghostly trees.

Ch. 4

THE RULE OF THE DEAD
Of Gods and Death

Izanagi and Izanami
Translated and adapted from the *Kojiki*

When the world was still in its chaotic state, two deities, Kunitokatchi and Amenominakanushi, arose from nothing and became the rulers of the sky. They created two divine beings, Izanagi and Izanami, and charged them to go down to Earth and make something useful of the remaining terrestrial realm. When walking down the Ame-no-ukihashi (Floating Bridge of Heaven), the two realized that there was nothing for them to stand on down below. So Izanagi received a jeweled spear named Ame-no-nuboko (Spear of Heaven), given to him by the two sky deities, which he swirled into the chaos of the ocean and created the first island, Onogoroshima (Self-forming Island).

When they arrived on the island, Izanagi and Izanami realized that their bodies were different and perhaps they were intended to be joined. Performing a marriage ceremony, they built a pillar, called Ame-no-mihashira (Pillar of Heaven), which Izanami walked around to the right and Izanagi on the left. Upon meeting in the middle, Izanami spoke first, saying, "Ah! What a fair and lovely youth!" and Izanagi replied, "Ah! What a fair and lovely maiden!"

They consummated their marriage, but their first child was a wretched leech-child named Hirako and a faint island named Awashima. Izanagi decided that their deformed child came about because Izanami, the female, spoke first during their wedding ceremony, which was a breach of etiquette. They performed the circle around Ame-no-mihashira again, this time with Izanagi first proclaiming, "Ah! What a fair and lovely maiden!" Izanami replied after Izanagi had spoken.

This was a successful exchange, and Izanami game birth to thirty-five gods and fourteen islands. However, when birthing the fire god Kagu-Tsuchi-no-Kami, Izanami was badly burned and became the first

thing to die in this new world. Overcome with grief, Izanagi chopped off Kagu-Tsuchi-no-Kami's head, from which were born the numerous deities of mountains, rocks, fire, and sharp snapping noises. Izanagi then made the perilous journey to the Land of Yomi, deep underground where Izanami's spirit remained.

Finding his beloved sister-wife's spirit down below, he was distraught to hear that she had eaten of the cooking furnaces of Yomi and would not be able to return. Izanami begged Izanagi not to look at her, but Izanagi lit a fire on his comb and beheld her. He was shocked to see her rotting flesh and polluted body, and fled from the Land of Yomi, with Izanami in close pursuit, accompanied by the Eight Ugly Females of Yomi. After a fierce battle, Izanagi escaped and closed the entrance to Yomi with a massive boulder and shouted the words of divorce to his sister-wife.

Enraged, Izanami vowed that she would cause the deaths of a thousand living beings daily as revenge. In response, Izanagi vowed to cause the birth of a thousand and five hundred living beings every day. Thus the balance between birth and death came to mortal things.

Aoi no Ue

Adapted from the noh play of the same name
by Motokiya Zeami, Muromachi period

Lady Aoi, the formal wife of the shining prince Genji Hikari, is possessed by a malevolent spirit and has fallen deathly ill. All the cures offered by the science of medicine have had no effect, so in desperation, the family summons the help of an exorcist.

Priestess Teruhi, master of the art of azusa, is said to be able to summon spirits with the sound of her cherry-birch bow. By plucking on her bow, the possessing entity is revealed to be none other than Rokujō-no-miyasudokoro, Lady Rokujō. Although a sophisticated and noble woman of good family and breeding, Lady Rokujō has been driven mad by her own jealousy after being spurned by her lover, Prince Genji, who chose to honor his wife over the distraught Lady Rokujō. In the same way that Lady Aoi has stolen Prince Genji's affections, the living spirit of Lady Rokujō plans to steal the life from Lady Aoi's body.

Realizing that she has not enough strength to withstand such a

powerful jealousy, Priestess Teruhi summons the help of Yokawa-no-kohijiri, master of the secret ways of Shugen-dō and skilled in exorcism.

The battle is bitter, as Lady Rokujō attacks not only the Lady Aoi but also the venerable Yokawa-no-kohijiri. However, the strength of the priest wins out, and Lady Rokujō is calmed and enters the merciful arms of the Buddha.

Ch. 5

THE WORLD OVER THERE
Stories from the World over There

In Which a Wife Meets Her Smoking Husband after His Death
Translated from *Konjaku monogatarishū*

A man from Yamato Province had a daughter who was in love with a skillful flute-player from Kawauchi Province. The two were married, and they lived together for two years full of love and happiness. Sadly, the husband was struck by a sudden illness and died.

The woman was overcome with sadness and would do nothing but cry and mourn her husband. Other men came to her earnestly and with good intentions, but she would not even look at them. The woman filled her life only with memories of her dead husband.

Three years passed in this way. One summer night when the woman lay crying at home, she thought she heard faint strains of the flute music her husband once played. Listening closely, she heard a voice from the next room saying, "Please open this door and let me in." There was no mistake. It was her husband's voice.

The woman peeked through a gap in the boards of the door and saw her dead husband standing there. He was playing a song that he had

composed for her long ago.

He looked exactly as he had when he was still alive, and when seeing him, the woman was chilled to the bone and overcome with fear. She looked closer and saw smoke escaping from the folds of his *hakama* trousers that covered his kimono, even where they were bound by a cord.

When the husband spoke, more smoke came from his mouth. "What is this? You were so sad and weeping and longing for me that I could get no rest! But now that I have come back to see you, you sit there shivering in fear? If that is the kind of greeting I get, then I will just go back. For this I withstood the scorching heat of Hell?" And with that said, the man disappeared.

So they say.

Gatagata Bashi–The Rattling Bridge

Translated from *Kyōka hyakumonogatari*

In the village of Ozaka in the province of Hida (modern-day Gifu Prefecture) there lived a man named Kane'emon. In front of his house was an old wooden suspension bridge that led across a mountain valley to the neighboring village.

One night, while Kane'emon was in his house, he heard the distinct rattling sound of someone crossing the bridge, accompanied by whispering voices. Making the crossing was far too dangerous at night, so Kane'emon rushed out of his house to warn the travelers, whoever they might be. He saw nothing.

This continued for night after night, always the rattling of the bridge and the whispering. On some nights, he even heard cries of sorrow and people weeping.

Unsure of what to do, Kane'emon consulted a fortune teller who told him that what he was hearing was a parade of the dead on their way to Tachiyama (modern-day Toyama Prefecture). It was known that there were several entrances to Hell located in Tachiyama and that the mojya (亡者; dead people) must have recently discovered his bridge as an expedient path.

Hearing that, Kane'emon resolved to move his entire household as far away from the bridge as possible and also arranged to have a

memorial service held at the bridge, praying to ease the sentence of those poor spirits cast into Hell. He had a permanent memorial posted at the bridge, and from that time, no more strange sounds were heard. However, that bridge is still known to this day by the name of Gatagata Bashi, meaning "rattling bridge."

Ch. 6

A GOOD DEATH
How to Die Well or Not Well

Diplomacy
Excerpted from *Kwaidan* (1904), by Lafcadio Hearn

It had been ordered that the execution should take place in the garden of the *yashiki*. So the man was taken there, and made to kneel down in a wide sanded space crossed by a line of tobi-ishi, or stepping-stones, such as you may still see in Japanese landscape-gardens. His arms were bound behind him. Retainers brought water in buckets, and rice-bags filled with pebbles; and they packed the rice-bags round the kneeling man, so wedging him in that he could not move. The master came, and observed the arrangements. He found them satisfactory, and made no remarks.

Suddenly the condemned man cried out to him—

"Honored Sir, the fault for which I have been doomed I did not wittingly commit. It was only my very great stupidity which caused the fault. Having been born stupid, by reason of my Karma, I could not always help making mistakes. But to kill a man for being stupid is wrong, and that wrong will be repaid. So surely as you kill me, so surely shall I be avenged; out of the resentment that you provoke will come the vengeance; and evil will be rendered for evil."

If any person be killed while feeling strong resentment, the ghost of that person will be able to take vengeance upon the killer. This the samurai knew. He replied very gently, almost caressingly:

"We shall allow you to frighten us as much as you please — after you are dead. But it is difficult to believe that you mean what you say. Will you try to give us some sign of your great resentment — after your head has been cut off?"

"Assuredly I will," answered the man.

"Very well," said the samurai, drawing his long sword; "I am now going to cut off your head. Directly in front of you there is a stepping-stone. After your head has been cut off, try to bite the stepping-stone. If your angry ghost can help you to do that, some of us may be frightened...Will you try to bite the stone?"

"I will bite it!" cried the man, in great anger, "I will bite it! I will bite" There was a flash, a swish, a crunching thud: the bound body bowed over the rice sacks, two long blood-jets pumping from the shorn neck, and the head rolled upon the sand. Heavily toward the stepping-stone it rolled: then, suddenly bounding, it caught the upper edge of the stone between its teeth, clung desperately for a moment, and dropped inert.

None spoke; but the retainers stared in horror at their master. He seemed to be quite unconcerned. He merely held out his sword to the nearest attendant, who, with a wooden dipper, poured water over the blade from haft to point, and then carefully wiped the steel several times with sheets of soft paper...And thus ended the ceremonial part of the incident.

For months thereafter, the retainers and the domestics lived in ceaseless fear of ghostly visitation. None of them doubted that the promised vengeance would come; and their constant terror caused them to hear and to see much that did not exist. They became afraid of the sound of the wind in the bamboos—afraid even of the stirring of shadows in the garden. At last, after taking counsel together, they decided to petition their master to have a Segaki-service performed on behalf of the vengeful spirit.

"Quite unnecessary," the samurai said, when his chief retainer had uttered the general wish..."I understand that the desire of a dying man for revenge may be a cause for fear. But in this case there is nothing to fear."

The retainer looked at his master beseechingly, but hesitated to ask the reason of the alarming confidence.

"Oh, the reason is simple enough," declared the samurai, divining the unspoken doubt. "Only the very last intention of the fellow could

have been dangerous; and when I challenged him to give me the sign, I diverted his mind from the desire of revenge. He died with the set purpose of biting the stepping-stone; and that purpose he was able to accomplish, but nothing else. All the rest he must have forgotten…so you need not feel any further anxiety about the matter."

And indeed the dead man gave no more trouble. Nothing at all happened.

The Yūrei Who Wanted to Say Thank You

Translated and adapted from Mizuki Shigeru's *Mujyara*

This took place sometime during the Meiwa era (1764–1772). In Shimabara, there was a famous courtesan named Uriuno. She had been redeemed from the Tomiya house and now lived in the vicinity of Takatsuji.

One night, Uriuno was awakened by a strange noise. When she listened closer, she could faintly hear the sound of footsteps. It sounded as if someone was approaching her bedroom from the garden just outdoors.

"Good evening. Is someone out for a stroll tonight?" Uriuno called out, thinking this was a very strange thing indeed. She strained her ears for an answer.

The answer came at last with a rattle of the paper screens that served as a wall between Uriuno's bedroom and the garden. The figure of a woman projected like a shadow against those screens. The mysterious shape bowed down and whispered expressions of gratitude to Uriuno. Just as Uriuno was about to raise her voice in response, the figure blinked out of existence.

When the mysterious apparition had vanished, Uriuno suddenly recalled an odd encounter she had when she still worked in the red-light district. One night, a maid of the Tomiya was looking at Uriuno as if she had something very important to say. But Uriuno did not get a chance to hear her because the maid soon fell terribly ill and fainted dead away. For several days and nights, the maid went in and out of consciousness. She spent her final breath saying that she needed to see Uriuno and tell her something. But it was too late.

Uriuno thought about the shape of the figure projected on her

screens and felt that there was no mistake about it. That figure must have been the ghost of that maid of Tomiya. It could be no one else.

A Dead Secret

Excerpted from *Kwaidan* by Lafcadio Hearn

A long time ago, in the province of Tamba, there lived a rich merchant named Inamuraya Gensuke. He had a daughter called O-Sono. As she was very clever and pretty, he thought it would be a pity to let her grow up with only such teaching as the country-teachers could give her: so he sent her, in care of some trusty attendants, to Kyoto, that she might be trained in the polite accomplishments taught to the ladies of the capital. After she had thus been educated, she was married to a friend of her father's family—a merchant named Nagaraya;—and she lived happily with him for nearly four years. They had one child,—But O-Sono fell ill and died, in the fourth year after her marriage.

On the night after the funeral of O-Sono, her little son said that his mamma had come back, and was in the room upstairs. She had smiled at him, but would not talk to him: so he became afraid, and ran away. Then some of the family went upstairs to the room which had been O-Sono's; and they were startled to see, by the light of a small lamp which had been kindled before a shrine in that room, the figure of the dead mother. She appeared as if standing in front of a tansu, or chest of drawers, that still contained her ornaments and her wearing-apparel. Her head and shoulders could be very distinctly seen; but from the waist downwards the figure thinned into invisibility;—it was like an imperfect reflection of her, and transparent as a shadow on water.

Then the folk were afraid, and left the room. Below they consulted together; and the mother of O-Sono's husband said: "A woman is fond of her small things; and O-Sono was much attached to her belongings. Perhaps she has come back to look at them. Many dead persons will do that,—unless the things be given to the parish-temple. If we present O-Sono's robes and girdles to the temple, her spirit will probably find rest."

It was agreed that this should be done as soon as possible. So on the following morning the drawers were emptied; and all of O-Sono's ornaments and dresses were taken to the temple. But she came back the next night, and looked at the *tansu* as before. And she came back also on

the night following, and the night after that, and every night;—and the house became a house of fear.

The mother of O-Sono's husband then went to the parish-temple, and told the chief priest all that had happened, and asked for ghostly counsel. The temple was a Zen temple; and the head-priest was a learned old man, known as Daigen Osho. He said: "There must be something about which she is anxious, in or near that tansu."—"But we emptied all the drawers," replied the woman;—"there is nothing in the tansu."—"Well," said Daigen Osho, "to-night I shall go to your house, and keep watch in that room, and see what can be done. You must give orders that no person shall enter the room while I am watching, unless I call."

After sundown, Daigen Osho went to the house, and found the room made ready for him. He remained there alone, reading the sutras; and nothing appeared until after the Hour of the Rat. Then the figure of O-Sono suddenly outlined itself in front of the tansu. Her face had a wistful look; and she kept her eyes fixed upon the tansu.

The priest uttered the holy formula prescribed in such cases, and then, addressing the figure by the *kaimyo* of O-Sono, said:—"I have come here in order to help you. Perhaps in that tansu there is something about which you have reason to feel anxious. Shall I try to find it for you?" The shadow appeared to give assent by a slight motion of the head; and the priest, rising, opened the top drawer. It was empty. Successively he opened the second, the third, and the fourth drawer;—he searched carefully behind them and beneath them;—he carefully examined the interior of the chest. He found nothing. But the figure remained gazing as wistfully as before. "What can she want?" thought the priest. Suddenly it occurred to him that there might be something hidden under the paper with which the drawers were lined. He removed the lining of the first drawer:—nothing! He removed the lining of the second and third drawers:—still nothing. But under the lining of the lowermost drawer he found—a letter. "Is this the thing about which you have been troubled?" he asked. The shadow of the woman turned toward him,—her faint gaze fixed upon the letter. "Shall I burn it for you?" he asked. She bowed before him. "It shall be burned in the temple this very morning," he promised;—"and no one shall read it, except myself." The figure smiled and vanished.

Dawn was breaking as the priest descended the stairs, to find the family waiting anxiously below. "Do not be anxious," he said to them: "She will not appear again." And she never did.

The letter was burned. It was a love-letter written to O-Sono in the

time of her studies at Kyoto. But the priest alone knew what was in it; and the secret died with him.

The Konnyaku Ghost of Tenri

Translated from *Tenri Monogatari* (Legends of Tenri)

This peculiar story comes from Tenri City in Nara Prefecture. In the span separating Kabata Ward from Inaba Ward, there is a stone bridge nicknamed the Konnyaku Bridge. This is why.

Long ago, a rice dealer named Magobei was making his way across the city at night when he went to cross the stone bridge. Before he could cross, a female yūrei appeared on the center of the bridge with a large piece of *konnyaku* hanging from her mouth. Terrified, Magobei dropped to his knees and began chanting the name of the Amida Buddha over and over again. When he reached the ninety-ninth repetition of the Buddha's name, the bizarre konnyaku yūrei disappeared. With the way cleared, Magobei ran home as fast as his legs could carry him.

He later heard that there had been a married couple in town who had quarreled over a piece of konnyaku, and that somehow led to the wife's death. The details were unclear, nor did anyone know exactly what the woman wanted. It is said that she appeared from time to time on that bridge, always with the same chunk of konnyaku dangling from her mouth. And that stone bridge has been known as the Konnyaku Bridge ever since.

GHOSTS OF HATE
Tales of Ghostly Vengeance

The Evil Split of Princess Sakura
Translated and adapted from *Sakura hime azuma no bunshō*

Long, long ago, there was a Buddhist monk who was in love with a princess. The object of his affections, Sakura, was young and beautiful, but she had been sent to the monastery as a nun due to a crippling deformity that kept her right hand closed in a permanent fist. Being so deformed, it was thought that she could never be married. The monk, Seigen, pursued her, and, to everyone's amazement, was able to open her fused fist, revealing a small incense box that had been hidden in her hand since birth.

Seigen alone was not surprised, instantly recognizing the elegant and detailed box. It had belonged to his lover, a young man who, agonized at the cruel laws of gender that prevented them from marrying, committed suicide years earlier. His dying vow was to be born again as a woman so that he could be a proper wife to Seigen. The Princess Sakura was Seigen's lover reborn.

Repulsed at this tale, she fled from the monastery, from her karma, from Seigen, and into the waiting arms of her lover, a thief and rogue named Gonosuke. Seigen pursued her but was no match for Gonosuke, who quickly skewered him on his sword. Free to do as he willed, the dastardly cad made a fast profit selling the unfortunate princess into prostitution.

But it didn't end there. The wraith of Seigen rose as an onryō. Sakura knew not another peaceful night, as the setting of the sun was swiftly followed by the rising of Seigen. "Cursed you are!" he screamed at her. "You have betrayed your karma, betrayed a promise made by your past self, betrayed a love that was ordained by fate." Sakura knew it was true and, after enduring much torment, decided to make amends.

First, she smothered the small child sleeping next to her—her own, an illegitimate byproduct of Gonosuke's lust. Next, she escaped the brothel and traveled the long road to Gonosuke's home. There, finding him asleep, she plunged a sword into his body repeatedly, while Seigen's ghost looked on approvingly. As a last act of contrition, she closed her hand again around the incense box, so delicately and intimately carved, and sheathed the sword in her own neck.

Tōkaidō Yotsuya kaidan

Translated and adapted from *Tōkaidō Yotsuya kaidan*

The ronin Iemon was not happy with his circumstances. After the death of his master, Iemon had made his way to Yotsuya in Tokyo to begin again, hopefully with an auspicious marriage to a wealthy woman. But his wife, Oiwa, was neither as bonny nor as wealthy as he had supposed, and he was filled with bitter regret at the dismal circumstances of their lifestyle. Eking out a small living as makers of oilcloth umbrellas, the family barely supported themselves, much less their young child who was yet another mouth to feed.

For Iemon, there remained but one ray of hope, one passage out of his hated life. Oume, the granddaughter of the wealthy Itō Kihei, was lovesick for Iemon, and her grandfather had promised both money and position should Iemon consent to take Oume for his bride. It was a beautiful plan, and only his ugly wife and hated child lay in his path. But, for Iemon to have some respect, he would have to carefully hatch his plan.

With the help of the Itō family, Iemon secured a source of poison that he administered to Oiwa in the night. The dose was not sufficient, however, and only disfigured the homely girl, causing her face to run like molten candle wax, her eye drooping over her whitened cheek. Oiwa herself was unaware of the effects of the poison and began to prepare herself for a formal visit from members of the Itō family.

Next, Iemon hired a rogue named Takuetsu to steal into the house and rape Oiwa, thus giving Iemon sufficient grounds for divorce. Takuetsu agreed to the plan, but when he entered Oiwa's room, he watched her as she attempted to comb her hair in preparation for the evening. Oiwa was in tears as her hair fell out in bloody clumps, torn from her fragile

head by the teeth of the comb. In pity, Takuetsu could not go through with his crime, but instead held up a mirror to Oiwa so she could see what she had become.

Overcome by her disfigurement and betrayal, Oiwa attempted to flee the room but somehow managed to accidentally cut her own throat on Takuetsu's sword. She died cursing Iemon and the house of Itō.

Pleased with his success, Iemon also killed a servant, Kobotoke Kohei, whom he had caught stealing the traditional medicines of the household. In order to link Kobotoke to Oiwa, frame them as lovers, and disguise his own guilt, Iemon had their bodies nailed to the opposite sides of a door, which was then cast into a nearby river.

Free and clear now, Iemon soon made plans to marry Oume, the granddaughter of Itō Kihei, and begin his new life. However, on their wedding day, as he lifted the bridal veil of his new wife, he saw not Oume's beautiful and delicate face but instead the monstrous visage of the murdered Oiwa. In a panic, Iemon drew his sword and lashed out at the fearsome face, only to look in horror as he saw Oume's head fall to the ground.

From there, Oiwa's vendetta began in full. Iemon and the Itō family never knew another restful night; the onryō of Oiwa and Kobotoke haunted them at every turn. In an attempt to satisfy them, Iemon kicked Oume's mother, Oyumi, into the Onbō Canal. However, while later fishing in that same canal, Iemon caught not the delicious bounty of the river but the corpse-bound door that he had put into the river.

Driven close to madness, Iemon fled to the Snake Mountain Hermitage, where he sought sanctuary from Jōnen, the master of the hermitage. Oiwa had been busy, causing the deaths not only of Iemon's companions and friends, but also the deaths of Iemon's natural parents. At last, she came for Iemon.

The Yūrei of the Melancholy Boy
Translated from *Nihon no obake banashi*

This story, from the Houken era, tells of the way things are. It comes from the Tohoku area.

Long ago, a boy fell dead exactly on the border between the provinces of Sendai (modern-day Miyagi Prefecture) and Souma (modern-day

Fukushima Prefecture). The boy was journeying from Sendai and planning to cross over into Souma when he collapsed. His head and upper body lay in Souma, while his legs and lower body lay in Sendai. Just then, a samurai patrolling the border of Sendai came upon the scene.

"Ohhhh…why did you have to die here? And who is going to be responsible for burying you? If you're from Sendai, it's our obligation, but if you're from Souma…"

Softly and secretly, the samurai of Sendai lifted the body in his arms and turned him, placing his head in Sendai and his feet in Souma. However, the samurai did not know that he was being watched. In the shadow of a tree, a samurai of Souma was hiding. Eager to disgrace his rival, the Souma samurai sprang from his position.

"Hey hey! What are you doing!? That kid's from your province! He only died while trying to enter my province."

"No way! You got eyes? He's clearly from Souma!"

"Look at his body for proof! His head is facing away from Souma, and his feet are firmly planted in Sendai."

"You're crazy! Look at his body! It's exactly the opposite!"

"Only because you flipped him! I saw it all!"

"How dare you accuse me!?"

The two samurai screamed fiercely. But no matter how strongly they disputed each other, neither would back down. Finally, the samurai of Sendai fixed the samurai of Souma with his most fearsome glare and said: "Fine. If we can't work it out ourselves, let us fetch a magistrate and they can decide."

"Okay, that sounds fair."

Eventually, the two magistrates arrived, one from Sendai and one from Souma. They discussed the problem of the boy's body. They could not reach an agreement. Now, it must be said that Sendai was a large and strong province. Souma was small and weak. Even if the magistrate of Sendai knew he was in the wrong, he would never admit it. Finally exasperated, he said:

"Souma is nothing compared to the might of Sendai. If this dispute escalates, what do you think will happen to your tiny province? Do you understand what I am saying?"

The implied threat was clear. From here, the discussion was ended. For it was true that if Sendai and Souma went to war, the outcome would never be in doubt. Souma would lose. They had no choice but to accede to the wishes of Sendai.

While they were coming to this grave decision, the sun had risen

and the body of the boy had begun to decompose. The magistrate and samurai of Souma were moved, and they said, "This poor boy. We will bury him here."

So they dug a grave and placed the boy inside.

The following day, a mysterious thing occurred. Although they knew they had buried the boy in the grave, he was seen sitting next to his headstone. For long hours he would gaze kindly in the direction of Souma. After that, his head would turn in the direction of Sendai and his face would turn horrible. With all of his heart, he would glare his hatred at Sendai.

The people of Souma said this: "The curse of that boy is on Sendai, and they will be destroyed by it. The anger of the living is nothing to be feared, but the anger of a yūrei…"

Not a single person of Souma suffered any ill effects. But the same cannot be said of the people of Sendai, who suffered from his wrath.

Ch. 8

GHOSTS OF LOVE
Tales of Ghostly Love

In Which a Wife, After Her Death, Meets Her Former Husband
Translated from *Konjaku monogatarishū*

There was a samurai living in poverty in the capital who was suddenly summoned to the service of a lord of a distant land. The samurai eagerly accepted the offer but abandoned his wife of many years in favor of taking another woman he desired along with him.

When his responsibilities to the lord had finished, the samurai returned to the capital and found himself longing for his old wife. He

went that night to the old house where they had once lived. It was midnight, and the full autumn moon bathed the home in light. The gate was open, and the samurai entered his old dwelling only to find his much-missed wife sitting silently by herself.

She showed neither anger nor resentment towards her husband for his ill-use of her, but instead offered him greetings and welcomed him back after his long time away.

The samurai, overcome with emotion, swore to his wife that they would live together from now on and never be parted. Pleased by the happiness this brought to his wife's face, the samurai embraced her, and they held each other until sleep took them.

The samurai was woken in the morning by the bright morning sun that battered the house more harshly than had the previous autumn moon. He looked about himself and found that instead of embracing his wife, he was holding a dry corpse, nothing but bits of flesh clinging to bone wrapped in long black hair.

He leapt to his feet and rushed into the neighbors' house: "What happened to the woman who lived next door?"

"Her? She was abandoned by her husband long ago and died of an illness brought on by her sorrow. It was just this summer that she died. Because there was no one to care for her or give her a funeral, her body lays still where she died."

So they say.

Botan Dōrō

Translated from *Otogi bōko*

Every year from July fifteenth to the twenty-fourth, the Obon Festival of the Dead is celebrated. Shelves in homes are decorated as each house prepares for the celebration. Lanterns of every description are made and hung from the eaves of the houses that line the narrow streets of the city. Or sometimes they hang in front of the graves themselves, beckoning the spirits home. These lanterns are decorated with flowers and birds, or sweet and beautiful plants, or with peonies. Inside are set candles that burn the whole night through. To see all of the lanterns lit is so splendid that none can look away from it. And then the dancers gather, raising their voices together in harmony to sing sacred songs.

Lanterns and dancers swaying together—it is the same all across the country from the humble villages to the grand cities.

In the fifth year of Tenbun (1536) in Gojo, Kyogoku, there lived a man named Ogiwara Shinojo. His wife had died recently. He still cried tears of longing for her into the sleeves of his kimono, and his chest still burned with yearning. He sat by himself under his window, lonely, thinking of his departed wife. His grief was unending. This year was especially painful as, for the first time, his wife's name would be entered into the remembrances for the dead and the Buddhist priest would call her name in prayer. As he heard the Buddhist sutras read for her, he saw children playing outside and thought about the cruelness of life. His friends tried to take him out to cheer him up, but instead, Ogiwara returned home alone. He stared into nothingness on his stoop, his mind blank.

"Why? My beloved wife's face is clear in my mind to comfort me, yet still I am lonely."

While staring blindly into space, Ogiwara sang softly to himself and allowed tears to flow freely down his face.

Late on the evening of the fifteenth, the bustle of people going to and fro began to thin. The night grew still and silent. Suddenly, a beautiful woman about twenty years old came walking by, accompanied by a servant girl who looked about fourteen or fifteen years old. The servant girl was carrying a beautiful lantern adorned with peonies. The woman's eyes were vivid, the color of lotus blossoms, and her body was slender and moved with the grace of a willow tree. Her eyebrows were sharp as a pine needle, and her hair was glamorously ornamented. Ogiwara saw her shining in a moonbeam.

"Is this one of the daughters of heaven, come down to Earth to play amongst us mere mortals? Or perhaps the youngest princess of the Dragon King, emerged from her underwater palace? For there is no way someone this beautiful could be human."

Ogiwara shuddered with delight at the sight of the beautiful woman. As much as he tried to stop himself, Ogiwara's heart was filled with longing. He stood and followed her. The woman noticed Ogiwara filing in behind her, and he waited for her rejection. Instead, she walked slowly ahead, turning to look over her shoulder.

"I came out tonight with no appointment, no expectations of a secret meeting. It was only that the moon was beautiful, and I wished to admire it. Unexpectedly, it grew late at night, and the path home was deserted and dreary. Will you accompany me on my lonely walk?"

Hearing this, Ogiwara took a tentative step in her direction. "Your way is far, and the night is dark. Surely returning home now would be troublesome? My house is dilapidated and piled with garbage; however, perhaps it would serve as a light in the dark night for you and be enough for you to stop for the night?"

Ogiwara said this with a joking tone, and the woman smiled in response.

"I see the warm light leaking out of your windows. You look alone and as lonely as I am. I will take you up on your offer and stay at your inn with pleasure. The human heart feels sympathy."

With this response, Ogiwara was overjoyed. He took her slender hand and led her into his house. He brought out a bottle of sake, and they took turns pouring for each other. The moon sank into the night, and it stretched into a most wonderful evening. He heard the words he desperately wanted to hear.

"It will be difficult not to change after this, not to forget myself. I want to assume this is the start of something, rather than a brief moment in the moonlight."

Ogiwara had been anxious about the future with this woman, and he said: "We don't know if we will meet again. Do we make a pledge that this is a beginning or an ending?"

To which the woman immediately replied: "If I ask, will you wait for me to come every night and every night again? Why do you look at me with a sad face so full of expectations of disappointment?"

With that said, joy blossomed in Ogiwara's heart. As they loosed each other's under-sashes, he made his first pledge with the woman. They whispered to each other that they would love without change or interruption. Unbidden, dawn broke. Ogiwara said: "Where is your house? Unless you vanish into the hollow of a tree like some fairy tale creature. Please tell me."

The woman answered: I am a descendent of the noble Fujiwara clan and trace my lineage there more than the Nikaidō clan. But it has been many years since my household prospered. Indeed, if my household even exists at all anymore, we now barely scrape by in a tiny hovel. My father perished in the Onin Wars. My siblings are all dead, and my house has declined. There is only myself remaining and this maid who has been in service to my family for her entire life. We live in the vicinity of Banshū Temple. The shack is far too humble for visitors and shames me. I become sad again just talking about it."

She spun her sad tale all the while being charming and gentle.

Lying peacefully, they looked out into the sky. The moon had sunk beyond the mountains and the sky was lined with flat clouds. The lanterns had burned down to just a faint sliver of light. It was dawn. Regretfully, the woman pulled herself from Ogiwara and went home. However, night after night when it became dark, she came back as promised, staying again until dawn.

Ogiwara was happy, but perplexed. He loved the woman dearly and thought she was wonderful, and she pledged herself to him with an unchanging heart. But he wondered why he could never see his love by light of day.

Next door to Ogiwara lived a learned old man who knew a lot.

Every night he heard a suspicious woman's voice coming from his neighbor Ogiwara's house. Every night he heard singing and laughing and playful gamboling. He thought it was strange. One night he snuck over to Ogiwara's house and peeked through a chink in the wall to see what was going on. To his shock, he saw Ogiwara sitting under the dim lamplight. Opposite him was a skeleton. Ogiwara was happily chatting with the skeleton and rubbing its hands and feet. The skull bobbed back and forth as if in conversation, and a voice emitted from the swinging mandible. The old man was astounded. He called on Ogiwara as soon as the dawn came.

"You have had a visitor at your house every night recently."

The old man put out his query subtly. But Ogiwara uttered not a sound. The old man continued.

"You are headed for certain catastrophe. What do you gain by hiding your activities? Last night I peeked at you through your wall, and I saw your visitor—a skeleton. Living things are filled with a pure, vital energy and vigor. When they die, this energy becomes corrupt in the heart. The hearts of ghosts are impure and wicked. That is why the living must purify themselves after contact with the dead and avoid taboos and impurities. Because you are under her gloomy spell, you don't know what it means to sit with a yūrei. You cannot perceive that you lie with an unclean thing, a foul creature of the underworld. She will drain you of your vigor, sucking your life energy and leaving you a hollow shell. In the end, you will fall desperately ill. No medication or treatment will help you. The consumption will grow in you, and you will be cut down in your youth like green grass, the years that should have been yours taken from you. You will become a creature of the world over there, rotting under the moss. Is that not sad?"

Ogiwara felt the first twangs of fear and astonishment. He saw that

the old man was telling the truth, and his eyes were opened for the first time.

"The lady said she lived near Banshū Temple. Perhaps we could go there and inquire," he said.

Ogiwara set out west from Gojo, traveling to Banri Lane, inquiring along the way if anyone knew of the young woman. He went to a willow tree embankment along the river, but no one had heard of her. As it neared darkness, he reached Banshū Temple, where he rested for a little while. Tucked behind the bathrooms to the north, he noticed an ancient mausoleum.

He went to take a look and saw a coffin with the posthumous Buddhist name of Iyoko; daughter of Saemon Masanori of the Nikaidō clan; Dhyana-samadhi Nun of the Utamatsu Temple. When he got a good look, he saw an otogi bōko coffin doll that had been placed inside. The name Asaji was written on the back. Over the coffin was hanging a peony lantern.

There was no mistake that this was the woman. Ogiwara's hair stood up all over his body as he realized the implications. He left the temple without looking back. His intense passion cooled, and he was terrified to think of the woman making her nightly visit tonight. Normally the dawn had seemed cruel to him, taking away his love, but now it was nightfall that he dreaded. He worried about what he would do when she arrived. He went to his neighbor's house to sleep there and consult him.

"What should I do?" Ogiwara sighed dejectedly.

The old man answered like this: "You must hurry to the eastern temple and state your situation. The exorcist Keiko is there, and he is learned in mountain asceticism."

Ogiwara went swiftly to the temple and had an interview with Keiko. Keiko said: "Your life essence is being drained away by this mysterious spirit. Your heart and spirit are ensorcelled. If this continues for ten more days you will die."

So it was said. Ogiwara told the truth about everything that had happened up until then. Keiko listened and began writing out protection amulets that he gave to Ogiwara. He hung them about the entrances to his home. And as expected, the woman did not come.

After fifty days, Ogiwara returned to the eastern temple to thank Keiko, and the two got drunk together. In his inebriated state, Ogiwara started to long for his lost love. He decided to drop by Banshū Temple for a short visit and stand before the graves. As he looked inside, in an instant she was there. She vented her rage on Ogiwara.

"You have heartlessly broken the pledge we made to each other and made yourself a great liar! I thought your love was not superficial, that you were a person of depth, and I trusted myself with you. From sunset to sunrise I was yours, with a love that would never fade. That was the pledge I made to you. But instead of the words of your love, you listen to this Keiko and allow him to build barricades between us. And more importantly, you built walls around your heart as well. But I am so happy to see you again now. And now you will come and stay at my house."

She took Ogiwara's hand and led him inside. The man who was with Ogiwara saw this and fled in fear.

The man ran back to Ogiwara's house and told everyone what had happened. They were shocked and made their way to Banshū Temple together but arrived too late. Ogiwara had been drawn into her grave. The cruel bones were wrapped around his dead body. The priest of the temple had the grave transferred to a mountain temple.

After, a mysterious rumor was heard. On rainy nights, when it became cloudy, Ogiwara and the woman can be seen walking hand in hand, the young child guiding the way by light of the Peony Lantern. And on those days, the neighbors hide in fear. When Ogiwara's family heard this, they had the Lotus Sutra copied a thousand times and chanted for him. And they held a memorial service for him and the woman. After that, the two were never seen again.

The Dead Wife Who Didn't Leave

Translated from *Nihon no yūrei banashi*

Long ago, deep in the mountains of Shikoku, a husband and wife lived happily alone far away from the nearest village in a small house. In the autumn of one year, the wife of that happy couple fell suddenly ill and was confined to bed. But because the couple lived so very far away from the nearest doctor in the village, they had no medicine. The wife's fever grew hotter every day, and the husband could do nothing but cool down her body with water.

The wife's condition worsened every day. The husband never left his wife's side and tended to her every moment of every day. One day, seeing the pain on his wife's face, the husband sought to comfort her agony.

"My love, we are the type of couple who can never be separated. No matter what happens, please say that you will never leave my side."

"I am so happy to hear you say that, my husband, because that is my feeling exactly. As it always has been, no matter what may occur in the future, I will never leave you."

"Then let us make a promise," the husband said, "no matter who is the first to die, we will not bury that person in a grave."

"That is for the best," answered the wife, "I know that I have not much life left in this body. Do not break the promise you make to me now. Do not put my body in a grave but leave me here as I am so that I may always be by your side."

With that said, the woman relaxed with a peaceful look on her face and exhaled her last breath. As he had promised, the husband didn't bury her but left her as she had died, inside the house, lying in bed. In this way, seven days passed. Nothing of note happened during those seven days, and the husband went about his business as usual. But on the night of the seventh day...

"Let's go outside, shall we?"

The husband heard these words in a thin voice, but from where they came, he could not say.

"Eh? Who said that? There is no one else here..."

The husband turned his eyes towards the mysterious voice and saw nothing but the dead body of his wife.

"That's strange...but there is no way I heard her voice! I must be imagining things."

But even as he thought this, he didn't really believe it. So he turned to his wife's body and said: "You say you want to go outside, but where do you want to go?"

Even so, he was shocked to get an answer: "Yes, I am bored just lying here all day. The moon must be beautiful tonight. Let us go out and view it."

"It's fine to say that," the husband replied, still unsettled, "but you are dead."

With that, the wife spoke no more. After that, two or three days passed uneventfully. But on the evening of the fourth day, a traveling salesman lost his way passing over the mountains while making his way towards the village. Seeing the couple's remote cottage, he knocked on the door.

"Hello? Would you be so kind as to let me stay just this night? I have lost my way and find myself in trouble."

"That is a tight spot," said the husband, "but come in and make yourself at home."

With that said, the traveling salesman went into the cottage. But the husband still had some errands to run outside and said: "Excuse me, but I must go out for a bit. Please wait for me here."

The traveling salesman had been hoping for some company as well as a place to stay and was a bit downhearted when the husband left him alone. Sitting in the cottage, he heard a small voice.

"Let's go outside, shall we?"

The voice, however weak, was unmistakably a woman's voice. The traveling salesman thought it was strange but answered: "Where do you want to go?"

"The moon must be beautiful tonight. Let us go outside to view it."

"Indeed, it must be beautiful. All right then, let us go outside."

Just as he answered, a woman appeared wrapped in a long white kimono. She stood before him wavering, as if blowing in a breeze. And she said: "Well then, shall we go?"

She reached out a stark white hand to him. The traveling salesman looked closer at her and saw that she had no feet.

"Ah! A yūrei!"

The traveling salesman was astonished and stepped back two or three feet. But he was no weakling, lacking in courage. Indeed, he was a robust and brave man. He muttered to himself: "OK now…this yūrei must want to whisk me off to the land of the dead. Well she will not find such easy prey."

With that, he sprang at the woman, grabbed her by the throat and threw her from the house. He stepped to the door to await her challenge, but there was nothing before his eyes. The woman had vanished. After a bit, the husband returned from his errand. The traveling salesman flew into his story of the mysterious encounter.

"That was a strange thing indeed! Hah! But maybe it was just the fog playing tricks on me after all!"

But instead of being entertained, the husband was furious. "What have you done? I show you a little sympathy, let you stay at my home, and you throw my wife out the door? Then you go out with her! If you want to stay in my cottage, go find my wife and bring her back!"

The chastised travelling salesman slowly plodded out the door and began his task of wandering the dark forest looking for the yūrei he had so roughly handled. But even with the bright light of the moon to guide him, the wife was never seen again.

THE GHOST OF OKIKU
The Many Legends of Okiku

A Doubtful Record of the Plate Mansion
Translated from *Sarayashiki bengiroku*

The Yoshida Mansion sits in the fifth ward of Ushigome-Gomon. The lot on which it was built was once the home to the palace of Lady Sen before she made her journey to Akasaka in Edo in 1626. After that, another building stood in the lot before burning down to the ground—the home of the minor lord Aoyama Harima.

In the house of Aoyama, a young girl named Okiku worked as a maidservant. On the second day of the second year of Jōō (January 2, 1653), Okiku accidently broke one of the ten precious plates that were the heirloom of the Aoyama clan. Harima's wife was furious and said that since Okiku had broken one of the ten plates, it was fair to cut off one of Okiku's ten fingers in return. The middle finger on her right hand was chosen, and Okiku was confined to a cell until the punishment could be carried out.

During the night, Okiku managed to slip her bonds and escape from her cell. She ran outside and threw herself into an unused well, drowning at the bottom.

The next night, from the bottom of the well came a woman's voice. "One...two..." Soon, the sound of her voice could be heard echoing throughout the mansion, counting the plates. Everyone was so terrified their hair stood up all over their bodies.

Harima's wife was pregnant. When she gave birth, her child was missing the middle finger on its right hand. News of this made it back to the Imperial Court, and the cursed Aoyama family were forced to forfeit their territories and holdings.

The sound of the counting of the plates continued. The Imperial Court held special ceremonies to calm Okiku's spirit, but all in vain.

At last, they sent a holy man to cleanse the spirit. That night, the holy man waited inside the house. He waited patiently as a voice counted, "Eight…nine…" and then he suddenly shouted "Ten!"

Okiku's yūrei was heard to whisper, "Oh, how glad I am" before she disappeared.

The Plate Mansion of Ushigome
Translated from *Tosei chie kagami*

A samurai named Hattori lived in the Ushigome area of Edo. His wife was surpassingly jealous. One day, the wife discovered that her husband's mistress had broken one of the ten heirloom plates that the house had from Nanking, rendering them unsuitable for service to guests. The wife would not take money but insisted that the mistress replace the broken plate. As the plates were quite old and rare, the wife knew this was an impossible demand.

Until the matter was settled, the wife had the mistress confined to a cell. She was given neither food nor drink, and the wife expected she would starve to death. However, on the fifth day, the wife checked in and found the mistress still alive. Out of patience, the wife took matters into her own hands and strangled the mistress in her cell. She then paid to have her body taken from the house. To everyone's surprise, the mistress suddenly revived inside her coffin and begged for release.

Exasperated, the wife paid four strong men to strangle the mistress and bury her body in an unmarked grave. With the deed done, the wife thought she was at last free of her rival.

But suddenly, the wife's throat began to swell. She could no longer swallow food and even had difficulty breathing. A doctor came to attend to her, but it was too late. The doctor could find no cause for her condition and decided it must have been the onryō of the mistress coming for revenge. Later, it was found that the four men who had killed the mistress had died in the same way.

Banchō Sarayashiki
Translated from the record of the Okiku shrine, Himeji, Japan

In the Eisho period (1504–1520), Aoyama Tessan, a vassal of Kodera Norishoku, the ninth Lord of Himeji Castle, schemed to take up his Lord's place. This plan was suspected by the loyal retainer Kinkusa Genshin, who had his wife Okiku secretly enter the women's quarters of Aoyama in order to uncover the plans. Aoyama had planned to poison Lord Norishoku as he took his seat during the flower viewing party on Masui Mountain, but when the time came, the great lord was not in his appointed place and the plan was ruined. Failing to carry out his poisoning, Aoyama reasoned that he must have a spy in his household and he ordered an investigation. Okiku's presence was soon discovered by Chonotsubo Danshiro. Danshiro loved Okiku and promised not to uncover her if she would leave her husband and become Danshiro's wife. Okiku refused.

To be so readily refused angered Danshiro, who broke one of the ten heirloom Delftware plates that were a treasure of the Aoyama family. Blaming the broken plate on Okiku, and using this as a pretext, he had the girl slain and her body flung into a well. From then on, night after night, Okiku's voice could be heard counting the plates, wailing in grief as she failed to find the missing tenth plate.

Soon, with the peace of the castle disturbed by the wailing spirit, Lord Norishoku became aware of the poison plot and its unfortunate consequences. To placate her, he had the Okiku Shrine built at the nearby Twelfth-Precinct shrine.

Night Stories of Takemata
Translated from *Takemata yawa*

Not long after the Kakitsu Revolt (1441), there lived a man named Odagaki Shumesuke, a chief retainer in a prestigious family in the Hatama country of Aoyama (modern-day Himeji City). Oda lived in a magnificent mansion in the mountains. In his household was a beautiful serving girl named Hanano who was the object of many desires.

A young samurai named Kasadera Shinemon pursued Hanano,

writing her love letter after love letter; but she always refused him.

One of the great treasures of the Odagaki family were five precious abalone drinking cups that they had received from the lord of the clan. One day, Odagaki noticed that one was missing. He questioned Hanano about the missing cup, but she could only express her surprise. In a rage, Odagaki tortured Hanano, demanding the return of the priceless heirloom.

In truth, the cup had been hidden by Kasadera in revenge for Hanano's repeated rejections. Kasadera eagerly joined in the persecution, beating Hanano severely while demanding return of the cup. Finally, while bound and hanging from a pine tree, Hanano died.

From then on, the terrible power of Hanano's rage could be felt at the mansion every night, and the tree from which she died became known as the Hanging Pine.

Okiku Mushi, the Okiku Bugs

There is an odd aside to the legend of Okiku—something that makes her already unusual legend even more bizarre.

In the year 1795, an infestation of small insects plagued Japan. These small bugs were found only in old wells and were covered in thread, giving the appearance of having been bound. It was widely believed at the time that these bugs were connected with the legend of Okiku, possibly even being an extension of her tatari curse. Appropriately, these marauding insects were named Okiku mushi, meaning Okiku bugs. After that year, the Okiku mushi never appeared again.

Ch. 10

THE EARTHBOUND SPIRIT
The Yurei Who Cannot Move

Yonaki Ishi

Translated from the record in the Kyuenji Temple, Kakegawa, Shizuoka

Long ago, a pregnant woman was traveling the Sayo no Nakama pass on the Tōkaidō Road. A bandit discovered her on the road and wasted no time in taking both her life and her money. Blood from her body sprayed on a stone near the side of the road, and when night fell, the stone began to cry loudly enough that it could be heard by nearby villagers.

The crying was repeated the next night, and the next, and finally some villagers summoned up the courage to go to the rock that cried so loudly at night and discover the source of the rock's anguish. They found next to the bloody stone a small baby who had been born from his mother's dead womb.

Realizing that this child must have suffered great hardships, a priest from the local temple decided to raise him only on a sweet syrup called *kosodate-ame* from which it could become big and strong.

However, this did not stop the crying of the rock, which still wailed in bitter anguish, so the priest moved the stone to the local Kyuenji Temple, where it could watch the child and placed an ofuda on it to make it blessed of Buddha. Finally the stone was quieted, but it can still be seen at the temple to this day.

The Story of the Futon of Tottori

Excerpted from *Glimpses of Unfamiliar Japan*, by Lafcadio Hearn

Many years ago, a very small yadoya in Tottori town received its first guest, an itinerant merchant. He was received with more than common kindness, for the landlord desired to make a good name for his little inn. It was a new inn, but as its owner was poor, most of its dogu — furniture and utensils — had been purchased from the furuteya. Nevertheless, everything was clean, comforting, and pretty. The guest ate heartily and drank plenty of good warm sake; after which his bed was prepared on the soft floor, and he laid himself down to sleep.

Now, as a rule, one sleeps soundly after having drunk plenty of warm sake, especially if the night be cool and the bed very snug. But the guest, having slept but a very little while, was aroused by the sound of voices in his room, voices of children, always asking each other the same questions:

"Ani-san samukaro?" "Omae samukaro?"

The presence of children in his room might annoy the guest, but could not surprise him, for in these Japanese hotels there are no doors, but only papered sliding screens between room and room. So it seemed to him that some children must have wandered into his apartment, by mistake, in the dark. He uttered some gentle rebuke. For a moment only there was silence; then a sweet, thin, plaintive voice queried, close to his ear, *"Ani-San samukaro?"* [Elder Brother probably is cold?] and another sweet voice made answer caressingly, *"Omae samukaro?"* [Nay, thou probably art cold?]

He arose and rekindled the candle in the andon, and looked about the room. There was no one. The shoji were all closed. He examined the cupboards; they were empty. Wondering, he lay down again, leaving the light still burning; and immediately the voices spoke again, complaining, close to his pillow:

"Ani-San samukaro?" "Omae samukaro?"

Then, for the first time, he felt a chill creep over him, which was not the chill of the night. Again and again he heard, and each time he became more afraid. For he knew that the voices were in the Futon! It was the covering of the bed that cried out thus.

He gathered hurriedly together the few articles belonging to him, and, descending the stairs, aroused the landlord and told what had passed. Then the host, much angered, made reply: "That to make pleased the

honorable guest everything has been done, the truth is; but the honorable guest too much august sake having drunk, bad dreams has seen." Nevertheless the guest insisted upon paying at once that which he owed and seeking lodging elsewhere.

Next evening there came another guest who asked for a room for the night. At a late hour the landlord was aroused by his lodger with the same story. And this lodger, strange to say, had not taken any sake. Suspecting some envious plot to ruin his business, the landlord answered passionately: "Thee to please all things honorably have been done: nevertheless, ill-omened and vexatious words thou utterest. And that my inn my means-of-livelihood — is that also thou knowest. Wherefore that such things be spoken, right-there-is-none!" Then the guest, getting into a passion, loudly said things much more evil; and the two parted in hot anger.

But after the guest was gone, the landlord thinking all this very strange, ascended to the empty room to examine the futon. And while there, he heard the voices, and he discovered that the guests had said only the truth. It was one covering — only one — which cried out. The rest were silent. He took the covering into his own room, and for the remainder of the night lay down beneath it. And the voices continued until the hour of dawn: *"Ani-San samukaro?"* *"Omae samukaro?"*

So that he could not sleep.

But at break of day he rose up and went out to find the owner of the furuteya at which the futon had been purchased. The dealer knew nothing. He had bought the futon from a smaller shop, and the keeper of that shop had purchased it from a still poorer dealer dwelling in the farthest suburb of the city. And the innkeeper went from one to the other, asking questions.

Then at last it was found that the futon had belonged to a poor family, and had been bought from the landlord of a little house in which the family had lived, in the neighborhood of the town. And the story of the futon was this: —

The rent of the little house was only sixty sen a month, but even this was a great deal for the poor folks to pay. The father could earn only two or three yen a month, and the mother was ill and could not work; and there were two children, — a boy of six years and a boy of eight. And they were strangers in Tottori.

One winter's day the father sickened; and after a week of suffering he died, and was buried. Then the long-sick mother followed him, and the children were left alone. They knew no one whom they could ask for

aid; and in order to live they began to sell what there was to sell.

That was not much; the clothes of the dead father and mother, and most of their own; some quilts of cotton, and a few poor household utensils, — hibachi, bowls, cups, and other trifles. Every day they sold something, until there was nothing left but one futon. And a day came when they had nothing to eat; and the rent was not paid.

The terrible Dai-kan had arrived, the season of greatest cold; and the snow had drifted too high that day for them to wander far from the little house. So they could only lie down under their one futon, and shiver together, and compassionate each other in their own childish way, —

"Ani-San, samukaro?" "Omae samukaro?"

They had no fire, nor anything with which to make fire; and the darkness came; and the icy wind screamed into the little house.

They were afraid of the wind, but they were more afraid of the house-owner, who roused them roughly to demand his rent. He was a hard man, with an evil face. And finding there was none to pay him, he turned the children into the snow, and took their one futon away from them, and locked up the house.

They had but one thin blue kimono each, for all their other clothes had been sold to buy food; and they had nowhere to go. There was a temple of Kwannon not far away, but the snow was too high for them to reach it. So when the landlord was gone, they crept back behind the house. There the drowsiness of cold fell upon them, and they slept, embracing each other to keep warm. And while they slept, the gods covered them with a new futon, — ghostly-white and very beautiful. And they did not feel cold any more. For many days they slept there; then somebody found them, and a bed was made for them in the hakaba of the Temple of Kwannon-of-the-Thousand-Arms.

And the innkeeper, having heard these things, gave the twenty futon to the priests of the temple, and caused the kyo to be recited for the little souls. And the futon ceased thereafter to speak.

THE FESTIVAL OF THE DEAD
Yūrei of Water and Fire

Tale of the Funayūrei
Translated from *Nihon no obake banashi*

Long ago, it was said that when a boat put out to sea on New Year's Eve, it was sure to catch the eyes of a *funayūrei*. A funayūrei is said to be the soul of a drowning victim. Bitter and wrathful towards the living, it rises up from the bottom of the sea to attack boats.

One time, at Mizushimanada in the Seto Inland Sea (west of modern-day Okayama Prefecture), a lone boat crossed the water heavy with goods for the New Year's festival. Due to the nature of its cargo, the boat had no choice but to cross on New Year's Eve and was now being tossed about by the white-capped waves.

"What, do you fear to go sailing on New Year's Eve? Are we boatmen to have our livelihoods ended out of fear of the funayūrei? The sky may be black as ink without a star in sight, but the wind is favorable and if we hold our course steady, we will be back home before we even left!"

Cheering themselves up in this manner, the boatmen continued along the pitch-black sea. For a time, everything was good. Their sails were full of wind, and they were traveling so fast it was as if they were flying over the water. But suddenly the skies opened up, and a hammering rain began to fall.

"Damn! This is some pretty bad stuff coming down on us…"

The boatmen didn't stop their work for even a moment and kept the boat steady as the violence of the rain increased. Suddenly, the boat ground to a halt as if something had moved up behind it and grabbed it. The wind fell to a dead calm.

"What just happened? Where is our wind?"

Then, just as suddenly, they were blasted by a fierce breeze that seemed to have come straight from the heart of winter.

"Everyone! Push us ahead! Heave to those oars!"

To the shock of the boatmen, the boat held its ground, frozen to the spot as if it had set down roots.

"Wha...what is that?"

From deep under the water, something was drifting up towards the boat. It looked almost like floating balls of cotton.

"No...it can't be!"

The white shapes moved relentlessly upwards, increasing in size as they approached. The boatmen could see them now; wrapped in kimono as white as snow, their hair floated wildly in the water. From below, a ghastly light illuminated their faces. There was no doubt these were the dreaded funayūrei.

"Lend us a *hishaku*...lend us a spoon..."

Their ghostly hands stretched up from the waves, and their voices carried their bitter grudge toward the living. It is known that if you should find yourself in such a situation and, overcome by fear, you actually hand over the hishaku spoon they are requesting, then you are as good as dead. Before your eyes, the single hishaku spoon will split into multiple spoons, and arms beyond your ability to count will stretch out from the ocean.

"Ei ya! Ei ya! Ei ya!"

Singing their loathsome song with voices filled with hate, the funayūrei will ladle water from their infinite spoons until your boat is swamped. And if this is not enough to sink your boat, they will reach up and drag it to the bottom of the ocean. How many hundreds of ships have been sunk in this manner?

"No no no...not to you...we will never lend you a spoon!"

These boatmen, shivering so badly they could barely hold their oars, refused absolutely and pulled the water with all their strength. This did not discourage the funayūrei. Slowly the boat moved forward in the water, followed closely by the funayūrei.

"Go away! Just go away!"

The boatmen took their oars and began to beat with all their might on the heads of the funayūrei.

"Lend us a hishaku...lend us a spoon..."

A funayūrei grabbed hold of one of the oars and pulled with such strength that one of the boatmen was dragged into the ocean.

"No!"

Letting go of the oar, he clambered up the side of the boat, upsetting the lantern they had used to guide their way through the black night.

Sparks flew off of the lantern, and the funayūrei fled before the power of the flame. With that, the boat that had been held almost still in the water suddenly broke free and sped along smoothly.

"Ahhh…thanks to that lantern…"

The boatmen pulled with all of their remaining strength for the shore. This legend comes from Okayama Prefecture, from an Edo-period book called Kasshi yawa. A fishing village in this area still sells specially made hishaku spoons with holes that are said to ward off the funayūrei. The funayūrei are found not only in the Seto Inland Sea, but anywhere in the waters surrounding Japan. Always they ask for the hishaku spoon. Because of this, some boats carry a specially prepared hishaku spoon with holes drilled in it. This way, when they pass over the spoon, the funayūrei are unable to fill the boat with water, and the sailors can make their escape.

Ch. 12

TALES OF MOONLIGHT & RAIN
The Courtly Yūrei of Noh

Ugetsu

Translated and adapted from the noh play *Ugetsu*

The monk Saigyō, tired from his long journey on the pilgrimage from his house in Sagano to the Sumiyoshi Shrine, stops at a small house along the way and begs for lodging for the night. His request is refused, however, as the master of the house and his mistress are too engaged in an argument on how best to appreciate the beauty of the season.

To the husband, the sound brought on by the autumn wind disturbing the dry branches of an overhead tree creates a sweet rain-song, and

closing the roof-plank would mute the gentle beauty. To the wife, the glory of autumn is best appreciated by viewing the fullness of the over-head moon, not by listening to rain-song, so she wishes to remove the plank and better see the hanging orb.

Saigyō interrupts the argument, chanting a poem about how the pet-tiness of their argument distracts from both the beauty of the moon and the gentle rain-song. Hearing this, the couple allows the holy monk to enter and stay at their house.

When waking to the morning sun, Saigyō finds himself not in a house at all, but sleeping underneath the boughs of a pine tree. In a dream, it is revealed to him that the couple was in fact the kami spirits of the Sumiyoshi Shrine, and that now Saigyō will be taught the secrets of poetry and how all things must follow the patterns of yin and yang, of heaven and earth.

Kanehira

Translated and adapted from the noh play *Kanehira*

A trusted retainer of the famous warrior Yoshinaka Kiso, Kanehira Imai no Shiro is a warrior for the Heike clan during the Heike/Genji wars that decided who would sit on the throne as emperor of Japan. After many wars and a disastrous campaign, Yoshinaka is slain, and his loyal retainer Kanehira falls on his sword, following his com-mander to death.

Much later, a traveling monk journeys to the Awazu battlefield in Omi Province on the shores of Lake Biwa in order to pray for the spirit of the fallen Yoshinaka. To reach his destination, the monk asks a boat-man to ferry him across the lake. During the voyage, the boatman tells the monk the story of the battle and the island on which Yoshinaka and Kanehira died.

At night on the island, as if in a dream, the monk is met by a spec-tacular figure in full armor who sings of the battlefield of Shura-do, where the souls of the warriors have no rest. The armored figure is the ghost of Kanehira, who asks the monk to turn the boat into a holy craft that he can ride to escape from hell.

Of a Promise Kept

Excerpted from *A Japanese Miscellany*, by Lafcadio Hearn

"I shall return in the early autumn," said Akana Soyëmon several hundred years ago, — when bidding good-bye to his brother by adoption, young Hasebe Samon. The time was spring; and the place was the village of Kato in the province of Harima. Akana was an Izumo samurai; and he wanted to visit his birthplace. Hasebe said: "Your Izumo, — the Country of the Eight-Cloud Rising, — is very distant. Perhaps it will therefore be difficult for you to promise to return here upon any particular day. But, if we were to know the exact day, we should feel happier. We could then prepare a feast of welcome; and we could watch at the gateway for your coming."

"Why, as for that," responded Akana, "I have been so much accustomed to travel that I can usually tell beforehand how long it will take me to reach a place; and I can safely promise you to be here upon a particular day. Suppose we say the day of the festival Chôyô?"

"That is the ninth day of the ninth month," said Hasébé; — "then the chrysanthemums will be in bloom, and we can go together to look at them. How pleasant! So you promise to come back on the ninth day of the ninth month?"

"On the ninth day of the ninth month," repeated Akana, smiling farewell. Then he strode away from the village of Kato in the province of Harima; — and Hasébé Samon and the mother of Hasébé looked after him with tears in their eyes.

"Neither the Sun nor the Moon," says an old Japanese proverb, "ever halt upon their journey." Swiftly the months went by; and the autumn came, — the season of chrysanthemums. And early upon the morning of the ninth day of the ninth month Hasébé prepared to welcome his adopted brother. He made ready a feast of good things, bought wine, decorated the guest-room, and filled the vases of the alcove with chrysanthemums of two colors. Then his mother, watching him, said: — "The province of Izumo, my son, is more than 100 ri from this place; and the journey thence over the mountains is difficult and weary; and you cannot be sure that Akana will be able to come to-day. Would it not be better, before you take all this trouble, to wait for his coming?" "Nay, mother!" Hasébé made answer — "Akana promised to be here to-day: he could not break a promise! And if he were to see us beginning to make preparation after his arrival, he would know that we had doubted

his word; and we should be put to shame."

The day was beautiful, the sky without a cloud, and the air so pure that the world seemed to be a thousand miles wider than usual. In the morning many travelers passed through the village — some of them samurai; and Hasébé, watching each as he came, more than once imagined that he saw Akana approaching. But the temple-bells sounded the hour of midday; and Akana did not appear. Through the afternoon also Hasébé watched and waited in vain. The sun set; and still there was no sign of Akana. Nevertheless Hasébé remained at the gate, gazing down the road. Later his mother went to him, and said: — "The mind of a man, my son, — as our proverb declares — may change as quickly as the sky of autumn. But your chrysanthemum-flowers will still be fresh to-morrow. Better now to sleep; and in the morning you can watch again for Akana, if you wish." "Rest well, mother," returned Hasébé; — "but I still believe that he will come." Then the mother went to her own room; and Hasebe lingered at the gate. The night was pure as the day had been: all the sky throbbed with stars; and the white River of Heaven shimmered with unusual splendor. The village slept; — the silence was broken only by the noise of a little brook, and by the far-away barking of peasants' dogs. Hasébé still waited, — waited until he saw the thin moon sink behind the neighboring hills. Then at last he began to doubt and to fear. Just as he was about to reenter the house, he perceived in the distance a tall man approaching, — very lightly and quickly; and in the next moment he recognized Akana.

"Oh!" cried Hasébé, springing to meet him — "I have been waiting for you from the morning until now! . . . So you really did keep your promise after all…But you must be tired, poor brother! — come in; — everything is ready for you." He guided Akana to the place of honor in the guest-room and hastened to trim the lights, which were burning low. "Mother," continued Hasébé, "felt a little tired this evening, and she has already gone to bed; but I shall awaken her presently." Akana shook his head, and made a little gesture of disapproval. "As you will, brother," said Hasébé; and he set warm food and wine before the traveler. Akana did not touch the food or the wine, but remained motionless and silent for a short time. Then, speaking in a whisper; - as if fearful of awakening the mother, he said: "Now I must tell you how it happened that I came thus late. When I returned to Izumo I found that the people had almost forgotten the kindness of our former ruler, the good Lord Enya, and were seeking the favor of the usurper Tsunéhisa, who had possessed himself of the Tonda Castle. But I had to visit my cousin, Akana Tanji,

though he had accepted service under Tsunéhisa and was living, as a retainer, within the castle grounds. He persuaded me to present myself before Tsunéhisa: I yielded chiefly in order to observe the character of the new ruler, whose face I had never seen. He is a skilled soldier and of great courage; but he is cunning and cruel. I found it necessary to let him know that I could never enter into his service. After I left his presence, he ordered my cousin to detain me — to keep me confined within the house. I protested that I had promised to return to Harima upon the ninth day of the ninth month; but I was refused permission to go. I then hoped to escape from the castle at night; but I was constantly watched; and until to-day I could find no way to fulfill my promise.

"Until to-day!" exclaimed Hasébé in bewilderment; —"the castle is more than a hundred ri from here!"

"Yes," returned Akana; "and no living man can travel on foot a hundred ri in one day. But I felt that, if I did not keep my promise, you could not think well of me; and I remembered the ancient proverb, Tama yoku ichi nichi ni sen ri wo yuku ["The soul of a man can journey a thousand ri in a day."] Fortunately I had been allowed to keep my sword; — thus only was I able to come to you.

"Be good to our mother." With these words he stood up, and in the same instant disappeared. Then Hasébé knew that Akana had killed himself in order to fulfill the promise.

At earliest dawn Hasébé Samon set out for the Castle Tonda, in the province of Izumo. Reaching Matsué, he there learned that, on the night of the ninth day of the ninth month, Akana Soyëmon had performed harakiri in the house of Akana Tanji, in the grounds of the castle. Then Hasébé went to the house of Akana Tanji, and reproached Akana Tanji for the treachery done and slew him in the midst of his family and escaped without hurt. And when the Lord Tsunéhisa had heard the story, he gave commands that Hasébé should not be pursued. For, although an unscrupulous and cruel man himself, the Lord Tsunéhisa could respect the love of truth in others and could admire the friendship and the courage of Hasébé Samon.

The Vengeful Ghosts of the Heike Clan
Translated and adapted from *Gikeiki*

The year is 1185. Minamoto no Yoshitsune stands in the prow of his boat as it speeds through Daimotsu Bay in the province of Settsu (modern-day Hyogo Prefecture). Yoshitsune is fleeing from his brother, Minamoto no Yoritomo, who recently seized power from the Heike clan and declared himself shōgun. Yoritomo sees his brother as a potential rival. By exiling himself from the capital, Yoshitsune hopes to calm his brother's jealousy and paranoia.

The omens for the trip had not been auspicious. Yoshitsune had been forced to leave behind his mistress, the famed dancer Lady Shizuka. But during a farewell dance she performed in his honor—her masterpiece shirabyoshi, also known as "The Parting"—her headdress had toppled to the floor. The seas were rough, and Yoshitsune thought of delaying his flight. But his faithful retainer, the mighty Musashibo Benkei, had pressured Yoshitsune into leaving without delay and braving the tumultuous seas. Delay could mean Yoshitsune's death at the hands of his brother's soldiers.

At first, the voyage went well despite the roughness of the seas. Then things changed. As the boat left behind the shores of Daimotsu Bay and headed towards the Yoshino mountains, a mist rose up without warning, swallowing his ship and cutting off all light. From the sea arose great waves that battered Yoshitsune and his men, tossing their ship around like a toy. Yoshitsune's ship was stuck in the sea—unable to advance or retreat, as if in the grip of some supernatural power.

Looking over the side of the boat revealed the truth—this was no sudden squall. Hidden in the depths of the waves were the white bodies of the warriors of the Heike clan recently destroyed by Yoshitsune himself. Skeletal hands swarmed about the ship, holding it fast in the water. The ship was going nowhere but to Hell.

One of the ghostly warriors leapt from the ocean onto the ship. At a glance, Yoshitsune knew who it was—Taira no Tomomori, dread general of the Heike. His eyes blazed red with wrath as he swung his massive naginata longspear and maneuvered to engage Yoshitsune. Remarkably, Yoshitsune betrayed not the slightest glimmer of fear. He calmly drew his own sword and prepared to face off with this dead warrior.

The warrior-monk Musashibo Benkei knew that the day would not be carried by skill at arms. No matter how deadly his master Yoshitsune's

blade was, it could not cut dead flesh. But Taira no Tomomori's naginata had no such concern.

Benkei dropped to his knees and began to chant an earnest prayer to the gods. He called on the five directions—the deities of the North, South, East, West, and the mysterious fifth and unknowable direction. While Yoshitsune's steel held off Taira no Tomomori's attack, and the rest of the onryō of the defeated Heike clan continued to assault their ship, Benkei fought a spiritual war of faith and devotion, pitting his prayer against the power of the dead.

Such was the earnestness of Benkei's spirit and the devoutness of his prayer that the waves and mist dissipated as quickly as they had arisen.

The vengeful ghosts of the Heike vanished, unable to stand against the protective power of the gods. Their attack was over, and Yoshitsune and his men peacefully continued their flight from Kyoto.

Glossary

A country as obsessed with the supernatural as Japan is obviously going to have more than a single word for ghost. Just as in English, there are several words meaning "ghost," but each with a different usage and feel. Here is a list of all the Japanese words for ghost that I know, along with other ghostly terms mentioned in this book. I am sure the list must be incomplete.

Airyō 愛 (love) + 霊 (spirit)
My own addition to Japan's ghostly lexicon, a ghost who returns for bonds of love.

Akuryō 悪 (bad) + 霊 (spirit)
This is a somewhat loaded term that means simply "bad spirit." It carries a more Western feel to it and could be applied to devils as well as ghosts. Definitely bad news.

Amekai yūrei 飴買い (candy-buying) + 幽霊 (yūrei)
A ghostly mother who uses her coffin coins to buy candy for her still-living child.

Ashinonai yūrei 足のない (footless) + 幽霊 (yūrei)
When yūrei are compared to the ghosts of neighboring countries like China and Korea, it is the ashinonai, or footless, aspect that is considered uniquely Japanese. Chinese ghosts wear a similar burial costume, but they saunter about on ghostly feet rather than float above nothingness like their Japanese cousins.

Ashura / Shura mono 阿修羅/ 修羅物 (warrior ghost)
Warriors who died in battle and are now cursed to wage war forever without rest or respite.

Bōrei 亡 (departed) + 霊 (spirit)
The Gothic term for ghost in Japanese, meaning ruined or departed spirit. This is the word with the most literary overtones. Probably the best example is Japanese translations of Shakespeare in which the ghost of Hamlet's father is called Hamlet no Bōrei.

Eirei 英 (heroic) + 霊 (spirit)
Spirits of the war dead/heroes.

Funayūrei 船 (boat) + 幽霊 (yūrei)
The spirits of dead people drowned in the ocean.

Fuyūrei 浮遊 (wandering) + 霊 (spirit)
A wandering yūrei not bound to any particular place or person.

Gaki 餓 (hungry) + 鬼 (demon)
The Japanese word for the Sanskrit preta, the gaki are those who died
in thrall to jealousy and greed, to consuming and possessions. Their
obsession with material things becomes their torture after death, as
they are filled with a hunger and a thirst that they can never satiate.

Goryō 御 (honorable) + 霊 (spirit)
Formless creatures of energy and power, not unlike the modern
depiction of the Shinto gods called kami, which have as their basis the
dead gods of old. These amorphous spirits were particularly feared,
especially when they came from those who had been wronged or
martyred.

Hone onna 骨 (bone) + 女 (woman)
An unlovely term for an airyō who has sex with a man, only to be
revealed as a corpse in the light of day.

Ikiryō 生 (living) + 霊 (spirit)
A specific term for a person who releases his or her ghost-energy while
still alive. It is a rare manifestation, seen mainly in *The Tale of Genji*.

Jibakurei 地縛 (earth bound) + 霊 (spirit)
A yūrei inextricably bound to its place of death.

Jinkininki 食人 (human-eating) + 鬼 (demon)
The Japanese equivalent of ghouls, which are said to resemble the
corpses they consume with sharp claws and glowing eyes.

Kaidan 怪 (weird) + 談 (tales)
The most literal possible interpretation of kaidan would be something
like "a discussion or passing down of tales of the weird, strange or
mysterious."

Kosodate yūrei　子育て (child-raising) + 幽霊 (yūrei)
A ghostly mother who returns from the grave to raise her still-living child.

Mojya　亡 (dead) + 者 (person)
Dead person. An older, seldom-used term for ghosts.

Obake/Bakemono　お化け (changing) + 物 (thing)
The terms refer not specifically to yūrei but translate in usage to something closer to supernatural creature. Obake and bakemono use the kanji 化 (bakeru), which carries the meaning of "to adopt a disguise or change form," with the implication of changing for the worse.

Onryō　怨 (grudge) + 霊 (spirit)
A popular figure in J-horror flicks, an onryō is a ghost who died with some lingering grudge and seeks revenge against those who wronged them.

Hitodama　人 (human) + 魂 (soul)
Spirits of the dead as well as mysterious and spectral lanterns accompanying other supernatural creatures. The exact nature of hitodama is a mystery.

Seirei/Shōryō　精 (vitality) + 霊 (spirit)
This combination of kanji has religious connotations. When pronounced seirei, it is most likely talking about Western ghosts. When pronounced shōryō, it has Buddhist connotations.

Seire　聖 (holy) + 霊 (spirit)
The same pronunciation as seirei above, but changing the kanji makes the word for the Holy Ghost of Christianity.

Shinrei　神 (shrine) + 霊 (spirit)
Another rarely used term, this refers to the spirits of Shinto shrines.

Shinrei　心 (heart) + 霊 (spirit)
Shinrei is the term preferred by spiritualists in Japan. It carries a more mystical feel.

Shiryō　死 (dead) + 霊 (spirit)
Because it has the kanji for "death" right there in the front, shiryō is a little bit scarier term for a ghost in Japanese.

Sōrei 騒 (disruptive) + 霊 (spirit)
This is a rarely-used term for poltergeist, meaning ghosts who just rattle the chandeliers and move chairs around. In modern Japan, most people would just use the loan-word "poltergeist."

Sorei 祖 (ancestor) + 霊 (spirit)
Similar pronunciation as above, but with a short vowel and a drastically different kanji. Sorei are ancestor spirits who protect the living and are deeply honored.

Ubume 産 (birth) 女 (woman)
Ghostly mothers bearing supernatural children.

Ukabarenairei 浮かばれない (cannot rest in peace) + 霊 (spirit)
Essentially, the Restless Dead. Often used for those who died in isolated places, like mountains, whose bodies were not properly cared for.

Yūki 幽 (dim) + 鬼 (demon)
Dim demon. A seldom-used term for evil ghosts.

Yūrei 幽 (dim) + 霊 (spirit)
The most common Japanese term for ghost, the word originally comes from China. According to researcher Suwa Haruo, the kanji for yūrei (幽霊) first appeared in the works of the poet Xie Lingyun, who wrote during the time of China's Southern Dynasty (5–7 CE). The kanji splits into two distinct halves—幽 (yū; dim, hard to see) + 霊 (rei; spirit)—translating directly as "dim spirit." The second kanji in the pair, 霊, is the cornerstone for almost all Japanese words dealing with ghosts and the realms of the dead. The word has a further connection: One of the phrases for the land of the dead in Japanese is Yū no Sekai (霊の世界), The Dim Land.

References

I made a purposeful decision not to list individual citations for *Yūrei: The Japanese Ghost* in order to make it more approachable and easier to read. Instead, I've listed my major resources for the book here.

Not all of these contain material that was directly referenced in this book, but they made up my reading list in preparation. There are also many other individual kaidan and monogatari collections which are not listed individually but are collected in the three-volume Edo kaidanshū series, which collects the majority of the important Edo-period kaidanshū.

All translations in this book are my own, unless otherwise noted.

Abe, Chikara (2002) *Impurity and Death: A Japanese Perspective,* USA: Dissertation.com

Addiss, Stephen (ed) (1986) *Japanese Ghosts and Demons,* USA: George Braziller, Inc. in association with the Spencer Museum of Art, University of Kansas

Akutagawa, Ryunosuke (2000) *Kappa,* USA: Tuttle Publishing Inc.

Alt, Matt; Yoda, Hiroko (2008) *Yokai Attack: The Japanese Monster Survival Guide,* USA: Kodansha USA Inc.

Alt, Matt; Yoda, Hiroko (2012) *Yurei Attack: The Japanese Ghost Survival Guide,* USA: Tuttle Publishing

Anon (2004) *A Familiar Kind of Horror; Japan's 'Ju-On' Echoes Fright Films from the U.S,* The Washington Times, October 20, 2004 p. B05

Anon (2005) *Interview with Koji Suzuki, Novelist of the Dank and Dread,* Kateigaho International Edition, Winter, 2005

Anon (2005) *Sakura Giminden-Sakura Sôgo,* [online] Available from: http://www.kabuki21.com/sakura_giminden.php [Accessed 27 October 2005]

Araki, James T. (1998) *Traditional Japanese Theater: An Anthology of Plays,* USA: Columbia University Press,

Arnold, Gary (1997) *Japanese Master's Haunting Legacy,* The Washington Times, February 16, 1997 p.1

Bakhtin, Mikhail (1990) *Creation of a Prosaics,* Stanford, USA: Stanford University Press

Beal, Timothy K. (2002) *Religion and its Monsters,* New York, USA: Routledge

Brandon, James R. (1992) *Kabuki: Five Classic Plays,* Hawaii, USA: University of Hawaii Press

Bush, Laurence C. (2001) *Asian Horror Encyclopedia,* USA: Writer's Club Press

Cavaye, Ronald; Griffith, Paul; Senda, Akihiko (2004) *A Guide to the Japanese Stage: From Traditional to Cutting Edge,* Japan: Kodansha International

Cook, David A. (1996) *A History of Narrative Film,* USA: W. W. Norton

Cott, Jonathan (1990) *Wandering Ghost: The Odyssey of Lafcadio Hearn,* New York, USA: Kodansha International

Dazai, Osamu (1993) *Blue Bamboo: Japanese Tales of Fantasy,* USA: Kodansha International Ltd.

De Benneville, James S. (2007) *Tales of the Tokugawa Vol 1 &2,* USA: The Echo Library

Dirks, Tim (2005) *Horror Films: The Greatest Films* [online] Available from: http://www.filmsite.org/horrorfilms.html [Accessed 1 December 2005]

De Bary, WM. Theodore, Keene, Donald, Tanabe, George, Varley, Paul (2001) *Sources of Japanese Tradition: From Earliest Times to 1600,* New York, USA: Columbia University Press

Ernst, Earle, (1956) *The Kabuki Theatre,* UK: Oxford University Press Figal, Gerald (1999) *Civilization and Monsters: Spirits of Modernity in Meiji Japan,* USA: Duke University Press

Frank, Fitzgerald S. (2002) *Gothic Writers: A Critical and Bibliographic Guide,* USA: Greenwood Press

Gilmore, David D. (2003) *Monsters: Evil Beings, Mythical Beasts, and All Manner of Imaginary Terrors,* Philadelphia, USA: University of Pennsylvania Press

Guiley, Rosemary Ellen. (1992) *The Encyclopedia of Ghosts and Spirits,* New York: Facts on File Press

Gregory, Sinda, Koshikawa, Yoshiaki, Mccaffery, Larry (2002) *"Why Not Have Fun? An Interview with Gen'ichiro Takahashi,"* The Review of Contemporary Fiction, 22(2): 192+

Ernst, Earle, (1956) *The Kabuki Theatre,* UK: Oxford University Press Finucane, R.C. (1996) *Ghosts: Appearances of the Dead and Cultural Transformation,* USA: Prometheus Books

Foster, Michael Dylan (2009) *Pandemonium and Parade Japanese Monsters and the Culture of Yokai,* USA: University of California Press

Hearn, Lafcadio (2001) *A Japanese Miscellany: Strange Stories, Folklore Gleanings, Studies Here & There,* Tokyo, Japan: ICG Muse, Inc.

_____.(1971) *In Ghostly Japan,* Singapore: Tuttle Publishing Co. Inc,

_____. (2001) *Japan: An Attempt at Interpretation,* Tokyo, Japan: ICG Muse, Inc.

_____. (2001) *Kwaidan: Stories and Studies of Strange Things,* Tokyo, Japan: ICG Muse, Inc.

___. (2001) *Shadowings,* Tokyo, Japan: ICG Muse, Inc.

Hearn, Lafcadio, Hirakawa, Sukehiro (1990) *Kaidan Kidan,* Japan, Kodansha Hughes, Henry J. (2000) *"Familiarity of the Strange: Japan's Gothic Tradition,"* Criticism (42) 1: p. 59

Ikeda, Yasaburo (1959) *Nihon no Yūrei*, Japan: Chuokoron-shinsha, Inc. Ito, Asushi (2002) *Nihon no Sarayashiki Densetsu*, Japan: Kaicho Press

Iwasaka, Michiko, Toelken, Barre (1994) *Ghosts and the Japanese: Cultural Experience in Japanese Death Legends*, Logan, Utah: Utah State University Press

James, Grace (2005) *The Moon Maiden and Other Japanese Fairy Tales*, New York: Dover Publications, Inc.

James, Victoria (2002) *One god to rule them all*, [online] The Japan Times, Available from: http://www.japantimes.com/cgi-bin/getarticle.pl5?fl20020811a4.htm [Accessed 11 August 2005]

Joly, Henry L. (1967) *Legend in Japanese Art*, Vermont, USA: Rutland Kanbe Junkichi (2006) *Nihon no Obake Banashi*, Japan: Kaiseisha Press Kawai Hayao (1996) *The Japanese Psyche: Major Motifs in the Fairy Tales of Japan*, CT, USA: Spring Publications, Inc.

Kawauchi, Sayumi, McCarthy, Ralph F. (1998) *Manga Nihon Hanashibanashi Aya no Ohanashi / Once Upon a Time in Ghostly Japan*, Tokyo, Japan: Kodansha International Ltd.

Keene, Donald (1955) *Anthology of Japanese Literature: From the Earliest Era to the Mid-nineteenth Century*, New York, USA: Grove Press, Inc.

Keij'e, Nikolas (1973) *Japanese Grotesqueries*, USA: Tuttle Publishing Kincaid, Zoe (1925) *Kabuki, the Popular Stage of Japan*, USA: Macmillan

Komparu, Kunio (1983) *The Noh Theater: Principles and Perspectives*, Weatherhill/Tankosha

Koki, Izumi (1996) *Japanese Gothic Tales*, USA: University of Hawaii Press
_____. (2005) *In Light of Shadows:* More Gothic Tales by Izumi Koki, USA: University of Hawaii Press

Littleton, C. Scott (2002), *Shinto: Origins, Rituals, Festivals, Spirits, Sacred Places*, New York: Oxford University Press

Lopate, Phillip (2005) *From the Other Shore*, [online] Criterion Collection, Available from: http://www.criterionco.com/asp/release.asp?id=309&eid=451§ion=essay&page=1 [Accessed 6 December 2005]

Lowell, Percival (2013) *Occult Japan; or, The way of the Gods: An Esoteric Study of Japanese Personality and Possession*, USA: Amazon Digital Services, Inc.

Lyons, Kevin (2000–2005) *Tōkaidō Yotsuya Kaidan*, [online] Encyclopedia of Fantastic Film and Television, Available from:http://www.eofftv.com/t/tok/tokaido_yotsuya_kaidan_main.htm [Accessed 6 December 2005]

May, Sanford (2004) *Ghosts In the Deus Ex Machina*, [online] Book Slut, Available from: http://www.bookslut.com/big%20in%20japan.php [Accessed 9 September 2005]

McRoy, Jay (2005) *Japanese Horror Cinema*, Hawaii: University of Hawaii Press

Mes, Tom (2001) *Crest of Betrayal*, [online] Midnight Eye, Available from: http://www.midnighteye.com/reviews/crestbet.shtml [Accessed 14 December 2005]

Mitford, A.B. (2005) *Tales of Old Japan*, New York: Dover Publications, Inc.

Mizuki, Shigeru (1978) *Ge Ge Ge no Kitaro,* Japan: KC Deluxe

Mullins, Mark (ed), Susumu, Shimazono (ed), Swanson, Paul (ed) (1993) *Religion and Society in Modern Japan,* USA: Asian Humanities Press

Nitannosa, Nakaba (2006) *Nihon no Yūrei Banashi,* Japan: Kaiseisha Press

Nowell-Smith, Geoffrey (ed) (1996) *The Oxford History of World Cinema,* Oxford, UK: Oxford University Press

Parry, Richard Lloyd (2014) *Ghosts of the Tsunami,* [online] London Review of Books, available from: http://www.lrb.co.uk/v36/n03/richard-lloydparry/ghosts-of-the-tsunami [Accessed 10 February 2014]

Rampo, Edogawa (1956) *Japanese Tales of Mystery & Imagination,* Singapore: Tuttle Publishing

Reader, Ian (1991) *Religion in Contemporary Japan,* USA: University of Hawaii Press

Reider, Noriko T. (2010) *Japanese Demon Lore: Oni from Ancient Times to the Present,* Utah, USA: Utah State University Press

_____. (2002) *Tales of the Supernatural in Early Modern Japan Kaidan, Akinari, Ugetsu Monogatari,* USA: The Edwin Mellen Press

_____. (2000) *The Appeal of Kaidan Tales of the Strange,* Folklore Studies, (59) 2 p. 265

_____. (2001) *The Emergence of Kaidan-Shu: The Collection of Tales of the Strange and Mysterious in the Edo Period,* Folklore Studies, (60) 1 p. 79

_____. (2003) *Transformation of the Oni: From the Frightening and Diabolical to the Cute and Sexy,* Folklore Studies, (62) 1 p. 133+

Richie, Donald (2001) *A Hundred Years of Japanese Film,* USA: Kodansha America, Inc

Righi, Brian (2008) *Ghosts, Apparitions and Poltergeists: An Exploration of the Supernatural Through History,* USA: Llewellyn Publications

Ross, Catrien (1996) *Supernatural and Mysterious Japan*, Tokyo, Japan: Yenbooks

Schilling, Mark (1999) *Contemporary Japanese Film,* USA: Weatherhill, Inc

Schneider, Steven Jay (ed) (2003) *Fear Without Frontiers: Horror Cinema Across the Globe,* England, UK: FAB Press

Scott, A.C. (1955) *The Kabuki Theatre of Japan,* London, UK: George Allen & Unwi

Screech, Tim (1992) *Japanese Ghosts,* Mangajin (1) 40 p. 21

Scholz-Cionca, Stanca (Stanca) *Figures of Desire: Wordplay, Spirit Possession, Fantasy, Madness, and Mourning in Japanese Noh Plays,* Asian Theatre Journal, (21) 1 p. 104+

Sekidobashi, Sakura (2005) *Banchō Sarayashiki Essay* [online] Available from: http://homepage1.nifty.com/aby/2005/bancho-sarayashiki-februarye.htm [Accessed 11 October 2005]

Serper, Zvika (2001) *Between Two Worlds: The Dybbuk and the Japanese Noh and Kabuki Ghost Plays,* Comparative Drama, (35) 3 p. 345+

Shimazaki, Chifumi (1993) *Warrior Ghost Plays from the Japanese Noh Theater,* New York, USA: Cornell University Press

Shirane, Haruo, Watson, Burton (2013) *Record of Miraculous Events in Japan: The Nihon Ryoiki,* USA: Columbia University Press

Silva, Arturo (ed) (2001) *The Donald Richie Reader: 50 Years of Writing on Japan,* USA: Stone Bridge Press

Schnell, Scott (1999) *The Rousing Drum Ritual Practice in a Japanese Community,* USA: University of Hawai'i Press

Stone, Jacqueline (Ed.), Walter, Mariko Namba (Ed.) (2008) *Death and the Afterlife in Japanese Buddhism,* Honolulu: University of Hawai'i Press Suzuki, Koji (2002) *Dark Water, Tokyo,* Japan: Kadokawa Shoten Publishing Co., Ltd

___. (2004) *Ringu, Tokyo,* Japan: Kadokawa Shoten Publishing Co., Ltd.

Takada, Mamoru (ed) (2002) *Edo Kaidanshū Vol 1-3,* Japan: Iwami Shoten Publishing

Tamaru, Noriyoshi (ed), Reid, David (ed) (1996) *Religion in Japanese Culture,* USA: Kodansha America Inc.

Tanabe Jr, George J. (1999) *Religions of Japan in Practice,* USA: Princeton University Press

Thal, Sarah (2005) *Rearranging the Landscape of the Gods,* USA:University of Chicago Press

Tsurumi, Maia (1997) *"Gender and Girls' Comics in Japan"* Concerned Asian Scholars, (29) 2 p. 46

Ueda, Akinari, Zolbrod, Leon M. (1974) *Ugetsu Monogatari: Tales of Moonlight and Rain: A Complete English Version of the Eighteenth-Century Japanese Collection of Tales of the Supernatural,* Vancouver, Canada: University of British Columbia Press

Ueda, Akinari, Chambers, Anthony H. (2007) *Tales of Moonlight and Rain,* USA: Columbia University Press

Ury, Marian (1979) *Tales of Times Now Past: Sixty-Two Stories from a Medieval Japanese Collection,* USA: Center for Japanese Studies, The University of Michigan Press

Weston, Mark (1999) *Giants of Japan: The Lives of Japan's Greatest Men and Women,* USA: Kodansha International

Wada, Kyoko (2012) *Yokai Manga Ukiyoe of Monstrous Creatures Vol. 1 & 2,* Japan, Seigensha

Yanagita, Kunio, Morse, Ronald A. (2008) *The Legends of Tono,* USA: Lexington Books

Yumoto, Koichi (2007) *Edo Tokyo Kaii Hyakumonogatari,* Japan: Kawade Shobo Shinsha Publishers

IMAGES

Page 9: *Ghost of Oyuki,* Maruyama Ōkyo. Photo by Benjamin Blackwell. On extended loan to the University of California, Berkeley Art Museum from a private collection

Page 10: *Ghost,* Shibata Zeshin. Digital Image © [2014] Museum Associates/ LACMA. Licensed by Art Resource, NY

Page 11: *The Ghost of Akugenta Yoshihira attacking His Executioner Namba Jirō at Nunobuki Waterfall,* Tsukioka Yoshitoshi

Page 12: *Kimi Finds Peace,* Evelyn Paul. The Stapleton Collection/Art Resource, NY

Page 13: *The Ghost of Kohada Koheiji,* Hokusai Katsushika (1760-1849) © RMN-Grand Palais/Art Resource, NY

Pages 14-15: *Maruyama Ōkyo,* Tsukioka Yoshitoshi

Page 16: *Ghost Appearing to a Warrior,* Utagawa Kunisada

Page 17: *Hokusai's Manga,* Image copyright © The Metropolitan Museum of Art. Image source: Art Resource, NY

Page 72: *Realm of Hungry Ghosts,* Hirotaka School. © The Trustees of the British Museum/Art Resource, NY

Page 73: *Court of King Emma in Hell,* Hirotaka School © The Trustees of the British Museum/Art Resource, NY

Page 74: *A Ghost (Ubume),* Tsukioka Yoshitoshi. Keio University, The Takahashi Seiichiro Collection of Ukiyo-e Prints

Page 75: *Female Ghost,* Kawanabe Kyosai (1831–1889). Photo by Erich Lessing/Art Resource, NY

Page 76: *Shimobe Fudesuke and the Ghost of the Woman in the Waterfall,* Yoshitoshi Tsukioka

Page 77: *Takagi Umanosuke and the Ghost of a Woman,* Yoshitoshi Tsukioka (1839–1892) Ashmolean Museum/The Art Archive at Art Resource, NY

Page 78: *Traveling Ronin Receiving his Child from the Ghost of his Wife,* from Utagawa Kuniyoshi's 53 Parallels of the Tokaido Road. Ashmolean Museum/ The Art Archive at Art Resource, NY

Page 79: *The Ghost of Genji's Lover,* Tsukioka Yoshitoshi. V&A Images, London/Art Resource, NY

Page 121: *The Ghost of Okiku at Sarayashiki,* Tsukioka Yoshitoshi, (1839–1892). HIP/Art Resource, NY

Page 122-123: *The Taira Ghosts Attacking Yoshitsune's Ship,* Kuniyoshi Utagawa (1791–1861). Ashmolean Museum/The Art Archive at Art Resource, NY

Page 124: *Kamiya Niyemon Terrified by Fire,* Kuniyoshi Utagawa, (1797–1861). Ashmolean Museum/The Art Archive at Art Resource, NY

Page 125: *Ghost of play Yotsu-ya,* Kuniyoshi Utagawa, (1797–1861). Ashmolean Museum/The Art Archive at Art Resource, NY

Page 126: *Female Ghost,* Utagawa Kunisada

Page 127: *The Ghost of Seigen Haunting Sakurahime,* Tsukioka Yoshitoshi Page 164: *Manga Yūrei,* Hokusai Katsushika

ACKNOWLEDGMENTS

This book was almost eight years in the making, and clearly there are many who helped along the way, either by listening patiently to my lengthy discussions on yūrei (or politely faking interest), acting as readers and soundboards, or filling those gaps that books and research can't cover. My greatest thanks goes to my beautiful wife, Miyuki Davisson, who has been a part of this from the beginning, since back when she was only my girlfriend and drove me desperately through the streets of Osaka to the post office before closing time so I could overnight my MA thesis and make my deadline. She also lived with me in haunted houses and put up with me tramping all over Japan looking for ghosts, and helped me translate obscure Heian-period kanji. Thanks, honey. You're awesome.

I also thank my mother, Leilani DeLong, who obviously raised me right and planted the first seed long ago when she bought me a subscription to the Time Life Enchanted Worlds series—which just goes to show you never know when you are about to change someone's life. Thanks mom. You're awesome too.

Much appreciation to Mike Lindsey, my old friend and long-suffering first reader, who read every single incarnation of this book since I started years ago. His help was much appreciated, although whether I achieved his advice of making my writing "flow like the Ganges flows" is up to the reader. To Tetsuya, the Buddhist monk/elementary school teacher who loved yūrei as much as I do and spent countless hours describing Japan's complicated afterlife in precious detail. And to the gang at the 100 Club who all shared their personal ghost stories and made the yūrei of Japan more real than any book ever could.

There are many others to thank: my publisher Bruce Rutledge, who saw something special in my book, and Elijah Zupancic, who introduced us; publicist Chelsey Slattum, who threw my book in front of everyone; David Jacobson, for hunting down the pictures; Carla Girard, my book designer who understands my old-fashioned aesthetics; Tom McAulay, my thesis adviser at the University of Sheffield; Kim MacKay, my writing teacher at Cornish; Erik Keefer for my fabulous author's photo; Noriko Reider, whom I have never met but whose research into kaidan and yūrei inspired and informed me; Matt Alt for advice and

trailblazing; James Kennedy, who showed me that normal people wrote books and that I could do it too; Mizuki Shigeru and Lafcadio Hearn for everything. To Tony Harris, Stan Sakai, Brandon Seifert, Dave Stewart, and Mike Mignola—the interest and encouragement of those whose works I admire meant more than you can know.

To those I haven't named personally, all apologies for the oversight, and thank you for everything.

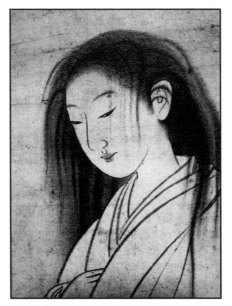

Ghost of Oyuki (detail),
Maruyama Ōkyo